Hellboy's World

The publisher gratefully acknowledges the generous support of the Robert and Meryl Selig Endowment Fund in Film Studies of the University of California Press Foundation, established in memory of Robert W. Selig.

Hellboy's World

Comics and Monsters
on the Margins

SCOTT BUKATMAN

UNIVERSITY OF CALIFORNIA PRESS

University of California Press, one of the most
distinguished university presses in the United States,
enriches lives around the world by advancing scholarship
in the humanities, social sciences, and natural sciences.
Its activities are supported by the UC Press Foundation
and by philanthropic contributions from individuals
and institutions. For more information, visit
www.ucpress.edu.

University of California Press
Oakland, California

Library of Congress Cataloging-in-Publication Data

Bukatman, Scott, 1957– author.
 Hellboy's world : comics and monsters on the margins /
Scott Bukatman. — First edition.
 pages cm
 Includes bibliographical references and index.
 ISBN 978-0-520-28803-4 (cloth : alk. paper)
 ISBN 978-0-520-28804-1 (pbk. : alk. paper)
 ISBN 978-0-520-96310-8 (ebook)
 1. Mignola, Michael—Criticism and interpretation.
2. Hellboy (Fictitious character : Mignola) 3. Comic
books, strips, etc.—United States—History and
criticism. I. Title.
 PN6727. M53Z57 2016
 741.5′973—dc23

 2015032474

Printed in China

25 24 23 22 21 20 19 18 17 16
10 9 8 7 6 5 4 3 2 1

The paper used in this publication meets the minimum
requirements of ANSI/NISO Z39.48–1992 (R 2002)
(*Permanence of Paper*).

This book is, of course, for Linus—
my own little Hellboy.

Monsters exist in margins. They are thus avatars of chance, impurity, heterodoxy; abomination, mutation, metamorphosis; prodigy, mystery, marvel.

Allen Weiss

Contents

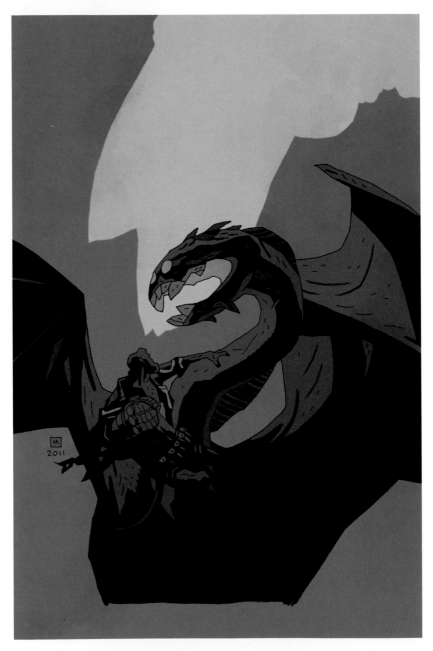

Figure 1. Mike Mignola, *Hellboy: The Fury,* no. 2, cover. Dave Stewart, color.
Dark Horse Comics, 2010.

Hellboy and the Adventure of Reading

You are given a book from the school library. In the lower classes, books are simply handed out. Only now and again do you dare express a desire. Often, in envy, you see coveted books pass into other hands. At last, your wish was granted. For a week you were wholly given up to the soft drift of the text, which surrounded you as secretly, densely, and unceasingly as snow. You entered it with limitless trust. The peacefulness of the book that enticed you further and further! Its contents did not much matter. For you were reading at the time when you still made up stories in bed. The child seeks his way along the half-hidden paths. Reading, he covers his ears; the book is on a table that is far too high, and one hand is always on the page. To him, the hero's adventures can still be read in the swirling letters like figures and messages in drifting snowflakes. His breath is part of the air of the events narrated, and all the participants breathe it. He mingles with the characters far more closely than grownups do. He is unspeakably touched by the deeds, the words that are exchanged; and, when he gets up, he is covered over and over by the snow of his reading.

Walter Benjamin, "One-Way Street"

I think that the young Walter Benjamin, the one who wrote so winningly of book collecting and the wonders of children's books, might well have appreciated what the medium of comics had to offer. And I would go so far as to speculate that there are aspects of Mike Mignola's *Hellboy* comics that might have resonated particularly well with his bookish sensibility.

For Benjamin, the library was a living thing, and any really worthy book collection would include what he called "booklike creations from fringe areas."[1] He was referring to things like pamphlets or autograph books, facsimiles of "unobtainable books," and "certainly periodicals"—all of these could "form the prismatic fringes of a library."[2] It hardly requires a stretch to drag comics into this, whether in the ephemeral forms of a periodical comic book or a clipped newspaper strip, or the voluptuous, archival reprint editions that present full-sized facsimiles of a master's original artwork on high-quality paper (the sumptuous, oversized reprints of *Hellboy* material are even called "Library Editions").

Benjamin evokes a child swept up in the swirls of words within the coveted book, but he has also written of the particular ways in which illustrated books activate their young readers: "This resplendent, self-sufficient world of colors is the exclusive preserve of children's books."[3] He refers to the way that the gazing child enters into those pages, becoming "suffused, like a cloud, with the riotous colors of the world of pictures."[4] That word *riotous* further points to what Benjamin sees as the real virtue of these images: they rescue children's books from the pedantry imposed on them by well-meaning moralists. While the written text had lessons to impart, the illustrations, being beneath notice, "were beyond the reach of philanthropic theories, so artists and children swiftly came to an understanding

over the heads of the pedagogues."[5] There is something a little subversive about these pictures, insofar as they are more seductive or distracting than instructional.

The kind of reading that Benjamin describes is fundamentally dialogic. I've elsewhere quoted Lynda Barry on the subject of play—"I believe a kid who is playing is not alone. There is something brought alive during play, and this something, when played with, seems to play back"—and have extended her notion of play to the act of reading.[6] Following her lead, I see something even more reciprocal than Benjamin overtly acknowledges (although he certainly suggests that the reader who is activated by a text activates that text in turn).[7] Reader and book are entwined; neither exists without the other. The unread book does not tell its stories. This is surely true of comics and their readers as well; as so many comics theorists have noted, the medium makes unique demands of its readers and thereby engages them all the more.

Benjamin's achingly beautiful evocation of a child reading a coveted book speaks to me as a reader, but it speaks to me more loudly as a reader of comics. Jules Feiffer, who apprenticed with Will Eisner on *The Spirit* before becoming a formidable creator of both comics *and* children's books, has written of the riotously colorful fantasias of the superhero comics that he cherished as a child: in a world of endlessly imposed expectations, comic books offered a "relief zone"—"within this shifting hodgepodge of external pressures, a child, simply to save his sanity, must go underground. Have a place to hide where he cannot be got at by grownups. With [comic books] we were able to roam free, disguised in costume, committing the greatest of feats—and the worst of sins.... For a little while, at least, *we* were the bosses." The antisocial influence that culture's moral arbiters ascribed to these seductive and distracting comics were, for Feiffer and

many another, their greatest strength.[8] As a child, I was never allowed to buy as many comics as I desired. Friends and I swapped some (and furtively bought, swiped, and hid others), and then—somewhat less so now—the wait between install-ments could seem excruciatingly long (a month was longer for me back then; now I barely note their thuddingly regular pas-sage). Finally, new issues would appear on whatever Wednesday it was, and I would rush home to become "wholly given up to the soft drift" of my comics. The comics themselves certainly didn't constitute a "soft drift," filled as they were with battles, cosmic odysseys, neurotic self-questioning, masks, capes, superpowers, secret identities, and secret weaknesses. But reading them was just as peaceful and exciting a project as Benjamin makes read-ing out to be, and I surely "mingled" with the characters to a degree that slightly alarmed my parents.

But reading habits change, as Benjamin notes, and my cathe-ction onto these fictional heroes ebbed, replaced—up to a point—with a new fascination for the artists and writers who crafted these comic books. The fictional worlds lost some of their hold over me, and I no longer arose "covered over and over by the snow" of my reading.

Then I found Hellboy (figure 1). To be sure, I'd known of him for some time. I had the first collected story arcs, *Seed of Destruc-tion* (1994) and *Wake the Devil* (1996), and I'd liked them well enough (figure 2). But I could never work out the publication schedule or the reading order, and every time I thumbed through a collection at the comics store, I couldn't shake the feeling that I'd read it before. It always seemed to involve Nazi gorillas. Gorgeous art, but not a story that I needed to have told. I was also peripherally aware that Mignola was no longer draw-ing the character and only cowriting most of the stories. Pure

Figure 2. Mike Mignola, *Hellboy: Wake the Devil,* no. 5, cover. James Sinclair, color. Dark Horse Comics, 1997.

corporate product, I figured, a cash cow for Dark Horse Comics without artistic integrity.

Or so I thought. Late in the first decade of this century, I began hearing that *Hellboy*'s spinoff series, *B.P.R.D.* (which stands for the Bureau for Paranormal Research and Defense), was one of the best comics out there; meanwhile, Dark Horse had begun rereleasing *Hellboy* in oversized Library Editions that showed off Mignola's extraordinary art to best advantage. Having some time on my hands and research funds to spend, I began buying *Hellboy* and *B.P.R.D.* And reading. And reading some more. For the first time in ages, I gave myself up to the drift of the text and mingled with the characters and events. I was not, however, returned to the world of my childhood (which, I have to tell you, isn't a place I especially want to revisit anyway). The stories and art satisfied the adult version of that comics-reading kid, even the story with the Nazi gorillas (*Conqueror Worm* [2001], which was *awesome*), and it was exciting to become so attached to something that wasn't a holdover of my childhood. There was a coherence to the events in both series (as well the other Mignola-led titles), and a rich, dense story was unfolding with elegance and panache. Mignola's collaborations were more thoughtful than I'd assumed, and it was clearly his steadying hand (or, as he later commented to me, his "gentle" hand on the rudder) that kept everything coherent, superlative, and unfailingly surprising. I thought this might be something worth writing about; as it turns out, this is the first book-length study of Mignola's work.

For those unfamiliar with him, Hellboy is a hulking, red-skinned figure with cloven hooves, a sinuous tail, muttonchops, and two bumps where his horns used to be. Swathed in a trench coat and usually packing some serious heat, he is one of the foremost paranormal investigators of his day, serving as a sometime

member of the Bureau for Paranormal Research and Defense (he comes down rather more heavily on the "defense" side of things). A demon summoned by desperate Nazis near the end of World War II to abet their plans of world domination, he first manifested as a small and frightened horned creature.[9] (Part of the joy and curse of comics studies is that you often find yourself typing sentences like that one.) A timely raid by Allied forces resulted in the l'il guy's adoption by Professor Trevor Bruttenholm, who raised him as a normal lad. Saddled with the knowledge that he is the demon Anung Un Rama, the Beast of the Apocalypse, whose destiny is to end the reign of humankind on Earth, Hellboy has lived a life of resistance, refusing that fate (hence the filed-down horns). He has aged more slowly than the humans around him, and his adventures have spanned more than five decades. The comics vary in structure and tone. Some stories are short, taking no more than ten pages, while others stretch over a five-to-eight-issue arc. Some connect to the larger cosmology, others are heavy with atmosphere and an unflinching melancholy, some are funny, and still others simply give us Hellboy punching out some sort of occult beastie. The comics combine mysticism and cosmic horror with superheroic action—Hellboy's response to the appearance of an ages-old demon or animated corpse is usually a brief exclamation of "Jeez!" or, more typically, the interrupted locution "Son of a—!" (figure 3) Both *B.P.R.D.* and *Hellboy* have recently wrapped up storylines that stretched back over a decade; Hellboy was killed and is presently residing in Hell, while in the apocalyptic *Hell on Earth* series, the B.P.R.D. is now dealing with an apocalyptic world overrun by the monstrous Ogdru Hem.

I could playfully describe *Hellboy* as a Howard Hawks movie set in an H.P. Lovecraft universe with art direction by Jack Kirby,

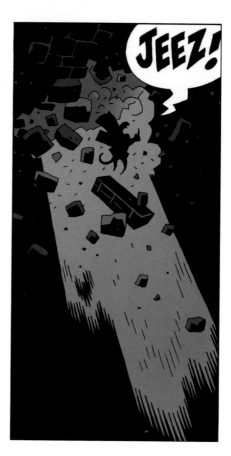

Figure 3. Mike Mignola, "The Varcolac," p. 3. Dave Stewart, color; Pat Brosseau, letters. Dark Horse Comics, 2000.

but, while there's something to that, it doesn't begin to get at the complexity of the hybrid, genre-juggling textual system that Mignola has developed. Hellboy's life as a paranormal investigator immediately positions the work as a rich mix of superhero adventure and horror—a heady, pulpy brew—but early on, Mignola planted the seeds of a greater cosmology. *Hellboy* and its spin-off series now form a deeply intertextual enterprise that incorporates a broad range of literary, visual, and cinematic influences, includ-

ing classic horror fiction, war films, folklore, monster movies, other comics, and Mexican *luchadores*.[10] And while a lot of genre comics art has moved toward a kind of realism that owes far too much to cinema and television, Mignola's art has become increasingly non-naturalistic, with a refreshing attention to—and pushing of—the formal properties of the medium of comics.

What is most striking about *Hellboy* is the balance that Mignola achieves, the breadth of influences and the amalgam of elements that he keeps in play. To fully appreciate his accomplishment—and I don't pretend that I do—is to understand the intermedial influences of Albrecht Dürer and Manly Wade Wellman, Jack Kirby and Charles Dickens, and Robert E. Howard and Jean Cocteau, among many others—including, I'm sure, many I'm unaware of. Stories are often structured around extensive quotations from Poe, Shakespeare, and Milton. One of my favorite moments in "The Island" has Hellboy quoting Ahab, but, quixotically enough, it's Gregory Peck's Ahab rather than Melville's. For comics creator Gary Gianni, Mignola's "high regard for classic foundations is mingled in a refreshing manner with pulp material from the 30s and 40s, as well as horror films and other comics," which allows him "to acknowledge his influences without being pedantic or ostentatious."[11] The conceptual brilliance lies in how Hellboy has continued, for over twenty years, to serve as the container for all of this—this range of tones and story types, this mix of fiction, folklore, and mythology, all filtered through the vehicle of Mignola's aesthetic sensibilities and this guy named Hellboy.

Beyond celebrating Hellboy (although, while we're at it, HAIL HELLBOY!), the real purpose of *Hellboy's World* is to open up new ways of understanding the experience of reading comics, using the work of Mike Mignola as its primary case study.

Mignola's comics exemplify what comics can do and what readers do in their encounter with comics, but they also constitute an idiosyncratic body of work with its own set of concerns. This book engages with the growing literature in comics studies, but in quest of new approaches, I frequently turn to other media—children's books especially, but also sculpture, pulp fiction, cinema, graphic design, painting, and medieval manuscripts. These comparisons are designed both to understand effects or possibilities in the medium of comics and to find vocabularies that will help articulate what it is that comics do.

Mignola has always worked within the commercial parameters and constraints of the mainstream comics industry, but he maintains creative control and displays a personal vision that is intimately connected to the power of his chosen medium.[12] He writes and draws many of Hellboy's adventures, but also collaborates with other writers and artists. His work is distributed to comics shops and through such online comics merchants as comiXology, as well as less specialized bookstores. In his position within the industry as well as his sustained interest in genre, Mignola reminds me of the film director Howard Hawks. Although he operated under work-for-hire conditions at Hollywood studios, Hawks also produced many of his films, and his personal stamp was (eventually) easily discerned. There are other stylistic and tonal resonances between Hawks and Mignola, and his name will surface here and there in these pages.

In taking Mignola's production seriously, I take it for granted that innovative work in the medium of comics can be found both at the center and at the fringes of commercial production, within the world of superhero and other genre comics as well as in the more overtly personal arenas of autobiography and lit/art comics. Charles Hatfield has argued for the ways "genre may exert a

determining influence on form," proposing that the superhero genre, from the 1960s onward, "has shaped the aesthetics of the American comic book, hence of comics generally, through a cluster of artistic habits that exaggerate certain formal tensions inherent to the medium."[13] Building on the foundation established by such early comic-strip practitioners as Winsor McCay and George Herriman, American and European artists working in genre comics have pushed comics in new directions in the treatment of human figure and movement as well as in ways of organizing the space of the page (a very partial and largely chronological list would have to include Jack Kirby, Will Eisner, Jim Steranko, Neal Adams, Moebius, Philippe Druillet, Howard Chaykin, Walter Simonson, Frank Miller, Jim Starlin, Trevor von Eeden, J.H. Williams III, Jae Lee, and Emma Rios) (figure 4).[14] Mignola's *Hellboy* books are not, strictly speaking, superhero comics, but they are similarly positioned within the industry, and are similarly overlooked by the emphasis in comics scholarship on more "respectable" work of the "graphic novel" or single-creator variety.

The filmmaker Stan Brakhage has written of the "adventure of perception" that constitutes the world of experience for the prelinguistic child, for whom all things are new and filled with mystery. Cinema itself constitutes something of an immersive perceptual adventure, but comics present something else: something more like a heightened adventure of *reading* in which syntheses of word and image, image sequences, and serial narratives are continually performed by the eager reader. Comics don't demand, and may not even permit, the same level of corporeal investment as the cinema, but they engage in other ways.

I hope to demonstrate not only that *Hellboy* generates an "adventure of reading," but that this particular adventure is

Figure 4. Walt Simonson, "Rebellion!" p. 2. *Detective Comics*, no. 440. Simonson and Alan Kupperberg, letters. DC Comics, 1974.

strikingly aligned with some of the concerns of young Walter Benjamin. A heightened formal rhetoric, an investment in inter-narrative referentiality, and the scholarly vocation of the occult detective constitute the world of Hellboy as a strikingly bookish one; the imaginative space that exists on the page and within the book becomes very much a meditation *upon* the imaginative space of page and book. Comics culture venerates books as objects, not just concatenations of signifiers, and this has partic-ular resonance in the world of *Hellboy.*

Art Spiegelman has wryly noted that comics, historically derided for contributing to illiteracy and delinquency, have become one of the last bastions of bibliophilia in our culture.[15] There are beautiful publications that reprint classic comic strips and comic books—it's safe to say these works have never looked so good—while the designs coming out of Fantagraphics, Pan-theon, Drawn & Quarterly, and other publishers of alternative, art, or lit comics are objects wonderful to hold and behold. And the bookishness that I'm ascribing to Mignola's thematic and aesthetic concerns are not his obsession alone—any number of contemporaneous comics creators have been meditating upon books and narratives. *Sandman* by Neil Gaiman and numerous artists; *Promethea* by Alan Moore and J.H. Williams III; the *League of Extraordinary Gentlemen* series by Moore and artist Kevin O'Neill; *Wimbledon Green* by Seth; Peter Carey's *The Unwritten;* and more than a few works by Grant Morrison have engaged in metatextual play around the book, including the comic book held in a reader's hands, as an object with power in the world. These are works obsessed with texts—making them, collecting them, consuming them, being consumed by them. Through the materiality of the book, stories themselves have a material presence in the world, and while many of these tales

are written indelibly, in others the possibility exists to exit the page and change the story.[16] Without engaging in the metatextual pyrotechnics of these others, Mignola is manifestly invested in all of this: in "The Third Wish" (2002), Sir Edward Grey says of Hellboy, "His story is not yet written." "It is!" objects another, but Sir Edward replies, "Then he is rewriting it."

When you open up a *Hellboy* or *B.P.R.D.* book, you're clearly looking at a *comic* (figure 5). The flat colors, the basic sound effects ("BOOM"), and a somewhat cartoony aesthetic all place the reader in a certain milieu, a certain kind of comic that has everything to do with exaggerated adventure and not much gravitas. And yet. And yet the strange thing is that the *Hellboy* books have *plenty* of gravitas without ever drowning in it, and I'm still not entirely sure how Mignola achieves and sustains this singular balance. Guillermo del Toro, an admirer well before he made his *Hellboy* films, wrote that Mignola produces "moments of quiet, almost elegiac horror juxtaposed with a kinetic energy only hinted at by the best of Kirby. And then—and then—above all!—an irritating simplicity" (figure 6).[17] I'm sympathetic to the breakdown of del Toro's syntactic structure when confronted by Mignola's accomplishment. *Hellboy* is the unique sum of an attitude and an aesthetic, and it's as personal a work as comics has produced. "Basically, it's taking everything I've been reading since high school, everything I ever liked, everything I ever read, old movies, tons of pulp magazines and stuff I read in college, fairy tales—all that stuff I've read, going back to *Dracula* in sixth grade, all that stuff I've been thinking about since then, I boiled it all down and made it into *Hellboy*."[18]

Mignola directs the reader's attention simultaneously in two directions: he provides effective storytelling, rich in atmosphere and inventive character design, but he also foregrounds an

Figure 5. Mike Mignola, *Hellboy in Hell,* no. 1, p. 3. Dave Stewart, color; Clem Robins, letters. Dark Horse Comics, 2012.

Figure 6. Mike Mignola, *Hellboy:* "The Island," no. 2, p. 25. Dave Stewart, color; Clem Robins, letters. Dark Horse Comics, 2002.

aesthetic that emphasizes flatness, stasis, and unified composition. The books become total environments for the reader, absorbing and dynamic. The encompassing cosmology of *Hellboy* is mirrored in the encompassing cosmology of the experience of reading *Hellboy*.[19] Despite a few adaptations into film and animation, the book is Hellboy's natural habitat, and Mignola's attention to the aesthetics of the whole (panel, page, book, series) reveals a bibliophilic sensibility that Benjamin might have recognized.[20] While contemporary media scholarship is increasingly intrigued by the proliferating intermedial, transmedia, or multiple-media artworks and narrative forms, I'm very taken with the fact that Mignola is, in his creative heart, undeniably a book guy.

The extended network of the Mignola-verse—a network that encompasses the relation of panel-to-panel, panel-to-page, story-to-story, story-to-series, series-to-series, and series-to-genre—constitutes that universe as something of an archive, a "living library," to return to Benjamin's terms. In the mythos of weird fiction, though, as practiced by such writers as H. P. Lovecraft and Mike Mignola, the notion of a living library takes on a more sinister cast, as one's engagement with the library holds the possibility of unloosing ancient evils upon the world. The haunted protagonists of Lovecraft's fiction have a kind of analogue in the book collector summoned up in Benjamin's writing—he, too, is something of a human possessed, and Benjamin's language has recourse to the supernatural to evoke the feelings peculiar to the breed: "For inside him there are spirits, or at least little genii, which have seen to it that for a collector—and I mean a real collector, a collector as he ought to be—ownership is the most intimate relationship that one can have to objects. Not that they come alive in him; it is he who lives in them."[21] Elsewhere, he refers to the "demonic qualities" that such passions as book collecting foster.[22]

To return to Benjamin's meditation on the reading child, what he describes can also be understood as an excursion into scholarly method—mine, at any rate. On the most basic level, I no longer write about things that don't resonate with me in just that way; if the text won't surround me "secretly, densely, and unceasingly," then I've no reason to stay with it or even turn my full attention to it. I give myself up to the drift of the text, letting it take me where it wants to go, remaining attentive not just to what the text says, but to how it feels. For the scholar, the "hero's adventures" may no longer be at the center of one's engagement with a work, but *something* "can still be read in the swirling letters like figures and messages in drifting snowflakes," and one's breath continues to be "part of the air" of these aesthetic and narrative events. What Lynda Barry claims for the child at play holds true for the engagement performed by the the reader, and it should also be true for engagement by the scholar—one should want to play, and the text should most certainly play back.

And if my method has its Benjaminian side, then that is entirely compatible with the method that Michael Camille has labeled "monstrous" in its attention to liminal works—objects, like comics, that "elude or slip through the network of classifications that normally locate states and positions in cultural space."[23] He proposes that "The medieval image-world was, like medieval life itself, rigidly structured and hierarchical. For this reason, resisting, ridiculing, overturning and inverting it was not only possible, it was limitless."[24] His sense of illuminated manuscripts as often unruly sites where image did battle with word aligns them with Benjamin's children's books and my comics. His emphasis is less on the reader than on the illuminator of these texts, yet I cannot resist his sense of the thirteenth-

century text as a "playground" and turn it to my own purposes: "Play has to have a playground, and just as the scribe follows the grid of ruled lines, there were rules governing the playing-fields of the marginal images that keep them firmly in their place."[25] Comics, too, with their grids and ruled borders, permit the emergence of what I've called little utopias of disorder, very much in keeping with Camille's evocation of these medieval images as brief and constrained disruptions of a system marked by order. Comics are little monsters, too, perhaps even what Camille pungently calls "verminous whimsies."[26]

Allen Weiss extends Camille's argument into a matter of aesthetic principle: writing of Kant's *Critique of Judgment,* Weiss proposes that "Kant shows how the aesthetic domain exists without any regulatory a priori whatsoever. This principle could be summed up and radicalized in one word: *monsters.*" And for Weiss, "Monsters exist in margins." In his "Ten Theses on Monsters and Monstrosity," he further tells us that "Monsters symbolize alterity and difference in extremis. They manifest the plasticity of the imagination and the catastrophes of the flesh," and here he could be writing of Hellboy or any of the other "enhanced agents" of the B.P.R.D. But he could also be referring to a different kind of monstrosity, which becomes more evident in his seventh thesis: "Monsters exist in margins. They are thus avatars of chance, impurity, heterodoxy; abomination, mutation, metamorphosis; prodigy, mystery, marvel. Monsters are indicators of epistemic shifts." Here it becomes possible to understand the monster as both Hellboy himself and the *Hellboy* comic book in which he appears; Weiss's language enumerates what goes on in many a comic book narrative, where abominations, metamorphoses, mysteries, and marvels abound. But the comics themselves could be said to embody much of this, and they have,

historically, been viewed as "indicators of epistemic shifts"—anxieties around atomic power undergird many a superhero origin, and the present moment of comics' respectability might tell us something about the importance of polyphonous hybrid texts that utilize words and sequences of images. *Hellboy* might, as my book suggests, speak to the "epistemic shift" around the changing status of the book in digital culture. In any case, Weiss and Camille tell us about monsters on the margins, and those monsters are to be understood as both representational agents and material forms.

The academy has, in general, become more alert to these kinds of marginalia. As urban historian M. Christine Boyer has written, "Zones once silenced and rejected as marginal territories now loom into view as what the past lacked and what must be brought back into memory: madness, carnivals and festivals, the masquerade and the melodrama, women's studies and black studies, subaltern cultures ... become frontiers of new exploration."[27] Comics fit squarely into this paradigm shift. After all, as Benjamin wrote of those looking for substance in literature, "the person who can see more deeply can find the elements he really needs in the lower depths of writing and graphic art rather than in the acknowledged documents of culture."[28]

I like the way that Benjamin's "lower depths of writing and graphic art" resonates with the "marginal monstrosity" found in Camille's illuminated manuscripts: "the realm of marginal monstrosity is irrevocably linked with the capacity of the human imagination to create and combine. What is most surprising is the obvious delight taken in the space of the imagination.... Here the artist did not limit himself to making images 'within the round circle of the Law' but purposefully stepped outside it in order to define its limits." Camille finds a purposeful disrup-

tion in play, while for Benjamin the challenges to established order arise more from a deeply fortuitous accident.

I'm far from the first comics scholar to turn to Benjamin in thinking about comics: Anthony Enns and Nathalie op de Beeck have both applied his writing to the urban narratives of Jason Lutes and Ben Katchor, but it's Jared Gardner who has most effectively mapped Benjamin onto the medium more broadly.[29] He rightly notes that comics coincide with Benjamin's call for new ways of writing that could draw upon the graphic energies of advertising or the cinema. He further argues that Benjamin's "archive"—that incoherent collection of the mundane and the marginal that collectively counters dominant historical narratives—and the hybrid form of comics share some qualities: "Like the archive, the comics form retains that which cannot be reconciled to linear narrative."[30] Referring to some of the most salient aspects of comics—the gutter between the panels, the tension between synchronic array and diachronic sequence— Gardner writes, "The comics form is forever troubled by that which cannot be reconciled, synthesized, unified, contained within the frame; but it is in being so troubled that the form defines itself. The excess data—the remains of the everyday—is always left behind (even as the narrative progresses forward in time), a visual archive for the reader's necessary work of rereading, resorting, and reframing."[31] And the book collector and the comics collector are not so far apart: "readers of comics are themselves (not always unfairly) stereotyped as obsessive collectors."[32] So, whether we consider the hybrid form of comics that aligns with Benjamin's call for new modes of writing, the material objects of comics and the collectors who are devoted to them, or the ephemeral everydayness of the comic strip and its mapping of urban modernities, comics scholars continue to

demonstrate how the form resonates with some of the concerns of Benjamin's early writings.

．　　．　　．

The chapters that follow deal with different aspects of what we can call "Hellboy's world." I'll begin with a consideration of Mignola's accomplishment in simultaneously building a complex world for Hellboy's adventures—a world defined narratively, structurally, and formally—and the development of the *Hellboy* franchise represented by the expanding number of interrelated series and the process of collaboration upon which that expansion depended. Comics reading is frequently a networked reading—not only do panels and pages connect in both sequential and nonlinear correspondences and continuities, but readers of superhero comics are heavily invested in character histories, narrative continuities, and the virtues and vicissitudes of the various "universes" in which those characters and stories commingle. The second chapter emphasizes elements of narrative, exploring Hellboy's relation to fate by considering some of his generic roots and the transformation that genres undergo in the translation from the evocative medium of prose to the more pictorial form of comics. The sublime and "unspeakable" horrors of Lovecraft's fiction must, by definition, be given form in the comics; how, then, do they remain "unspeakable"?

Having considered *Hellboy*'s history and roots, in the remaining chapters I take on the materiality of the comics themselves. The third chapter aligns comics with children's literature, with particular attention to the prominent place and nonrational power of color. The fourth chapter emphasizes the "bookishness" at *Hell-*

boy's core, concentrating on what, following the work of medieval scholar Martha Dana Rust, I call its "codicological imagination." In the final chapter—the longest—I take on Mignola's aesthetic sensibility, the surprising foregrounding of stasis and stillness in the pages of *Hellboy,* and the implications of that stasis for the materiality of the reading experience.

My sources are diverse and not necessarily congruent, but one was particularly helpful: Mike Mignola was considerate enough to sit down with me one day to discuss his work. My main goal was to learn more about his collaborations with the writers, artists, colorists, letterers, and editors with whom he's worked, but the conversation revealed much about his overall creative process, and had the happy collateral of confirming many of my own intuitions about his work. That conversation is referenced throughout.

Finally, here's what this book is not: it is not a thorough guide to the wonderful work of Mike Mignola, it does not grapple with the ins and outs of the twenty-year-and-counting story that is being told in his comics, and there are long stretches where Hellboy and Mignola aren't even mentioned. I'm chagrined that I don't give Mignola the writer his full due. Make no mistake, Mignola is a *demon* writer who combines intricate, long-game plotting with an admirably minimalist approach to dialogue. His recent scripts for *Hellboy in Hell* and *The Midnight Circus* are allusive and elusive; they don't give up their secrets easily. But words never get in the way of Mignola's art, and in fact, their presence on the page reinforces one's aesthetic encounter with the page, punctuating the space and slowing the eye. To pay more attention to Mignola's stories, though, would force this book to detour into the kind of extended plot synopses that are

inevitably tedious to those not already on board with the whole *Hellboy* "thing." It also would tell us comparatively less about the medium of comics, so my emphases fall elsewhere. I'm offering a very selective view of Mignola's work, one that speaks to my own interests as much as Mignola's creation, but which is everywhere indebted to *Hellboy* for inspiration.

Enworlding *Hellboy*

Cosmology and Franchise

Mike Mignola has succeeded in building a world (or cosmos) for Hellboy and his associates and nemeses, and at the same time he has succeeded in building *Hellboy* into a successful franchise. The first is an aesthetic and structural accomplishment, the second a commercial one, but these successes are interrelated; the strategies of one also proved useful for the other. In both, stylistic consistency and a combination of authorial and editorial control provide a coherence that feels unique in the history of American comics.[1]

Perhaps because of the rise of game and comics studies, world-building has become a central concern of scholars. The first part of Eric Hayot's *On Literary Worlds* provides a nuanced model for thinking about world-building in literary texts, much of which is easily extrapolated to other media. What is the relation between *work* and *world*? Citing Heidegger and Jean-Luc Nancy, Hayot points out that there is "mutual connection to totality governing both objects. The work and the world name a self-enclosing, self-organizing, self-grounding process. This process is neither act

nor event, subject nor object; it is the ground of activity, eventful-
ness, subject- and object-hood, and of procession." Further, there
is "no common word for what the work and the world share,
unless it is 'world' itself."[2]

Works first constitute worlds through their diegetic totality,
the system of relations within the work that constitutes the whole.
But aesthetic worlds are never entirely whole and sufficient unto
themselves; readers and viewers bring their normative sense of
experience to bear upon the world of the work. "Aesthetic world-
edness is the form of the relation a work establishes between the
world inside and the world outside the work." The work consti-
tutes a world, then, but it's a world that shows us worlds; the work
"worlds" us both through the world in the text and in the ways
those worlds intersect one's own lived-world experience.

Hayot proposes the category of "pure romance" to describe
works that, at their extremes, define their worlds as either
"microcosm—a ship, a city, an apartment building—or … a
completely formed alternative to the lived world in which it is
produced. So with fantasy, utopia, science fiction. Such created
worlds often leave open an aperture to a realistic version of their
contemporary world."[3] Actually, some fully extrapolated alter-
native worlds present themselves to readers either *through* or *as*
microcosms: the generation ships that travel interstellar space in
Brian Aldiss's *Non-Stop* (1958); the compacted and unbounded
urbanism of J.G. Ballard's "Concentration City" (1957); the
buildings that structure Thomas Disch's *334* (1972) or Robert Sil-
verberg's *The World Inside* (1971). Indeed, the concept of world-
building is most frequently used with regard to such "com-
pletely formed alternatives" of imaginary realms, worlds,
universes, or even multiverses. Tolkien's richly peopled Middle
Earth, to take one of the best-known examples (although "peo-

pled" is surely the wrong word here), contains hobbits, orcs, Elv-
ish cities, a rich linguistic tradition, and a long, imagined his-
tory, all of which inform the shape of a narrative traced across
four volumes. *Hellboy* and its spin-off series now consist of
twenty-plus years of stories set across a seventy-year span, all
undergirded by a rich cosmology and intertextually connected
to folkloric traditions as well as to the work of other writers and
artists. And as Hayot points out, even in these worlds that are
presented as worlds apart, there remain, implicitly or explicitly,
relations to the lived world.

A surfeit of SF and fantasy novels become part of a series.
Having expended so much energy in the creation of geogra-
phies, politics, technospheres, biologies, physics, characters, and
societies, authors—and readers—are understandably loath to
leave it all behind. While many of these series use their abun-
dant length to convey narratives of Byzantine complexity, it can
also be said that many of these series exist primarily to present
their worlds, complex but increasingly familiar spaces in which
readers can dwell (much fan activity is organized around such
works, demonstrating, or in many ways performing, the possi-
bilities of increased audience investment).

But world-building is not only a function of rich narratives or
detailed backstories; it also derives from aesthetics and style.
The length and rhythm of sentences, the selective use of detail,
and the tone of the language together generate an experience
for the reader of a novel that is also constitutive of the "world"
that the work creates. Leonard Bernstein has said that "Any
great art work ... revives and readapts time and space, and the
measure of its success is the extent to which it makes you an
inhabitant of that world—the extent to which it invites you in
and lets you breathe its strange, special air." (In "The Third

Wish" [2002], a shaman tells Hellboy that "all your roads lead to strange places.")

Book designer and reading theorist Peter Mendelsund has argued that reading is an act of completion; the indeterminacy of language (he asks: What *exactly* does Anna Karenina look like? Do we know? Do we *need* to know?) solicits an engagement by a reader who necessarily fills in visual or contextual detail according to her own experience: "Words are effective not because of what they carry in them, but for their latent potential to unlock the accumulated experience of the reader."[4] Mendelsund finds something almost mystical in the combination of author and reader: "We take in as much of the author's world as we can, and mix this material with our own in the alembic of our reading minds, combining them to alchemize something unique." He further proposes that "this is why reading 'works.'" Phenomenologically, "reading mirrors the procedure by which we acquaint ourselves with the world.... [T]he practice of reading feels like, and is like, consciousness itself: imperfect, partial; hazy, co-creative."[5] Wolfgang Iser, another phenomenologist of reading, has written that "The convergence of text and reader brings the literary work into existence [but] this convergence can never be precisely pinpointed"—a point to which I'll return in a later chapter.[6]

The main thrust of Mendelsund's book is to demonstrate that we often *don't* see (or need to see) when we read. Rare is the writer who provides thorough descriptions of characters, and even then, as with someone like Alain Robbe-Grillet, it can be argued that the reader's encounter is more with the language on the page than with the object so exhaustively described. Citing a scene in Twain's *Huckleberry Finn* in which a dawning on the river is presented as the gradual accrual of newly visible detail, Mendelsund muses that "description is not additive. Twain's mist does not

carry over while I am seeing the log cabin. By the time I reach the words *log cabin,* I have forgotten about the mist entirely."[7]

"Vision, however, is additive," Mendelsund continues, "and simultaneous." Prose, then, is fundamentally different from cinema or comics. In the camera shot or the comics panel we see character, setting, and action at once, with a taken-for-granted clarity. Comics readers and film viewers need not bring the same knowledges to the acts of reading or viewing, since the artist or director will visualize on their behalf.

It's obvious, then, that images contribute mightily to the act of world-building—N.C. Wyeth's painted plates for Robert Louis Stevenson's *Kidnapped* are fundamental to the experience of the reader of that volume, not only as a result of the subjects depicted, but also through the richness of the palette, the material opulence of oil paint, and the Romanticism of Wyeth's forms. John Tenniel's illustrations for Lewis Carroll's *Alice* books create a world less immutable than the one given us by Wyeth and Stevenson. Lines and hatching present a world solid enough to inhabit, but not so fully rendered as to preclude the ensuing metamorphoses. Tenniel's mastery of scale helps the reader feel the corporeal shifts that Alice undergoes, even as his deadpan style permits the absurdity of everything to make itself known. (Mendelsund correctly points out that illustration partly—but only partly—obviates the imaginative work that a reader brings to bear upon a book.)[9]

Comics are an exemplary world-building medium: the interplay of word and image is fundamental to the form, and the comparative immediacy of our engagement with images transports a reader more quickly to the world of the fiction. As with diverse styles of writing, different visual styles create different aesthetic experiences and different worlds, often more rapidly

than prose. Some of the formal elements that define and structure worlds in comics include the quality of line, the use (or nonuse) of color, the slickness of the production, the number and regularity of panels on the page, the acceptance or rejection of the grid, the size of the page, the legibility of panel transitions, the presence or absence of text, the placement and style of text, and the overall sense of unity or disjunction that the comic imparts.[10] The medium unavoidably undercuts any pretense of objectivity, as every line reveals the literal hand of the author.[11]

Every comics creator deploys these elements. A prose novel, by contrast, depends almost exclusively on the use of language, with some—but far less—attention to the design of the book: the font choice, the amount of white space on the page, the thickness of the paper. Without taking anything away from book design, it's inarguable that the aesthetics of most books are incidental to the meanings produced (or at least to the meanings intended by the author). Books are reprinted with different designs; e-readers allow readers to choose fonts, font sizes, and the spacing of words on the "page."[12]

Comics, on the other hand, are tied to their aesthetics, and while there may be reformatting from one version to another (recoloring, for example), this tends to be more the exception than the rule. The design of the comic is fundamental to what it is, to the effects it produces, and to the world it builds. Comics critic R. Fiore has written on the pleasurable experience of reading comics, asking how it is that compelling comics can be created around the least promising narrative materials.

> What sustains this substance is the experience of inhabiting the subjective world the cartoonist creates. The writer of poetry or prose however vivid his imagery must depend on the reader's internal image of the things he describes. The cartoonist doesn't merely

describe a tree, he determines what trees look like. And so with every person and object in the cartoonist's world. While a painter also creates a subjective world, a painting or drawing is not a narrative.... If the cartoonist's subjective world is vivid enough all the narrative really has to do is be engaging enough to draw the reader into it.[13]

Questions are posed and answered at once: what is the place of the body in this world? Are these bodies like mine? Can they feel pain? Is death a part of this world? Will actions have consequences? Should this be regarded as humorous, satirical, allegorical, or realistic? Before processing a single sentence, or even a single word, the comics reader confronts the ontological gulf that exists between, let's say, the sun-lit, clean-lined, squashy-stretchy world encountered in Carl Barks's *Donald Duck* comics and the fragmented, chiaroscuroed, and negative-spaced reality depicted in Frank Miller's *Sin City*, and neither of these would be mistaken for the more realistic, classically cinematic approach taken by Ed Brubaker and Steve Epting in their take on *Captain America* (figures 7–9). The parameters of the universe begin to be established; reading protocols and horizons of expectation begin to emerge.

The world of *Sin City* is literally darker than Duckville, and the bodies that inhabit it are both more solid and, we quickly learn, more susceptible to pain. Donald's squashed body, true to his plasmatic animated origins, snaps back to normal in the next panel, whereas Marv just accumulates wounds and bandages as his story progresses. Yet both Barks and Miller share a taste for hyperbolic imagery that exceeds the strictures of strict realism: in *Sin City* and *Donald Duck*, cars happily or grimly bounce above the road bed, while in *Captain America* (which strove for a more plausible physicality, especially for superhero comics) the laws of gravity seem to be more consistently applied.

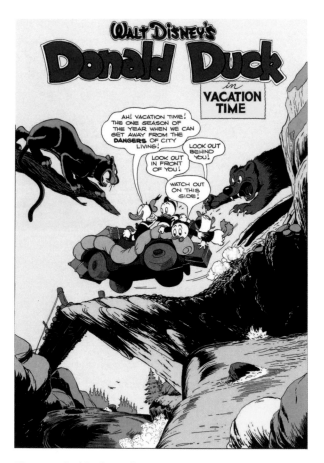

Figure 7. Carl Barks, *Walt Disney's Vacation Parade*, no. 1, "Vacation Time," p. 1. Dell Comics, 1950.

While Mignola has worked in film, animation, and prose, his preference for comics is rooted precisely in its world-building power and authorial control: "Comics is the place where you can create a world and not have somebody say, 'we can't afford to film that.' There's never been a close second." He acknowledges the undeniable world-building power of the cinema, but identi-

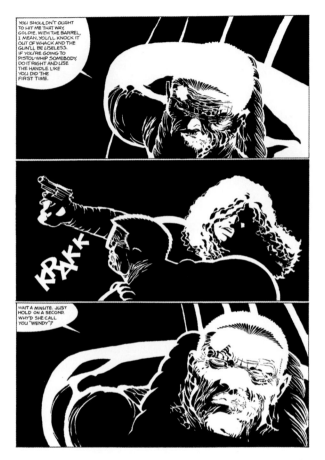

Figure 8. Frank Miller, *Sin City: The Hard Goodbye,* p. 145. Dark Horse Comics, 1992.

fies two problems stemming from his own involvement with the two *Hellboy* films: first, the temporal gap between conception and realization can be maddening; while Mignola admits that it would be "fun" to visualize various worlds, "within a few minutes in the world [of filmmaking] or in some cases a couple of weeks, all you can think of is, I should've stayed at home." A

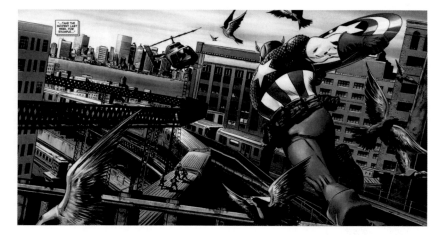

Figure 9. Steve Epting, *Captain America,* vol. 5, no. 1. Frank D'Armata, color. Marvel Comics, 2005.

second frustration for him is that "Most of the [art]work you do on a film is invisible, most people will never see it, a lot of it's just destroyed. But also so much of it makes no impact on the film at all. And the idea of doing work that nobody sees, that serves no purpose...." And there are so many intervening hands. By contrast, I have before me a page of original art for the second issue of *Hellboy in Hell* (2013) and it's evident that no hands other than Mignola's have touched this—word balloons, letters, and color were later added to high-resolution scans of the original art. Mignola employs no assistants, not even to fill in the swathes of blackness that dominate his pages, believing that his involvement gives "a bit of life to it, even if nobody sees it" (figure 10).[14]

A look at the prologue sequence that begins *Conqueror Worm* will help demonstrate the world-building ability of comics while providing a glimpse of Mignola's idiosyncratic approach. The first page presents an almost unremitting field of black,

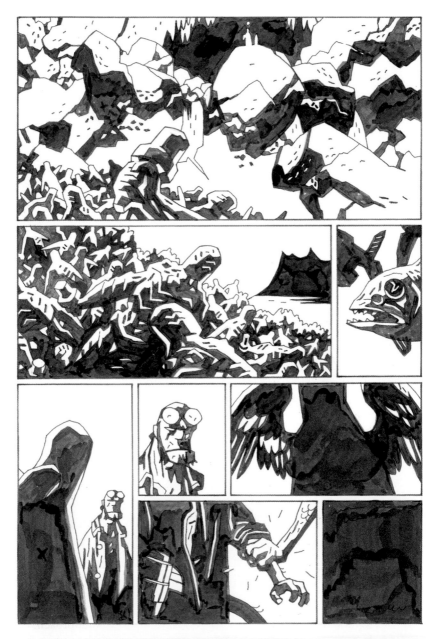

Figure 10. Mike Mignola, *Hellboy in Hell*, no. 2. Original art.

which is a particularly good place to begin a formal analysis of Mignola's work. Black is a Mignola hallmark. Where most comics artists "spot" black areas to provide visual variety and guide the eye, Mignola's pages are drenched in black, binding all together like some aesthetic aether.[15] Black gives the page a palpable thickness, and envelops the reader as it does the characters. This blackness reminds me of film noir, but not just any noirs—the ones shot by John Alton (*Raw Deal, The Big Combo*) that swim in an obsidian blackness that has little to do with diegetic shadows and everything to do with an atmosphere redolent of threat. At times, on Mignola's pages or in Alton's frames, black seems to swallow the world, or comes to constitute a world from which there seems no possibility of escape. It sometimes marks states of unconsciousness (see figure 38 [chapter 3] and figure 50 [chapter 4], among others). Black depicts and delimits the world, but at the same time it flattens and abstracts the graphic space of the page. Black does a lot of work, it *matters* to Mignola, so it should come as no surprise, then, that his are the hands that lay it down on the page.

So, an unremitting field of black. A sky punctuated by violet stars, the introduction of some mountains with that same light reflected in the snow, and narration boxes of pale blue (with a text taken from Poe) are all we see. The following page brings us to a castle, and a Nazi guard. All is shades of bluish-gray, broken only by the pale orange of pulp hero Lobster Johnson's goggles and a brownish splash of blood. Black, blue-gray, and those goggles define the palette of the next page as well. The next pages bring us into that mountain aerie as some Nazis prepare to launch a manned rocket, its mission and destination unknown. The panels on these pages are large, for the most part: three on the first page, followed by a rhythmically even run of pages: six panels, five panels, five again, six.

A flash of yellow illuminates a banner on one page, and that same yellow marks out the rocket on the next; otherwise, black and shades of bluish-gray. Oh, and the orange goggles make an appearance in the last panel of these two pages. *"Here is The Claw!"* the "Lobster" yells at the top of the next page (it's his signature cry). Guns fire, the palette shifts from murky blue-gray to the yellow of muzzle-flashes (or is it the light from the rocket launch, or is something else responsible for this yellow that washes out all visible detail?). The castle is seen again from without, yellow light now spilling from its apertures. On this climactic page, nine unevenly sized panels convey the chaos. In the final panel, the tower seems to dissolve or erupt into yellow (figure 11). This is how the prologue ends. The action shifts to a slightly more naturalistic palette as, forty-one years later, Hellboy and Kate Corrigan are briefed about the Nazi space capsule that seems to be heading back, not just to Earth, but to the site of that very same tower.

Much of this is typical of Mignola's art: the enveloping blackness, the reduction of visual detail, the emphasis on mass, the flatness of the color, the surprising quietude. So what world does it create for the reader? The first page is undeniably arty, highlighting the text of Poe's *Ligeia* more than any other element. The blackness, as something of a Mignola hallmark, establishes generic expectations for the knowing reader. The star field in the first panel serves as literal background to the centrally placed text—it's not clear whether this is a represented space or a nondiegetic design flourish. The second panel introduces more representational elements, and the final view of the mountains is the most naturalistic image on the page. The castle viewed at the top of the following page is surrounded by shapes that suggest clouds more than realistically depict them. Faces

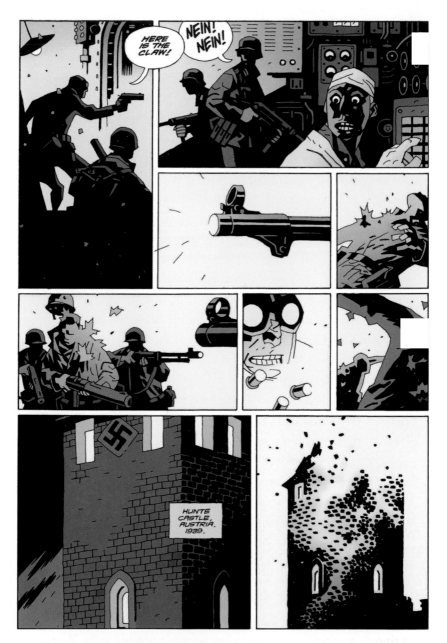

Figure 11. Mike Mignola, *Hellboy: Conqueror Worm*, no. 1, p. 6. Dave Stewart, color; Pat Brosseau, letters. Dark Horse Comics, 2001.

are defined by heavy black, blocky shadows and barely limned features (Mignola often leaves out all facial detail in long shots). Realism is not the aesthetic mode at work here—not even the selective realism of most superhero comics. The action scene, Lobster taking out a guard, is presented noiselessly—no sound effects or motion lines disturb it—and the narration continues in some sort of counterpoint to the sequence of images. The pace is even, stately; the large panels convey a sense of grandeur (of both setting and style). Word balloons are minimal and contain minimal text—the images command attention.

All is subdued, until all erupts. Even then, the action is stylized: panels lose their background detail, bullet impacts are rendered as two-dimensional jagged shapes, and images stay within the boundaries of the panels (nothing bleeds off the sides of the page). While depicting a terrific pulp action sequence replete with a costumed hero, Nazis, rockets, and exploding castles, there is a formal restraint and control; the effects are measured, but nevertheless present. The reader is watching more than participating; it all remains somewhat elliptical and mildly opaque. The narration (to use Tom Gunning's term for the organization of storytelling elements in cinema)[16] is more complicated than the action would suggest; it is no less involving, but it is perhaps involving in a different way, one which, as I'll demonstrate, connects the reader to the very involving act of reading.

There are things to say about the way the style connects to the larger narrative of *Conqueror Worm,* but my goal here is simply to illustrate how the first pages of a comic address the reader and create a world almost through aesthetic choices alone.

World-building also emerges across comics, not simply within a single story. So, to the world extrapolated on the narrative level and the world presented through its aesthetics, there is also the

world constituted across an author's or artist's *oeuvre,* whether the individual works are explicitly interconnected (Balzac) or not (Hitchcock). Mignola falls into the former category, with his world of intertwined stories. Mignola's narrative and the world it builds encompasses the twenty-plus-year history of *Hellboy* comics, along with *B.P.R.D.* and its numerous offshoots, including *Lobster Johnson, Sir Edward Grey: Witchfinder,* and even *Frankenstein Underground.* Hayot notes that Raymond Chandler's Philip Marlowe novels are entirely independent of one another, and what Marlowe does "between" books is not a question to ask or answer.[17] Mignola, though, while presenting individual adventures, seems to have a pretty good idea of what Hellboy is up to between books, and his willingness to present stories nonchronologically affords him plenty of opportunities to selectively fill in the gaps in our knowledge of Hellboy's history.

For that to happen successfully, rules about the world are put in place, explicitly or not. Hayot writes, "These rules collectively amount to the physics governing the most basic properties of the diegesis.... From this perspective any aesthetic world is also an epistemological engine: a mechanism for the generation and exhibition of knowledge about itself as a totality."[18] The world–universe–multiverse is defined as much by what it includes as by what it doesn't, and Mignola's work, which has held its secrets for over two decades, exemplifies a structure in which "knowledge will be full of gaps and silences, will include blanks and refusals." Mignola fills in the gaps, but not all of them. Rules governing inclusion and exclusion together "constitute the conversance of a world, its knowing relation to its own world-structure."[19]

Hellboy's world, then, is built on narratives structured by exclusions, elisions, and enigmas, and on an aesthetic that eschews naturalism and transparency in favor of something

more stylized and foregrounded. In this interplay of the aesthetic and the enigmatic, the reader is continually brought back to the act of reading, to the world of reading itself.

But Mignola has done more than single-handedly author a world. His collaborations with writers, artists, and filmmakers (not to mention the fan fictions and artworks visible online or in 'zines) constitute a world in yet another sense: *Hellboy* and its offshoots become, as Hayot puts it, "sites for the production of a wide variety of works, authorized and unauthorized, by any number of authors (including fans) drawn to the representational and narrative possibilities they hold in store."[20] Through this expanded field of textual production—at least the authorized works that obey the rules governing diegesis, aesthetics, and strategic exclusions (that are, in other words, powered by the same "epistemological engine" that drives *Hellboy*)—Mignola's world becomes the Mignola-verse.

The "worlds" produced by the genre of superhero comics, especially those in the DC and Marvel "universes," are of greater scope and have evolved, over their seventy-five-year history, into a set of Byzantine multiverses of extended continuities in which the events of one story influence the next, in which characters cross over into one another's stories to team up or do battle. Kate Fitzsimons has written that "the DC and Marvel Universes are one of the most fascinating and multi-faceted experiments in collaborative storytelling ever to see print, and that's nothing to sneeze at."[21] The movement of television drama (and even comedy), beginning in the 1990s, toward a more authored, long-form narrative model has spawned much scholarship, yet comics arguably got there first (although it's undeniable that they have been, in turn, influenced by the new structures of episodic television).

But superhero comics did not begin as a coherently conceived "universe"; there were no mechanisms "for the generation and exhibition of knowledge about itself as a totality." For the first half of their history, events of one comic had no bearing whatsoever upon the events of another, whether within single titles or across them. Each existed in its own space and time—an eternal present.[22] *Batman* was a far more kid-friendly comic from the 1940s through the '60s than it became in the '70s and '80s, and the very different styles of illustration and types of stories (the impish Bat-Mite made relatively few appearances later on) somewhat precluded the establishment of a fully consistent universe.

From its insurgence into the world of superhero comics in the early '60s, Marvel strove for greater coherence, permitting its characters to team up and appear in (and help sell) each other's books; stories had implications that carried over to the following issues. (It's difficult for my aging self to believe that the comparatively new "Silver Age" Marvel Comics universe is over half a century old.) But a near mania to produce consistent, coherent universes with "official" histories began to take hold in the 1970s at both Marvel and DC. Fans-turned-writers such as Roy Thomas and Steve Englehart had much to do with imposing these new logics and reconciling accidental paradoxes, often with great inventiveness.[23] Did Clark Kent first take up the identity of Superman as an adult in Metropolis, as in the first comics from the 1930s, or was he a fully fledged Superboy back in his Smallville days, as a later series from the '40s proposed? A solution: Super*boy* existed on a parallel Earth (call it "Earth 2"), but not on ours. *O-kaay.*

The floodgates were open. Multiple cosmologies unfolded, and every effort to decimate the hordes of character variations and universes (e.g., *Crisis on Infinite Earths* [DC, 1985]) worked only temporarily. The weeds may have been pruned back, but lo and

behold (and for once that cliché seems appropriate), universes would reappear, which meant that the new Sisyphean mandate for writers was now to account for both the obliteration and regeneration of multiverses. "Fan-favorite" writers were the ones who could retroactively shape the most amorphous events into a coherent history (such stories have come to be called "continuity porn"), but other writers began to have a bit of fun with it all, reinstating the absurdity that others labored to paper over: in Alan Moore's Pirandellian *Supreme* (Image Comics, 1996), each revision of a superhero's universe was actually experienced by the occupants of that universe as a massive reality-morph. The latest iteration of Supreme visits his "hometown" to experience his newly revised existence: "I felt a long, peculiar life well up around me." In *Animal Man* (DC–Vertigo, 1988–90), Grant Morrison showed us the limbo where forgotten characters awaited their inevitable reboot, and later took it upon himself to write *Batman* as though every earlier adventure was canonical, including the stories featuring ghosts, magic, and that spritely Bat-Mite.[24]

All of this is interesting in the terms that Hayot set out: superhero universes began with few diegetic and no extradiegetic rules (other than that there should be no connection among stories), then evolved something of a willfully coherent set of rules before essentially drowning in the maelstrom of unassimilated events and archaic rule-structures from the past and present. Meanwhile, such figures as Moore and Morrison managed to create, within the world of superhero comics, "knowing relation(s) to its own world-structure(s)" that were necessarily brief incursions into the larger story. Shaggy things, these comic book universes.

The industry norm, as represented by the "big two" publishers, Marvel and DC, has increasingly been for the editorial staff to

dictate, from on high, the changing shape of their respective universes. Writers and artists are teamed by editors and often never meet in the course of their collaborations. Ever since the days of *Marvel Super Heroes Secret Wars* (1984) and DC's *Crisis on Infinite Earths* (1985), company-wide, editor-mandated "events" have come to dominate the schedules of both Marvel and DC, connecting the major and minor titles (and often introducing special miniseries at the core of the event and/or on its peripheries), further reducing the specific contribution of individual writers and artists. Production schedules have been accelerated: where once the most frequent schedule was monthly, twenty issues of something like *The Superior Spider-Man* (Marvel) appeared in only eleven months in 2013. This has led to a new reliance on fill-in artists and even multiple artists working on a single issue, which has often resulted in visually jarring transitions and inconsistencies.

As an example, *Uncanny X-Force* (Marvel, 2010–2012), one among a plethora of *X-Men* spin-off titles, was marked at first not only by Rick Remender's effective scripts, but by the striking art of Joseph Opeña. Yet the final six-issue arc of the series, "Final Execution," featured no fewer than four different pencilers.[25] Some consistency was provided by keeping the same cover artist (Opeña) and colorist (Dean White). But at least each issue was handled by a single penciler, something that Marvel seemed to strive toward; over at DC it required two pencilers, three inkers, and two colorists to produce a single twenty-page story in *Action Comics* in 2012.[26] It's unsurprising that where once comics artists were the favorite figures of fandom, writers have risen in star-status. Words dominate image in today's superhero comics, apart from some obligatory full-page heroic poses or battle scenes (which happen to command higher prices on the original art market).[27]

Editors and writers became, along with a fervent fan base, the keepers of continuity and character. As these histories grew—across years and then decades, first in a handful of titles and then in all (or more than) the market could bear, across the occasional reboot and then to the painful predictability of deaths and returns from the dead—continuity became an end in itself (that dead superheroes never stay dead for long has actually become a jokey trope within the comics themselves). Artists came to be viewed, improperly, as marginal to these character and universe histories, and the writers who played most effectively with these histories garnered the most attention.[28]

Meanwhile, the legacy characters (Superman, Wonder Woman, Spider-Man) had to be protected from overly radical change, given the importance of both product licensing and movie adaptations; reboots offer what are often temporary changes to the status quo, and often lead to multiple versions of the same characters being published simultaneously. Brian Azzarello's 2011 *Wonder Woman* seemed to have no connection to the more familiar Wonder Woman concurrently appearing in DC's *Justice League* comic book, although both were part of DC's "New 52" revamping, which was supposed to produce greater consistency along with more updated approaches. And despite a number of legal confrontations, these characters are controlled by the owning corporations, rather than their original writer/artist creators.

What is different about the *Hellboy* universe is that it has been continuously helmed by Mike Mignola for over two decades and remains anchored to his creative vision, not to mention the rules he has put in place. If the initial *Hellboy* stories give little sense of the vast cosmology that would soon come into play, neither did they present impossible challenges when they were placed in

this larger context. There are noncanonical *Hellboy* stories, but these were almost always by other writers—the character loaned out, as it were, but only temporarily.

In the decade preceding *Hellboy*'s 1993 debut, the comics industry had shifted significantly. The model of newsstand distribution had been faltering, and comics sales were dropping. Under that system, a newsdealer received comics from a distributor and could return any unsold copies. Magazines and comics competed for scarce rack space, and bundles of books were often returned with their original wrapping unbroken, never having been racked. Given this, publishers had to print vast numbers of comics to produce significant sales, while an overall decline in small retailers made it ever more difficult to place (and find) comics. In 1972, Phil Seuling, a Brooklyn high school teacher and comics convention organizer, had another idea: a distributor that would buy comics from the publisher on a discounted no-return basis and ship them to dedicated comics retail outlets. With this new "direct market," publishers would know the number of orders they had for a particular title and could print just that number. Production could be rationalized, smaller print runs could be supported, and the onerous strictures of the Comics Code (directed at newsstand distribution to, presumably, children) would no longer apply.[29] Comics shops catered to older readers and collectors, and this more knowledgeable audience was as, or even more, committed to favorite artists and writers as it was to characters.

All of this had some very positive effects on the comics themselves. New comics companies sprang up, giving creators full ownership of their characters and worlds; even Marvel and DC instituted profit-sharing agreements. Superhero comics lost some of their hold over the marketplace as other genres came

into being: crime and horror comics, banned since the comics-censorship hysteria of the 50s, returned, and books by such non-genre creators as the Hernandez Brothers (*Love and Rockets,* published by Fantagraphics books beginning in 1982) and Harvey Pekar (*American Splendor,* self-published beginning in 1976) found both rack space and buyers. More discriminating readers led to the adoption of higher production standards: heavier paper, more vibrant color printing, and better reproduction became the norm. These less ephemeral products were also collected into paperback reprint volumes; both Frank Miller's *The Dark Knight Returns* (1986) and the *Watchmen* series by Alan Moore and Dave Gibbons (1987) were immediately strong sellers and have not been out of print since. This helped pave the way for the "graphic novel" boom and bookstore distribution.[30]

Hellboy is somewhat typical of this shift in the production, distribution, and reception of comics. Mignola, a graduate of the California College of Arts and Crafts, had spent over a decade "honing his craft" as a work-for-hire artist at both Marvel and DC before creating Hellboy.[31] Dark Horse was the publisher, but Mignola held the trademarks and copyrights. While sharing some characteristics with superhero comics (an extraordinarily powerful continuing character was at its center, fighting on the side of the good), *Hellboy* was a comic steeped in the heretofore taboo genre of supernatural horror. The richness of color and improved reproduction suited Mignola's emerging aesthetic, while the increasingly complex cosmology was well served by collected editions and the availability of back issues at those same comics shops. Even the formerly disallowed word "Hell" in the title represented a push beyond the prissy restrictions of the Comics Code.

Hellboy first took form in a 1991 convention sketch that shares little with the more familiar incarnation of the character—

there's a familiar bulk and some devilish features. But the name stuck, and his first comics appearance was in a four-page story in a Dark Horse sampler—*San Diego ComicCon Comics*—in 1993. Hellboy fought a giant dog who turned out to be Anubis, the Egyptian god of mummification. John Byrne provided the script, Mignola the plot and art. Byrne also scripted the first extended story arc, *Seed of Destruction,* which appeared across four issues in 1994. Short stories followed, some in the anthology title *Dark Horse Presents,* others in dedicated *Hellboy* books. The next extended story was *Wake the Devil* in 1996, followed by shorter works and *Conqueror Worm* in 2001. This combination of shorter and longer works became a hallmark of the series: the longer story arcs tended to move the mythology forward by introducing major characters, revealing important bits of Hellboy's backstory, and emphasizing the apocalyptic stakes of it all. The short stories tended to be lighter in tone, the scale smaller. While other companies gear their production solely toward the five- or six-issue, trade-paperback-sized arc, *Hellboy* stories are as long as they need to be.

As *Conqueror Worm* concludes, Hellboy quits the B.P.R.D.—it's not clear whether he wants to confront his destiny or avoid it. As editor Scott Allie wrote, Hellboy was "sprawling out alone into the world, sinking deeper in the world of myth.... Without the framework of the Bureau, Hellboy's life was about to go crazy."[32] Hellboy's adventures would move farther from reality, a tendency that reached its fruition with the completely fantastic setting for the ongoing *Hellboy in Hell* series. Hellboy's departure also created the conditions for the creation of the spin-off series *B.P.R.D.* Mignola had originally conceived *Hellboy* as something of a paranormal superhero team book, but for various reasons he didn't move the material in that direction. With

B.P.R.D. in its own book and other creators in the mix, the team concept was reestablished (though without the superheroes) and *Hellboy* became a franchise.[33]

The *B.P.R.D.* spin-off series got going in early 2002, and many more titles followed. At first, others scripted *B.P.R.D.* adventures, but Mignola quickly established a system in which he served as cowriter with a more limited set of collaborators—John Arcudi, Christopher Golden, and Scott Allie most frequently. In 2006, Richard Corben became the first artist other than Mignola to illustrate a *Hellboy* story (not counting the character's guest appearances in other comics), and Duncan Fegredo became a strong collaborator in 2007, handling the art chores in the extended story that comprised *Darkness Calls, The Wild Hunt,* and *The Storm and the Fury.* Mignola reassumed the artist's role for the tonally different *Hellboy in Hell* series, which began in 2012. Relatively few artists have drawn Hellboy over the years, most for only a story or two: P. Craig Russell, Corben, Fegredo, Scott Hampton, Kevin Nowlan, Mick McMahon, Gabriel Bá, Alex Maleev. Guy Davis was the primary artist on *B.P.R.D.* from 2004 to 2011, but since his departure, numerous artists have contributed to the various *B.P.R.D.* titles as well as the *Edward Grey: Witchfinder, Baltimore, Lobster Johnson,* and *Sledgehammer 44* titles. After twenty years, the Hellboy franchise is going strong.

With some rare exceptions early in the character's history,[34] Mignola has served as either author or coauthor on all of Hellboy's adventures. He has even gone so far as to write or rewrite Hellboy's dialogue in crossover adventures with such characters as The Goon or the canine paranormal investigators of *Beasts of Burden.* He has elaborate coplotting sessions with John Arcudi (*B.P.R.D.*) and Scott Allie (*Abe Sapien*) in which he maps out where the characters and story need to go over the next few

narrative arcs, even as he gives these writers latitude as to how to get there. There is thus a consistency of voice across this universe. There are other writerly consistencies as well: Mignola's books use dialogue more economically than the superhero comics racked alongside them. A *Hellboy* or *B.P.R.D.* story may begin with lengthy exposition, but it soon settles into something more minimal. Clem Robins's word balloons allow significant white space around the text, emphasizing their spareness while contributing to the aesthetic of the page. The entire treatment of the word, in fact, directs attention to the art even as it structures the pace of reading.

Although Mignola has drawn fewer comics in recent years, what has inevitably come to be called the "Mignola-verse" has something of a house style, even as practiced by artists as different as Richard Corben, Duncan Fegredo, Guy Davis, and Tyler Crook (figure 12). Mignola's stable of artists tend toward less realistic, more "cartoony" styles—characterized by relatively minimal visual detail, clear lines, physical exaggeration, and flat color. Creature designs by James Harren or Guy Davis are used by other artists (who make contributions of their own). From quite early on, Mignola has used the same colorist, Dave Stewart, and letterer, Clem Robins, giving the books visual consistency (Stewart even refers to a "Hellboy-world" palette). Most of his artists hew to some variation of a grid formation—bleeds off the page are relatively rare, as are oddly shaped panels. There is, overall, a sense of formal restraint that not only provides a franchise-wide continuity, but also acts as an effective counterpoint to the chaotic and eldritch horrors around which the stories turn.

There are exceptions to everything I've just listed: Mignola solicits work from stylistically diverse artists, and his stories are

Figure 12. Guy Davis, *B.P.R.D.: Hell on Earth: New World,* "Seattle," p. 1. Dave Stewart, color; Clem Robins, letters. Dark Horse Comics, 2011.

often tailored to the specific talents of each artist. Nowlan's meticulous draftsmanship provided a deadpan realism to a wonderfully absurdist tale of extraterrestrials and a humanoid cow. Fegredo's (comparative) realism and visual depth lend gravitas to a more psychologically complex Hellboy, whose actions have a tangible effect on a larger world (figure 13). The more fantastical art of Richard Corben is given to folkloric tall tales that are often narrated—Mignola handled the art for the framing story of "Makoma" (2006), but the mummy's tale of the titular figure was illustrated by Corben. Brazilian twins Fabio Moon and Gabriel Bá have produced art of ethereal beauty, while another pair of Brazilian twins, Max and Sebastian Fiumara, combine realistic settings with figural exaggeration. Mignola himself has been experimenting with bleeds and a lessened reliance on the grid structure in his *Hellboy in Hell* title. So while the books have an overall look and feel, there is ample diversity within that unity; individual contributors are indeed collaborators, permitted—encouraged—to put their mark on Hellboy's world.[35]

To return to the distinctions I drew among the world-building aesthetics of Carl Barks, Frank Miller, and Brubaker and Epting, the Mignola-verse is defined by a range of styles that establish different horizons of expectation for readers: Mignola's work is the most overtly stylized and probably the most melancholic, as well as the most restrained. Fegredo renders three-dimensional space more realistically; this also has the effect of giving Hellboy greater interiority. Moon and Bá are oneiric; the Fiumaras, horror-film immediate. At the same time, the consistent elements of the "house style" help readers recognize that while the emphases may differ, this remains the same universe, the same Hellboy.

Figure 13. Duncan Fegredo, *Hellboy: The Storm,* no. 2, p. 18. Dave Stewart, color; Clem Robins, letters. Dark Horse Comics, 2010.

The expansion of the *Hellboy* line into *B.P.R.D.* and other series demanded that Mignola bring collaborators into his orbit, many of whom are employed on a work-for-hire basis, which was the norm in the exploitative factory system of mainstream comics production and so might seem something of a step backward. Mignola, though, aspires to work-for-hire with a human face, giving his collaborators not only a paycheck but creative latitude and—for the writers, artists, and colorist Dave Stewart—profit-sharing agreements. It's certainly no secret that Arcudi handles scripting and coplotting chores on his *B.P.R.D.* books, and Mignola's penchant for writing to the strengths of particular artists furthers the sense that these are collaborations rather than dictates from above. Asked about his level of overall control, Mignola replied, "I feel my hand … is very *gently* on the rudder."[36]

But why, beyond the potential financial reward, expand the line at all? Mignola has cited as inspiration the interconnected books that made up "The Marvel Universe" in the 1960s and '70s, which wove together characters from World War II stories (like Sgt. Fury and Captain America) and Westerns (like the Two-Gun Kid) with web-slinging and billy-club-throwing superheroes. Mignola wanted to create something with a similar sense of scale, history, and interconnectedness. Writing in the career overview *Hellboy: The First 20 Years* (2014), Mignola proposed that the concept behind the book was "to show the evolution of the whole *Hellboy* thing, from a single drawing of a big, shaggy monster to a whole bunch of different books about a whole bunch of different characters, all functioning in one world, one history, and telling (sort of) one big story."[37]

Opposite: Figure 14. Mike Mignola, *Hellboy in Hell,* no. 4. Dave Stewart, color; Clem Robins, letters. Dark Horse Comics, 2013.

Thus, the expansion of Mignola's world-building ambitions led to the expansion of his work into a franchise, involving other writers and artists who could tackle different aspects of that emerging universe. Arcudi's *B.P.R.D.* has a strongly (and increasingly) militaristic focus. Allie's writing tends more toward the psychological and the supernatural. Meanwhile, Mignola's initial creation now—and forever?—resides in Hell, in a fantasy world entirely of Mignola's own devising (figure 14).

CHAPTER TWO

Occult Detection, Sublime Horror, and Predestination

Hellboy has situated itself within two related genre traditions in the field of horror literature, both of which emphasize the act of making visible, of bringing to light. The weird fictions most associated with the work of H. P. Lovecraft frequently build to the revelation of the monstrous, described in extensive detail, while the tradition of the occult detective brings mystery fiction's emphasis on seeing-as-reading to the field of paranormal events.

The cosmology that underlies Hellboy derives from the fiction associated with the pulp magazine *Weird Tales,* specifically the writings of Lovecraft and the authors who followed him during the magazine's glory years in the 1920s and '30s (figure 15). In Lovecraft's fiction, cosmic forces (the "Great Old Ones") that once ruled the Earth now slumber, waiting to be awakened by their acolytes. The great book of forbidden knowledge, the Necronomicon, explicates the Pantheon, reveals its history, and provides incantations that we may summon its members back into our reality. Lovecraft's writing has a more sublime affect than much horror fiction. As he wrote:

A certain atmosphere of breathless and unexplainable dread of outer, unknown forces must be present; and there must be a hint, expressed with a seriousness and portentousness becoming its subject, of that most terrible conception of the human brain—a malign and particular suspension or defeat of those fixed laws of Nature which are our only safeguard against the assaults of chaos and the daemons of unplumbed space.[1]

This is a different experience of the sublime, however, than that conceptualized by Immanuel Kant or Edmund Burke: the mind is not exalted by its conceptual engagement with overwhelming powers beyond the scope of human understanding. What happens in weird fiction threatens more than the health or sanity of the tales' protagonists; it threatens all that we understand; it threatens human existence itself—hence the experience of *horror* as opposed to a more straightforward terror.

Aspects of Lovecraft's mythos were adopted and developed by such writers as Clark Ashton Smith and Robert E. Howard, creating an early example of a "shared universe." Following Lovecraft's death, the publisher and writer August Derleth not only rescued Lovecraft's work (founding the publisher Arkham House to do so) but expanded upon and, to some extent, formalized what now became known as the "Cthulhu Mythos," named for one of the malevolent ancient forces that lurk behind these stories.

The elements that link Mignola's work to the traditions of weird fiction are explicit and acknowledged. In *Hellboy*'s cosmology, the Ogdru Jahad are seven entities that once subjugated the Earth but who are now imprisoned in crystalline form in deep space, and stories frequently turn upon attempts to liberate these ancient gods (figures 16 and 17). Hellboy's mysterious "right hand of doom" seems key to these attempts, and the

Figure 15. Margaret Brundage, *Weird Tales,* November, 1935.

Overleaf: Figure 16. Mike Mignola, "The Island," no. 2, p. 10. Dave Stewart, color; Clem Robins, letters. Dark Horse Comics, 2002. Figure 17. Mike Mignola, "The Island," no. 2, p. 11. Dave Stewart, color; Clem Robins, letters. Dark Horse Comics, 2002.

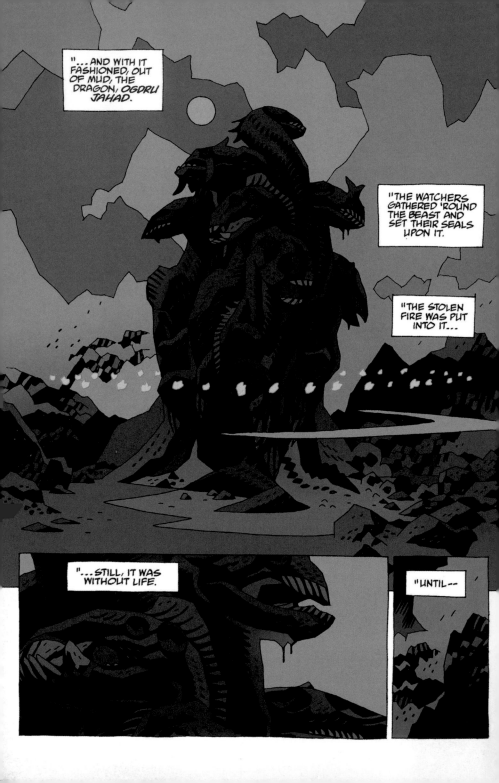

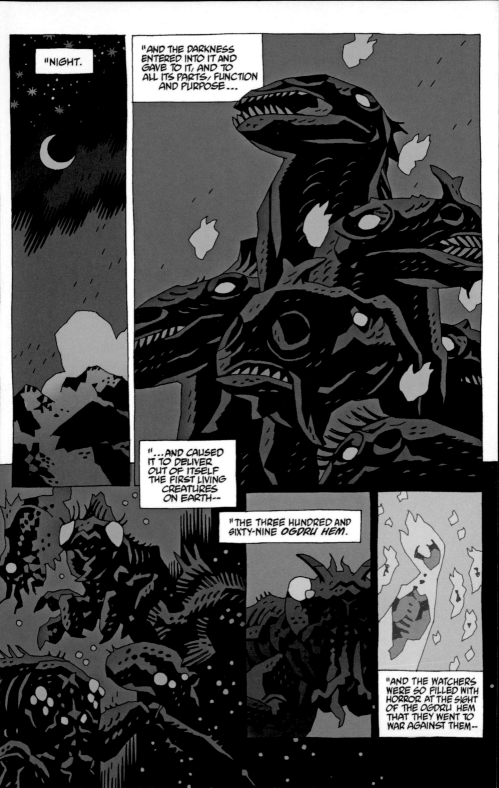

"NIGHT.

"AND THE DARKNESS ENTERED INTO IT AND GAVE TO IT, AND TO ALL ITS PARTS, FUNCTION AND PURPOSE...

"...AND CAUSED IT TO DELIVER OUT OF ITSELF THE FIRST LIVING CREATURES ON EARTH--

"THE THREE HUNDRED AND SIXTY-NINE *OGDRU HEM.*

"AND THE WATCHERS WERE SO FILLED WITH HORROR AT THE SIGHT OF THE OGDRU HEM THAT THEY WENT TO WAR AGAINST THEM--

history of that hand wends through the prehistoric land of Hyperborea—a realm introduced by Smith and taken up, in turn, by Lovecraft and Howard. A Hyperborean sword is now being wielded against the Ogrdru Hem, to devastating effect, by Agent Howard of the B.P.R.D. in the *Hell on Earth* series— the agent's name is a nod to Robert E., as is the term "right hand of doom," which was the title of an unrelated Howard story.[2]

Often, weird prose fiction will devote no little space to describing the shambling, unspeakable, and sublime horrors that appear on the scene. The narrative pauses to allow this thick description to emerge, yet what is described is frequently something unresolved, amorphous but nevertheless menacing. In the words of one Lovecraft story, "The thing itself, however, crowded out all other images at the time. It would be trite and not wholly accurate to say that no human pen could describe it, but one may properly say that it could not be vividly visualised by anyone whose ideas of aspect and contour are too closely bound up with the common life-forms of this planet and of the three known dimensions." The "thing" in question is then described at length—here, *in part*:

> Below the waist, though, it was the worst; for here all human resemblance left off and sheer phantasy began. The skin was thickly covered with coarse black fur, and from the abdomen a score of long greenish-grey tentacles with red sucking mouths protruded limply. Their arrangement was odd, and seemed to follow the symmetries of some cosmic geometry unknown to earth or the solar system. On each of the hips, deep set in a kind of pinkish, ciliated orbit, was what seemed to be a rudimentary eye; whilst in lieu of a tail there depended a kind of trunk or feeler with purple annular markings, and with many evidences of being an undeveloped mouth or throat.[3]

It's up to the reader to picture this fetid presence, but the words manage to be both precise and elusive at once—how is the reader to envision "the symmetries of some cosmic geometry unknown to earth"?[24]

Transposing a Lovecraftian sensibility to the medium of comics presents some challenges, since comics work differently than prose: language-based description is replaced by image (often literally in the production process, in the move from scripted instruction to drawn comic), and the reader is quickly brought face to face (assuming there's a face) with such eldritch horrors that would almost have to be more defined, more fixed than Lovecraft's narrators could get away with. Guy Davis's art for *B.P.R.D.*, following upon and extending Mignola's way with monsters, manages to be both concrete and vague at once; his creatures have mass and solidity, yet his loose, sketchy line makes it difficult to decide what is orifice and what is limb, and where these creatures end is frequently lost in the mist (figures 18 and 19). The image has an immediacy that the prose doesn't: the reader can take in the image at once, while the wordy descriptions accumulate detail across the time of reading. The prose creature emerges in time, the comics creature appears in space.

. . .

Do comics lend themselves to the experience of the sublime? They might be hampered in their evocation of the grandeur and terror of the sublime—they lack the ability to overload the senses as cinema or large-scale paintings (such as those by Church or Turner) can. Those Guy Davis monsters (or their spiritual brethren) made their big-screen (read: IMAX 3D) debut in Guillermo del Toro's wonderful *Pacific Rim* (2013), and the sublimity of these immense, amorphous shape-shifters is beyond

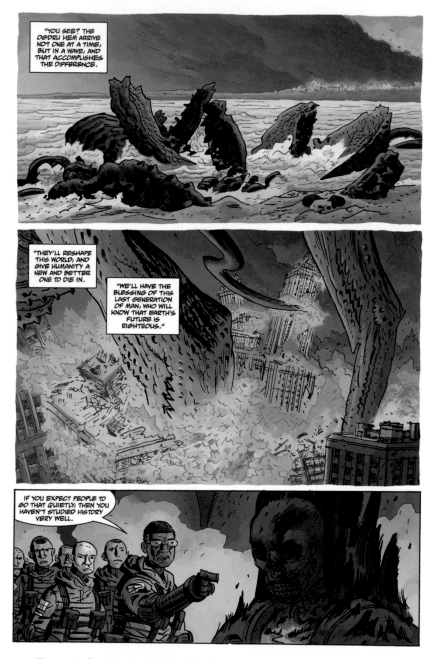

Figure 18. Guy Davis, *B.P.R.D.: King of Fear,* no. 3, p. 15. Dave Stewart, color; Clem Robins, letters. Dark Horse Comics, 2010.

question. Comics images, no matter how grandiose, are easily contained by the boundary of a page, frequently limited to a size that can be held comfortably in the hands. They *denote* more than *connote*. Works of literature and philosophy can use language to point to the limitations of language—Lovecraft's descriptions of creatures that defy description—and thus suggest worlds beyond human ken. Written language in comics generally serves to complement the accompanying image or play off it in some way—again, serving more of a denotative function. Materially, then, comics are perhaps at a disadvantage in the expression of the sublime, possessing neither the scale of other visual media nor the linguistic evocativeness of prose or poetry.

But still. My first experience of the sublime was undoubtedly the Jack Kirby–Stan Lee issues of *Fantastic Four* and *The Mighty Thor* in the 1960s. Galactus, the planet eater, was mind-blowing, as was the mere existence of Ego, the Living Planet, the other-dimensional Negative Zone, the Hidden Land of the Inhumans (not to mention the Inhumans themselves), and the list goes on (figure 20). Kirby's version of outer space was packed with exploding suns, cascading comets, crackling energies, and moons upon moons—a "cosmos between covers."[5] And Kirby's machines were riots of shiny surfaces, inelegant protrusions, jagged lines, and those same crackling energies—Charles Hatfield is entirely right to align Kirby's aesthetic with a technological sublime: "Kirby pushed his drawing to extremes, indulging an ecstatic, newly heightened graphomania and shooting for grand, cyclopean images. This was his way of not only, so to speak, pumping up the volume of comic books but also of opening them to disorienting new vistas from which everyday human perspectives might be reframed and questioned."[6] And Kirby's attention to gods, creation myths, and ragnaroks and similar apocalyptic events aligns him with the

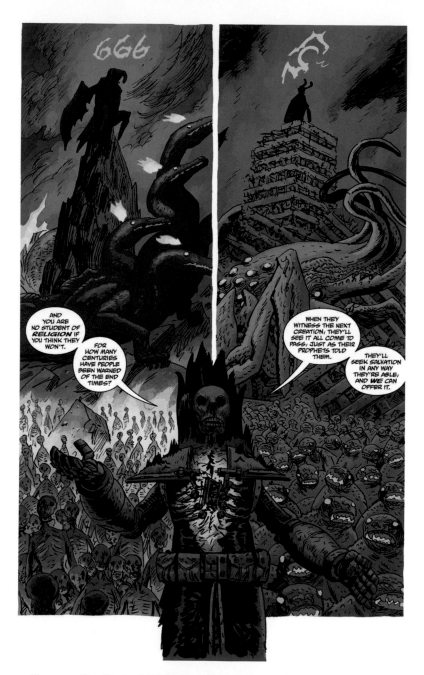

Figure 19. Guy Davis, *B.P.R.D.: King of Fear,* no. 3, p. 16. Dave Stewart, color; Clem Robins, letters. Dark Horse Comics, 2010.

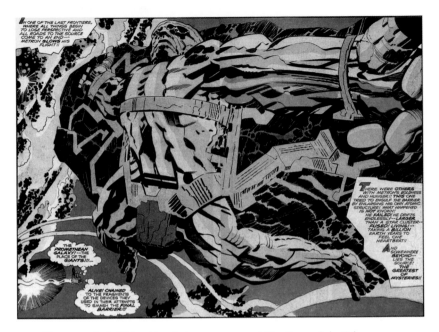

Figure 20. Jack Kirby, *New Gods*, no. 5, pp. 2–3. Mike Royer, inks; John Costanza, letters. DC Comics, 1971.

sublime in its most profound forms: "What attracted Kirby was the chance to depict the godlike, the superlative, and the cyclopean: in a word, the sublime. He was fascinated by the question of how encountering the Absolute, in the sense of the infinite or cosmic unknowable—what he sometimes called the ultimate knowledge— might shake the human mind to its foundations."[7]

Kirby evoked the sublime through more than the content and energy of the imagery; he exploited the fundamental tension between the panel and the page to evoke awe or transcendence. Panels would enlarge, opening onto full-page panoramas that the eye would linger over or (even better) onto double-page spreads in which spectacle entirely overwhelmed narrative progress. Kirby even varied his style, using paste-up collages

Great Western Sky

Figure 21. John Porcellino, *King-Cat Comics and Stories,* no. 69, 2008. © John Porcellino. Used with permission.

rather than straight-up illustration to evoke the worlds beyond those our senses can know. Out beyond the world of superheroic fantasy, other comics artists have used similar devices. John Porcellino's minimalist art in *King-Cat Comics and Stories* would seem to be as far from Kirby's cacophonies as possible: simple outlines, sparse backgrounds, lines of unvarying weight. But Porcellino, too, evokes transcendence by enlarging his panels and reducing narrative information, giving each image greater weight on the page and encouraging acts of quiet contemplation (figure 21). A story in Kevin Huizenga's *Gloriana* (2001) presented a moment of transcendence experienced in a library that culmi-

nated in a fold-out section that literally moved beyond the dimensions of the book to evoke the euphoric.

. . .

So, yeah, comics can convey sublimity. Mignola's, however, do so relatively rarely given their Lovecraftian bent (although some stories, including *B.P.R.D.: King of Fear* (2010) and *Hellboy: The Storm and the Fury* (2010–11), are hardly lacking in sublime affect). To understand why, we need to turn to the other subgenre that strongly informs Hellboy—the tradition of the occult detective.

The occult detective has its roots in Sheridan Le Fanu's tales of Dr. Martin Hesselius, published in 1872, and it's a fictional tradition that extends to the present, crossing over into such media as television (*The X-Files*, 1993–2002) and comics (Drs. Fate and Strange). Many occult detectives have occult powers of their own, whether the "interior vision" of Hessilius, John Thunstone's mastery of arcane arts in the stories of Manly Wade Wellman, or Hellboy's right hand of doom. But there are a few, such as Dracula's nemesis Abraham van Helsing and Hellboy's mentor Professor Bruttenholm, who lack extrasensory or psychic powers. It's worth noting, as we navigate the bookish world of Hellboy, that occult detectives are often scholars, whether independent or accredited.

Hellboy's role as an investigator, a detective, is announced in several ways. The first Hellboy saga, scripted by John Byrne, featured a first-person narration that heavy-handedly echoed such writers as Raymond Chandler and Mickey Spillane ("Mostly it's the worst pain I've ever felt—and I've been hurt by experts."). There's also that rumpled trench coat he sports, similar to those worn by characters portrayed by Robert Mitchum and Humphrey Bogart, not to mention Peter Falk. There are the

cigarettes and the booze. And many of the early stories begin at the scene of the "crime" to be investigated: "Mr. Heath, now that we're here, can you run us through the whole thing one more time?" In the mode of film noir, flashbacks ensue.

Srdjan Smajić has written an intriguing study of tales of occult detection, that unlikely hybrid of the two seemingly incommensurable genres of detective and ghost fictions, within the larger context of the relations between contemporaneous theories of vision and Victorian literature.[8] Detectives are firmly committed to empirical evidence and the possession of a properly trained vision that can "read" visible, natural space more thoroughly than the rest of us. Detective fiction gave us a world in which the properly trained mind could have sensory access both to the real and to the truth. Ghost fictions, though, turned upon the existence of the in-visible, a *super*-natural in its most literal sense that impinged upon and affected the natural order.

Smajić points to how science in the late nineteenth century was engaging with and conceptualizing a world that lay beyond the perceptual capacities and limits of the five senses, and how such concepts as "aether"—an omnipresent yet undetectable medium without density that occupied all the space between things—opened the door to other sorts of inquiry.[9] Once an invisible, unmeasurable substance was taken up by respectable science, could notions of the supernatural be far behind? Spiritualist literature proposed that humans have neglected the senses that might reveal to us the supernatural world. The first occult detective, Dr. Hesselius, discusses how an "interior vision" could do just that: "The seat, or rather the instrument of exterior vision, is the eye. The seat of interior vision is the nervous tissue and brain, immediately about and above the eyebrow."[10] A different *kind* of seeing is called for, one open to other stimuli. The

danger is that "Inner vision ... may also operate as a channel for the invasion of demonic spirits into the seer's body and mind."[11] Not all spirits are benign, and here's where the occult detective has to go to work.

As a side note, I find the concept of aether remarkably apposite to the "strange, special air" of Mignola's aesthetic, with which I'll engage more fully in chapter 5. Mignola's pages are characterized by an emphasis on mass more than line, an effect accentuated by Dave Stewart's flat coloring (see figure 1). There is no empty space in a Mignola drawing—a field of gray on the first page of "The Island" is simultaneously the undifferentiated regions of sea and sky and a negative space that solicits attention as fully as the wrecked ships that punctuate it (see figure 53 in chapter 5). Space in Mignola's work possesses a materiality unusual in the medium of the comics—weirdly appropriate to tales of supernatural forces and beings that lurk somewhere beyond the visible.

While the larger mythos that informs the Hellboy universe can be traced back to Lovecraft, Mignola insists that "the bigger, fundamental structure" of the work derives from the short occult-investigation stories by writers such as Wellman and Howard, both of whom wrote nonchronological tales involving a continuing character "who kind of wanders around and runs into stuff" (occult stuff, that is).[12] This, too, is the structure of many a Hellboy short story, which, as editor Scott Allie notes, "feature Hellboy as John the Balladeer or Solomon Kane"—the respective creations of Wellman and Howard.[13] Hellboy, whether sent by Professor Bruttenholm or simply in his wanderings, encounters someone in some sort of occult trouble. For example, in "The Corpse" (1996), a couple living in a remote area of Ireland suspect that their child is a changeling—which turns out to be true. To

effect the return of the real baby, Hellboy must do the bidding of a group of Daoine Sidh (something like elves or fairies in Irish mythology) who want their dead (and rapidly ripening) friend buried in Christian ground; in a single night, Hellboy, with a talking corpse draped about his neck, must shuttle from sacred ground to sacred ground, and the task proves more challenging than at first appeared. There is no explanation for his being in Ireland; he's just there.

If the structures are indebted to Wellman, then so is their method. Mignola, like Wellman, often draws from folkloric traditions, but of a broader range than the Appalachian tales that Wellman used as a source for his tales of John the Balladeer. Well-worn books of folklore line Mignola's bookshelves. "The Corpse," often cited by Mignola as among his favorites, has its roots in an Irish folktale called "Teig O'Kane and the Corpse," supplemented by "bits and pieces" from other English or Irish tales.[14] Other stories, collected in the volumes *The Chained Coffin, The Right Hand of Doom,* and others, draw from numerous traditions. "King Vold," a story from 2000, combines two Norwegian folktales and "other bits of Norwegian folklore thrown in to show just how much weird stuff goes on over there."[15] "Heads" (1998) has its source in a Japanese folktale; Russian and Romanian tales provide the basis for other stories; and still others are inspired by the work of horror writers or filmmakers, or are entirely the product of Mignola's imagination. Mignola acknowledges his debt to these varied sources: the horror story *The Crooked Man* (2008) immediately evokes, through its Appalachian setting, the stories of John the Balladeer, and it's Wellman to whom the work is dedicated (see figure 39 in chapter 3).

As editor Scott Allie wrote, what Mignola "was focussed on [in the short works] was simply telling stories for the pleasure of

it, drawing things he wanted to draw, and once he got them out of his system, moving on," while preparing for the next larger-scale adventure. Allie notes that the history of fantastic fiction had always lent itself to shorter works, "from M. R. James and William Hope Hodgson to Poe and Lovecraft, and on to the comics vaults of EC comics," and beyond.[16] Mignola describes himself as "a short story guy" who prefers to both read and write them. "There is something about making the most out of a small idea. Or taking a big idea and handling it in a small way."[17]

Mignola draws upon the sublime horrors of the Cthulhu mythos in his fictions, but at the same time his characters face those horrors with aplomb. There are many precedents for this in the field of occult detection: occult detectives engage with phenomena that often reduce those around them to conditions of helpless imbecility, but they themselves are often strikingly blasé about what they see. They don't experience these eldritch, even apocalyptic, events with anything resembling awe. Wellman's John Thunstone, for example, is a two-fisted heroic figure who is appropriately confident of his ability to outthink and out-punch whatever weirdness he encounters. Occult detectives have jobs to do, and they approach the most fantastical happenings with pragmatic, even deadpan, efficiency. Hellboy is particularly unimpressed by his adversaries; he's never as cowed as they'd like him to be. When a statue of Moloch comes to malevolent life, his response is simply "Well, you knew *that* was going to happen." Note the absence of an exclamation point. In "The Island," the spirit of Hecate the Damned proclaims: "You and I will be together on the last day … at the ending of the world." "Great," a hard-boiled Hellboy replies. "Til then, stay the hell out of my way." He's not entirely unflappable, but he's not easily flapped.[18]

In fact, one could see the occult detective as the paranormal equivalent of "the man who knows Indians" in the fiction of James Fenimore Cooper. Leatherstocking is able to cross between civilization and wilderness, retaining the morals of white culture while avoiding its decadence. This is quite apposite to the occult detective, a liminal character who has partaken of the paranormal without becoming corrupted by it. Their well-trained "interior vision" and extensive experience permits them to serve as reliable guides to, and rescuers from, the world of the occult ("the men who know monsters"?). And that reliability means that they are not given to feelings of panic, helplessness, or dissolution: they've been there and done that. (Walter Benjamin locates Cooper as an important progenitor of detective fiction more generally: "Owing to the influence of Cooper, it becomes possible for the novelist in an urban setting to give scope to the experiences of the hunter.")[19]

And just as the protagonists of movie Westerns are rarely overawed by the majesty of the Western landscape (among the most sublime of landscapes, historically), so occult detectives are able to navigate the immensities of the supernatural without succumbing. Of course, some Western film directors evoke the sublime for the film *viewer*, even as their protagonists seem immune to its power. In *The Searchers* (1956), Ethan Edwards rarely pauses to contemplate the wonders of Monument Valley as he quests after his young niece, but John Ford's camera frames the landscape to emphasize its scale and majesty for the audience. Mignola's work, though, recalls a different director, in whose work the sublime would be just as unexpected: Howard Hawks. The characteristic Hawks scenario, in such films as *Only Angels Have Wings* (1939), features a band of professionals, living and working together with efficiency and mutual dedication;

this precisely describes the operations of the B.P.R.D. Mignola's understated dialogue, as his characters confront all kinds of Lovecraftian strangeness, is the polar opposite of Stan Lee's overwrought monologuing, and in Hawks one finds a similar formal restraint. It isn't even a reach to compare Hawks's eye-level perspective and eschewal of visual gimmickry to Mignola's predilection for rectilinear layouts and flat color, and to find in the work of both an understated attention to adult behavior and emotions. The Hawksian "Westerner" and the occult detective are strange cousins, then, and they fuse in the figure of Hellboy, which begins to explain why I've always felt that Hellboy could very plausibly have been played by the older, more accepting John Wayne of *Rio Bravo* (1959).

For Hellboy, though, the stakes are higher than for many a Westerner or monster hunter. To acknowledge a power so much greater than his own would undermine the tactics of resistance upon which his sanity depends. "You know how I live?" he asks Kate at one point. "I never deal with what I am. I don't think about it, I just do my job, which usually involves me beating the crap out of things a lot like me. But I don't think about that." What he doesn't think about is that he is a horned demon with cloven hooves, summoned to Earth not only by a resurrected Grigori Rasputin but also a bunch of Nazis: as Hellboy might remark, "*That's* not good." Things go from "not good" to worse when he is later revealed to be the hybrid offspring of a witch and a demon ("That's what I get for being curious"). And his destiny, like it or not, is to "deliver the world back into chaos," his mysterious, blocky right hand the key to letting loose the dragon, Ogdru Jahad (figure 22).

He has a destiny. But for reasons of his own, Hellboy has no interest in that destiny, and when he's of age, he hacksaws the

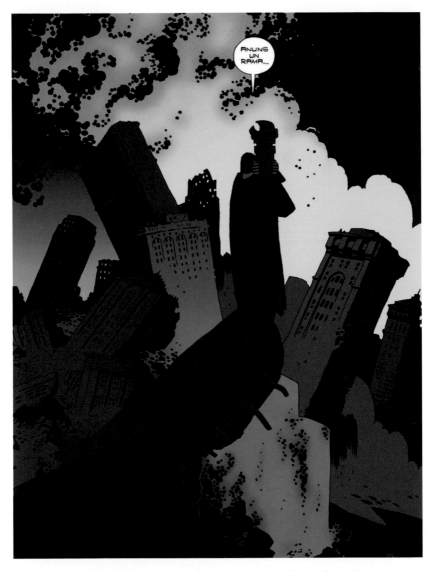

Figure 22. Mike Mignola, *Hellboy:* "The Right Hand of Doom," p. 8. Dave Stewart, color; Pat Brosseau, letters. Dark Horse Comics, 2000.

demon-horns from his brow, leaving two stumps in their place (in the first film, we see him grooming them with a power sander). Tale after tale leads Hellboy to greater and greater understanding of his place in this evil cosmology, but always he reaffirms his opposition, often performing a profound disinterest. (In "The Right Hand of Doom" [1998], Hecate tells him, "You cannot escape your destiny!"—to which Hellboy replies, "Blah, blah, blah.") Small wonder that more than a little melancholy marks his nature. Resisting one's destiny is hard and lonely work—those horns can grow back.

Hellboy decides to leave the B.P.R.D. because Roger, his homunculus partner and friend, was implanted with a bomb by suspicious higher-ups. But he also departs because he's feeling the weight of all that destiny:

> HELLBOY: "It's all this other stuff on me. Crown of the Apocalypse? Right Hand of Doom? Flowers growing out of my blood?"
>
> KATE CORRIGAN: "You never told me about the flowers."
>
> HELLBOY: "I just heard about that one myself."

Hellboy needs some alone time, but as a shaman tells him, "All your roads lead to strange places." When he washes ashore at the start of the 2005 story "The Island," he has been literally adrift for two years. After a drunken revel with some resurrected sailors, he is confronted by an arch-nemesis, Hecate the Damned. She has been calling to him from the first pages, and it's never clear whether Hellboy has been hearing and/or ignoring her. The inertia of these early pages, to be discussed more fully later on, is emblematic of Hellboy's larger ennui.

And so, as much as he might emulate his hard-boiled progenitors in both normal and paranormal traditions, Hellboy is fundamentally different—he is, himself, often implicated in the events

to be investigated. In truth, he *is* an event to be investigated. One story begins with a fairly standard opening for a private-eye yarn. A priest welcomes him: "I knew you'd come. The doctors say I don't have much time, but I knew if I wrote to you, you'd come." "You're Adrian Frost?" This is followed by a flashback about Frost's father. The priest then shows Hellboy a mysterious paper with an inscription in "old Lemurian" that reads, "Behold the right hand of doom." A generational saga, a mystery to be solved, stories that must be brought to light—we're firmly within the detective genre. But the mystery is of paranormal origin, so it's more the tale of an occult detective. But that "right hand of doom" is Hellboy's own right hand; he might tear off his horns, but the destructive power represented by that hand—"power to loose and command the dragon, Ogdru Jahad … to breathe life into the life-less soldiers of hell … and set that army to war against heaven"—is not so easily removed.[20] It is, he learns, his burden; he must see that it is never used, as it will usher in the apocalypse ("Yeah," he replies—need I add?—drily). Hellboy may affect the disinterested stance of the private eye, but he is constantly forced to confront his own place in these stories. Here is their tragic dimension, and their recurring melancholy.

Mignola's coauthored and co-illustrated novella *Father Gaetano's Puppet Catechism* (2013, with Christopher Golden) is set on the island of Sicily in World War II. A newly assigned priest discovers a puppet theater that, he hopes, will engage the interest of the grieving, traumatized orphans in his charge. But these puppets have an animist force of their own and begin taking their assigned roles in the puppet catechism all too seriously— which becomes a real problem when the Lucifer puppet shows up. Once again, the "destiny" of characters is thematized. In fact, it's striking how many of Mignola's works are about bringing

something to life or to light. Puppets come to life, Hellboy is brought into life, texts are brought to life, and, of course, readers are brought to life through their engagement with the dense network of the comics.[21]

Mignola dedicated the *Puppet Catechism* to Carlo Collodi, "who forever altered my idea of what puppets can (and should) be," and the story of Pinocchio also looms large in *The Midnight Circus* (2013), a story set in 1948, in which the young Hellboy runs away to a mysterious circus, where he becomes interested in the "Wooden Boy" attraction (figure 23). Like Pinocchio, Hellboy is something of a *disobedient machine,* a term I coined in *The Poetics of Slumberland* to describe animated creations that defy their creator/masters to take on, not just life, but a life of their own. One doesn't find in *Hellboy* the same struggle between Mignola the creator and Hellboy the creation, but the overarching narrative of *Hellboy* is, after all, about the character's defiance of his programming. Hellboy emerges as a character with will and agency, despite the constancy of the forces that try to seduce him into fulfilling his "destiny." I'm reluctant to label just any character that exhibits free will a "disobedient machine," but here I think the shoe, or cloven hoof, fits.

Where Pinocchio wanted to become a real boy, Hellboy is already one—at least to hear Professor Bruttenholm tell it: "Whatever he was *before,* now he's just a little boy." But this little boy is caught between warring factions. Bruttenholm reads in a tome called *Visions and Revelations* that "I saw a city, silent as a tomb, barren as dry bones, and the angel said, 'This is *desolation.*' And I went down into it and the only living thing there was the *creature*"—a creature that seems to bear Hellboy's mysterious right hand. Meanwhile, at the circus, the ringmaster suggests to young Hellboy that Pinocchio's nightmarish circus experience

Figure 23. Mike Mignola, *Hellboy: The Midnight Circus,* cover. Dave Stewart, color. Dark Horse Comics, 2013.

was actually good for him: "It showed him how foolish he was to be a donkey, and led him back to being what he was, what he was meant to be." Hellboy is being not so subtly guided toward an acceptance of his destiny, yet he remains nervously oblivious. "But he wanted to be a real boy," he points out, to which the ringmaster replies that Pinocchio "suffered from a terrible lack of vision." "I don't know what that means," says Hellboy. Again the discourse of *what one is meant to be* is offered, and again Hellboy refuses or fails to take the bait.

Bruttenholm becomes Geppetto in this replaying of Pinocchio at the midnight circus, aging and dying in the belly of a whale. Hellboy could tap his demonic energies to save him ("You can light a fire with a *word.*"), but this would portend the fulfillment of the prophecy: "I saw in its right hand it held the key to the bottomless pit... and I saw a great fire come out of it, out of the depths of hell, and roar across the whole face of the earth.... And after that only darkness, and the far off lamentation of angels in heaven, weeping for the fall of man." Struggling to escape, Hellboy sees his reflection in the demonic form of Anung Un Rama in a funhouse mirror. But escape he does.

My own interest in *Pinocchio* has been more with Disney's 1940 film, with its realist aesthetic overlaying a discourse on "real" and obedient boys. I've argued that, contra the overt moral of *Pinocchio,* it is not obedience and being a good boy that makes Pinocchio into a real boy, it's his disobedience, through which he inadvertently demonstrates his autonomy (rather than automatism), his independence ("There are no strings on me!"), and his "realness." Thus, Pinocchio becomes a "real boy" well before the Blue Fairy reappears to grant his wish. It's unclear whether Hellboy is innately a good little boy, but it's strongly suggested that it's Bruttenholm's treatment of him as "a little boy" that has

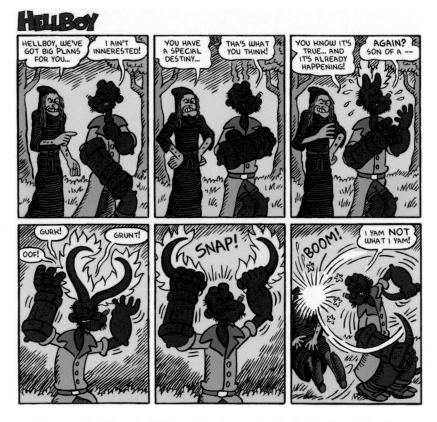

Figure 24. R. Sikoryak, *Hellboy 20th Anniversary Sampler,* "Color Comics Fun," p. I. Dark Horse Comics, 2014.

helped make him one. Nurture trumps nature, then—at least for the moment, and not without a struggle. Pinocchio, in book and film, achieves stability and closure; Hellboy must continually resist ("I yam NOT what I yam" is his motto in R. Sikoryak's irresistible mash-up of Hellboy and Popeye) (figure 24).[22]

In 1999, Mignola published a two-page story, the first to deal with Hellboy's childhood. A two-year-old Hellboy is cajoled

into trying pancakes (or "pamcakes," as he memorably calls them). After a reluctant taste, he declares his love for them. The scene shifts to Pandemonium, the capital city of Hell, where demons are writhing and shrieking in agony. "What's the noise all about?" asks Astaroth, Grand-Duke of the Infernal Regions.

> MAMMON: "It is the boy. He has eaten the pancake."
>
> HABORYM: "He will never come back to us now."

Already he resists his programming, unenthusiastically but willingly tasting the "pamcake." His childish stubbornness, childish locutions, and childish delight all speak to his developing character, his emergence as an individual. And, as Walter Benjamin reminds us, with scary appropriateness, "Where there is character there will, with certainty, not be fate, and in the area of fate character will not be found."[23] I yam not what I yam.

Children's Books, Color, and Other Nonlinear Pleasures

The pictorial fantasies offered by children's literature, to which Benjamin was so devoted, has more than a few parallels in the world of comics. In his recently translated *Comics and Narration,* Thierry Groensteen points to some interesting convergences and divergences of comics and children's picture books. They overlap most obviously in that both "tell a story by harnessing the power of both text and drawings." He also points to the tremendous stylistic diversity that each form can accommodate.[1] Where children's books differ from comics is "in their slimmer pagination and lesser narrative breadth." He also argues that they "do not normally feature either the partitioning of space typical of comics (the division of the page into strips and strips into panels) or the integration of dialogue into the image by means of speech balloons,"[2] but contemporary children's books, perhaps spearheaded by Spiegelman and Mouly's *Little Lit* series, incorporate such comics-y elements quite readily.

I see further convergence where Groensteen finds divergence. While the comics page offers itself as a fundamental compositional

unit, he argues that the children's book more characteristically emphasizes the panoramic *double*-page spread, and frequently the images bleed to the edges of the page rather than rest contained in their panels.[3] Yet double-page spreads are hardly unknown in the world of comics—Jack Kirby or J. H. Williams III, anyone? (see figure 20 in chapter 2)—and the double-page clearly operates as a compositional unit for artists as seemingly different as Chris Ware and Mike Mignola. Bleeds off the page are no longer remarkable. In an echo of Benjamin, Groensteen writes that "In the children's illustrated book, the artist's goal is to offer the reader, at the turn of each page, if not something spectacular then a visual thrill, a little pictorial excitement—at the very least the chance of absorption in the image and so a projection into the fantastical world of the fiction."[4] Here, too, I think comics produce a similar effect. Groensteen doesn't consider the scale of the image, which in the case of a *Little Nemo in Slumberland* page surely contributes to a feeling of something spectacular, thrilling, and absorbing, an encounter with images that encourage, if not demand, "a projection into [a] fantastical world." And even a single-page feature in a Sunday supplement is encountered by turning pages.

Comics scholars and children's book scholars have historically been wary of one another, with comics a bit déclassé for the children's book folks, and comics scholars "reluctant to (re)claim the association between young readers and comics," with the advent of the new respectability that accompanied the emergence of the "graphic novel."[5] Charles Hatfield and Craig Svonkin regard both as popular forms of what W. J. T. Mitchell has called "imagetexts," hybrids of word and image (and word as image, and image as sign).[6] It's true that the forms circulate differently in the world and are consumed differently, but their convergences of technique and materiality are truly formidable.

Figure 25. David Wiesner, *Free Fall*, pp. 2–3. Lothrop, Lee & Shepard, 1988.

David Wiesner makes luxurious, often wordless, children's books that are rich in fantasy and the transforming power of imagination. In *Free Fall* (1988), a boy's dream takes him from his bed into a smoothly morphing landscape: blankets become fields, fields lead to castles, a castle's stone wall becomes a dragon's tail, and on it goes (figure 25).[7] Wiesner's characteristically horizontal pages effectively constitute one continuous image that stretches across twenty-six pages (laid end to end, the panoramic image would measure about twenty-four feet). The book no longer sim-

ply represents a world of dreams; it becomes something of a dream itself, a Slumberland into which the reader/dreamer is completely absorbed. As I wrote with regard to *Little Nemo,* an obvious precedent that informs *Free Fall* at all levels, "Slumberland is more than just a marvelous world for Nemo and its other citizens; it is an aesthetic space primarily defined through the artist's innovations, an animated space that opens out to embrace the imaginative sensibility of a reader who is never farther than an arm's length from this other realm, a space of play and

plasmatic possibility in which the stable site of reading or view-ing yields to an onslaught of imaginative fantasy; and it is an impermanent space."[8]

Wiesner is clearly not only cognizant of comics, but seems to hold them in some esteem (a brick conspicuously labeled "Coconino" is a tip-off in a later book).[9] The sumptuous word-less realms that exist in Wiesner's books summon thoughts not only of Winsor McCay, but also of Jim Woodring's *Frank* com-ics, which similarly combine the solid and the mutable (Woodring is Mignola's favorite cartoonist, by the way).[10]

At the same time, Mignola is no stranger to book illustration. He has illustrated and cowritten some novels and novellas with Christopher Golden: *Baltimore, or, The Steadfast Tin Soldier and the Vampire* (2007), *Father Gaetano's Puppet Catechism: A Novella* (2012), and *Joe Golem and the Drowned City* (2012). As some of these titles might indicate, the world of childhood toys, that Benjaminian realm, is never far away in Mignola's universe. Mignola's approach to book illustration doesn't quite square with the kind that Benjamin celebrates, though; perhaps because he's illustrat-ing books for adults, for the most part he takes a quieter, less action-oriented approach. Rather than visualize climactic nar-rative elements, he emphasizes small, quiet, almost ambient details. He has described these images as "mood pieces": "As a reader I don't want an illustrator to show me too much—as an illustrator I don't want to tell the reader too much."[11] Barry Moser is an influence—Moser's editions of *Frankenstein, Alice's Adventures in Wonderland, Moby-Dick,* and other books take a simi-larly nondramatic approach.[12] The illustrations that pepper *Moby-Dick,* for example, emphasize the tools and processes that contour life aboard a whaling ship—there is nary an image of Ahab, Ishmael, or Moby-Dick himself. Mignola's full-page fron-

tispiece to *Father Gaetano's Puppet Catechism* shows us the titular character in full figure, looking out at the reader, but every other illustration is smaller, nested within the text, and provides only thumbnail portraits of the puppets, both benevolent and malign, that in the course of the story begin to take their dramatic personae rather too literally.

Comics and the picture books of which Benjamin is so enamored are both bound up (ha) in the materiality of the book, the sensuality of color, and the sustained encounter with aestheticized worlds. Books and comics are both proximate objects—their illustrated worlds only a few inches from the eyes—and physical objects—held in the hand, demanding the physical interaction of holding and page-turning. The page (or double-page) needn't be Slumberland-sized, it only needs to fill your field of vision. Benjamin writes that "In one of [Hans Christian] Andersen's tales, there is a picture book that cost 'half a kingdom.' In it, everything was alive."[13] Benjamin faults Andersen for missing one key detail: the inhabitants of that wondrous book step from its pages to greet the child reader; in reality, Benjamin argues, it is the reader who crosses the threshold, who "overcomes the illusory barrier of the book's surface and passes through colored textures and brightly painted partitions to enter a stage on which fairy tales spring to life."[14] I'd say there's a greater operation of reciprocity at work: the vivacious inhabitants of Andersen's tales, McCay's Slumberland, and even Mignola's Hell solicit the reader; they reach *out* to invite us *in* to those splendid otherworlds. Fictional and flesh-and-blood characters are equally activated.

When Benjamin discusses the illustrations in children's books, he repeatedly emphasizes their "colored textures." Some of the power of these images derives from their "riotous colors" that work against the monotony and pedantry of the accompanying prose.[15]

Once we pass from childhood, the books on our shelves are over-whelmingly devoid of illustration—graphemes alone line their pages in lock step. The authority of written text is firmly estab-lished.[16] "Of course, schoolteachers soon discovered that not only did children have problems with the primer, but the primer had problems with children. The obvious solution was to separate the visual as far as possible from the word, and even more from the let-ter." Picture books constitute, quite literally, a space apart, and they have a very privileged, albeit brief, status in our lives. So it's disheartening to read, in the *New York Times,* that "The picture book, a mainstay of children's literature with its lavish illustrations, cheerful colors and large print wrapped in a glossy jacket, has been fading" in popularity. Parents are encouraging their kids to begin reading "chapter books" at an earlier age, under the misguided impression that they are more sophisticated, more "advanced."[17] So much is lost here: the stimulating of a visual imagination, decoding the subtle interplays of text and image, and the engagement with that "resplendent, self-sufficient world of colors." Here we have the triumph of Benjamin's hated "pedagogues," banishing the hard-to-regulate world of pictures from the realm of the children's book.[18] While color is hardly absent from contemporary image culture—websites are, after all, often blazingly colorful, and color images assail us from all directions—picture books, I think, offer a differ-ent experience, in which intertwinings of color and imagined worlds are more considered, more coordinated, and more self-con-tained, producing something more absorbing, even contemplative, for their readers.[19]

The rejection of richly illustrated children's literature could be aligned with the larger suspicion of images and vision in our cul-ture,[20] and more specifically a suspicion of the kind of "riotous colors" that stimulate the imagination while eluding the strictly

rational. In this, the history of children's literature bears strong traces of what David Batchelor effectively calls "chromophobia." He writes that "in the West, since Antiquity, colour has been systematically marginalized, reviled, diminished and degraded.... As with all prejudices, its manifest form, its loathing, masks a fear: a fear of contamination and corruption by something that is unknown or appears unknowable."[21] Where Western culture has celebrated whiteness as "clean, clear, healthy, moral, rational, masterful," color has been regarded as alternately (or even simultaneously) corrupting and trivial, something addressed more to the senses than to the mind.[22] I can't help but wonder whether the fear of comics in America, manifested in their dismissal and disparagement throughout their history, is, to a significant degree, a chromophobic reaction.

Color, in literature and film, is often figured as belonging to a separate realm. Batchelor notes that in 1939, Technicolor separated the drab reality of Kansas from the wondrous land of Oz, and it also separates the drabness of the afterlife from the lividity of the real world in *A Matter of Life and Death* (Powell and Pressburger, 1946). I'd add another work by Powell and Pressburger: their next film, *Black Narcissus* (1947), is also profoundly chromophilic. British nuns in their white habits are dropped into the polychromatic world of the high Himalayas, with its radiant silks, ethereally blue skies, and profligately blooming vegetation. The nuns' struggle for purity through their ethos of hard work and denial is no match for this sensually heightened environment.

Here and elsewhere, color not only speaks to the eye; it defines the world of experience, the world of the body and its sensory existence. In the cinema, it frequently stands in for all the other senses: touch, smell, taste. But color can also signify the world of the imagination—and one can find this in each of the films just discussed in the context of physical experience. It also holds for

Benjamin's reading child, who, we recall, is found "sitting before his painted book" and who "overcomes the illusory barrier of the book's surface and passes through colored textures and brightly painted partitions to enter a stage on which fairy tales spring to life."[23] Color speaks equally to the world of the body and the world of the spirit. The life richly experienced and the life richly imagined are more closely aligned than one might suspect.

Black Narcissus is typical of Western culture's aligning of color with a host of Others, including, as Batchelor lists them, the primitive, the infantile, and the vulgar (to be clear, though, Powell and Pressberger are profoundly on the side of color).[24] Women's clothing is more polychromatic than menswear. Children and artists, too, are permitted an undisciplined sensibility in which color has a place, but the rationalist culture of productive adulthood makes other demands for which a more monochromatic palette is, presumably, more appropriate.[25]

Benjamin is an unabashed chromophile. His early writings are peppered with short essays and fragments in which he celebrates the power of the colorful book and the immersive pleasures that it offers, detours from the pedantic lessons imparted by language. Batchelor notes that the rhetoric of both chromophiles and chromophobes is very similar—both emphasize, perhaps exaggerate, the power that color holds—and his book is a useful compendium of writings about color that point in both directions.[26] Chromophilic writing tends toward the erotic, or at least the sensual. "Colour is like a closing eyelid, a tiny fainting spell," writes Barthes: it is "a kind of bliss." Such diverse persons as Henri Matisse, Julia Kristeva, and Adrian Stokes have written about color as an escape, a liberation, most frequently as something that exceeds—and thus has the power to free us from—the strictures of language.[27] It so often evokes another world, but

at the same time it is the very means of entry into that world. And this is precisely the source of Benjamin's own fascination.

Benjamin returns again and again to the subject of color, especially in children's books. He cherishes the boldness of their conception, how they generate totalizing, immersive experiences. Images are complex forms that elude attempts to quantify their operations. Language has rules, images not so much—and images greatly differ in how receptive they are to being reduced to language. There are so many variables, and language can handle only so many. And if there is something ineffable about the image, that effect is hugely magnified with the addition of color. We see a continuous range of colors within the field of visible light, and the somewhat arbitrary labels that Isaac Newton applied to a handful of these (red, orange, yellow, green, blue, indigo, and violet) are evidently inadequate to the task of encompassing the subtleties of the world of color as we experience it. That's why Stan Brakhage asks, "How many colors are there in a field of grass to the crawling baby unaware of 'Green'?"[28] To complicate our experience further, colors change with the light and with juxtapositions with other colors. Projected color and reflected color have different properties and, arguably, affects.

Comics are not illustrated children's books, but they, too, have their riotous colors and painted partitions. The Hernandez Brothers (Mario, Gilbert, and Jaime) have often spoken of the voracious consumption of comics that structured their childhoods; for Mario, vivid, abundant color was their most attractive element.[29]

The contribution of colorist Dave Stewart, working with Mike Mignola on the color for *Hellboy* and nearly all of Mignola's other books, is impossible to overstate.[30] In a way, the Mignola-verse came fully into focus only when Stewart joined

the team (which happened early on), and Mignola has clearly realized this—it's rare that a colorist gets a cover credit, but *Hellboy in Hell* (2014) has two names on the cover, his and Stewart's.

Color in Mignola's comics is far from mimetic and makes few claims to naturalism. "The Amazing Screw-On Head" was a particularly absurdist story that appeared in 2002, but its wild color shifts were only slightly more exaggerated than in the more serious books (*Hellboy in Hell* has inherited much of its craziness). The fifth page has six panels and begins with a detail of an ancient artwork ostensibly depicting Gung the Magnificent and the "fabulous melon-sized jewel" from which he derived his supernatural powers (figure 26). Mister [Screw-On] Head and his assistant, Mr. Groin, consult with Mr. Dog, who may or may not be alive in a glass vitrine, to learn Emperor Zombie's location. The next panel, tall, on the left side of the page, shows us EZ's airship cruising above La Mancha, and the last panels on the right have Mister Head referencing a globe and, in two close-ups, some foreboding dialogue. The colors on the left side of the page (the artwork detail and Emperor Zombie's airship) are dominated by brown tones, while the images on the right tend toward slate gray. Mister Dog's glass case is at the very center of the top of the page, and whatever gas is being pumped into the case is giving everything a green overtone. The narrative sequence leads the eye one way, while the colors lead it down two other paths: downward and toward the left (the brown tones), all the way to the right and down (bluish-gray). The green makes a nice accent of its own, unconnected to either trajectory. Stewart has argued that color in comics can be bolder and less naturalistic than color in the cinema; compared to film, "Comics is a step away from reality so stylization is easier to pull off."[31]

Figure 26. Mike Mignola, "The Amazing Screw-On Head," p. 5. Dave Stewart, color; Clem Robins, letters. Dark Horse Comics, 2002.

In the days before *Hellboy* and comic books, an important event in the history of comics occurred in the late nineteenth century when new rotary presses in America brought color to comic strips.[32] And, quite apart from the comics, the color supplements of the Sunday newspaper provided a cornucopia of polychromatic images, some sensationalist and some informative, in features that were, not insignificantly, mostly geared toward women and children (Goethe: "[I]t is also worthy of remark, that savage nations, uneducated people, and children have a great predilection for vivid colours").[33] But comics and color printing were almost literally made for one another. If color had its disreputable connotations (infantile, primitive, vulgar), then so did early comics, replete as they were with misbehaviors and disorders of all kinds. In an address to the National Association of Newspaper Circulation Managers in June 1906, newly elected President M.J. Darby asked, "Is the Comic Supplement a Desirable Feature?" Form and content were equally problematic: "The crude coloring, slap-dash drawing, and very cheap and obvious funniness of the comic supplement cannot fail to debase the taste of readers and render them to a certain extent incapable of appreciating the finer forms of art."[34]

The carnivalesque aspects of early American comics were abetted by color. Batchelor writes that while "Bakhtin did not connect carnival to colour … Kristeva did when she described Giotto's colours as 'the visual precursors of the earthy laugh that Rabelais only translated into language a few centuries later.'"[35] As noted above, color is so frequently aligned with that which eludes control and containment that one can't help but wonder whether the Katzenjammer Kids, Foxy Grandpas, denizens of Hogan's Alley, and all the others that populated the funnies would have made quite the same impact without their colorful Sunday

showcases, color adding a soupçon of further vulgarity and disreputability.

But if critics thought that the Sunday *funnies* suffered from crude coloration, the four-color *comic book* was even more garish, its printing presses not exactly the finest. It didn't take comic books very long to hit upon the perfect characters for the medium, though. One could argue that the superhero comic was a highly technologically determined genre, its characters garbed from head to toe in screamingly loud primary colors (figure 27). The names of the heroes and villains often proclaimed their characteristic chromaticity: Blue Beetles and Black Widows, Red Tornados and Black Tornados, Green Lanterns from Earths 1 and 2 (if you have to ask, never mind), Crimson Dynamos and Red Skulls, the Silver Surfer, and the list does go on (with black the overwhelming favorite).

The crude drawing and garish color of the early superhero comic did nothing to endear it to cultural watchdogs, and the lurid use of color in horror and crime comics also brought the industry a great deal of unwanted attention.[36] While all these books were a far cry from the kind of colorful children's book about which Benjamin repeatedly rhapsodized, it's precisely the associations of color and illustration that reinforced, or even created, the sense that comics were a medium for children.

As with children's books, the brassy colors of early comic books allowed ingress to that other world. And the rotary presses that produced the Sunday newspaper comics were capable of remarkably subtle effects, put to good use by such artists as Winsor McCay, Frank King, and Lionel Feininger. The Sunday pages by these artists, and others, in fact evoked the world of children's literature again and again. Feininger's *Wee Willie Winkie's World* (1905–7) speaks for itself, and Hal Foster's *Prince Valiant*, which began in 1937, captured the lushness of the kind of Wyeth-illustrated editions of

Figure 27 (Left). Jack Cole, *Silver Streak Comics,* no. 8, cover. Lev Gleason Publications, 1941.

Figure 28 (Right). N.C. Wyeth, *The Boy's King Arthur.* Charles Scribner's Sons, 1922.

Kidnapped or *The Boy's King Arthur* that had appeared in the 1920s (figures 28 and 29). (It's worth pointing out that other than Frank King's *Gasoline Alley,* which began in 1918, all these strips appeared only in the colorful pages of the Sunday supplement—and King's monochromatic daily strip was far more naturalistic than his more fanciful Sunday pages of the 1920s and '30s). In these instances, and others, children's literature and the comics perform very similar work and engage their readers in similar ways.

So color has its seditious side (which also happens to be its seductive side)—it can overwhelm meaning and exceed the

Figure 29. Hal Foster, *Prince Valiant,* May 3, 1942.

limits of language. It can constitute a space apart that absorbs a reader, and provide an antidote to pedantry.

But comics themselves have been theorized as a form that works against (or at least alternatively to) traditional modes of reading. Tom Gunning links the medium to other modern forms that mobilized the gaze: "arrangements of images in the popular arts frequently portray succession rather than a single pictorial event, invoking a temporal process similar to reading."[37] At the same time, however, Gunning also reads comics into longer traditions of pictographic communication. One of the hallmarks of comics, noted by theorist after theorist, is that a page can be encountered in two ways: it can be processed one panel after the other, as a planar, diachronic form; or perceived as a totality, a tabular, synchronic unity. That this is fundamental to comics is beyond argument at this point, but Gunning pushes further to

reconnect this nonlinear mode of reading to earlier forms. Following Benjamin's intellectual buddy André Leroi-Gourhan, who wrote that "The invention of writing, through the device of linearity, completely subordinated graphic to phonetic expression,"[38] Gunning argues that comics reintroduce the pictographic and, in so doing, form or revivify what he calls a "counter-tradition of writing."[39] Comics instantiate a form of reading that both relies upon and resists the linearity of Western reading protocols: they "show us that reading can exceed and break its dominant rigid protocol, liberating the imagination, expanding the frames."[40]

One caveat, though: it's worth noting that one's performance of reading rarely obeys the linearity of the text. Designer and theorist Peter Mendelsund argues that readers do not consume prose one word at a time; rather, "we take in whole eyefuls of words. We gulp them like water." And, he adds, "To say fiction is linear is not to say we read in a straight line. Our eyes perform leaps, as do our minds. 'The frantic career of the eyes' is how Proust described reading."[41] The text may be arranged in linear sequence, but the eye, as it were, has a mind of its own. But if this is somehow implicit in the act of reading prose, it is elevated to a visible principle in comics by the nonlinearity of the tabular array of images on the page. Comics theory needs to accommodate that nonlinearity; as strong as Scott McCloud's analyses are, his singular emphasis on "the gutter"—the gap between panels that the reader "fills in" through inference—presents simply too linear a model of reading.

For Thierry Groensteen, comics are a network of interconnected elements, not all of which depend upon the passage from one panel to the next. Michael Camille and Eric Hayot also turn to the idea of the network to emphasize nonlinear aspects of the reading experience.[42]

As comics and comics readers matured, better paper and print-ing technologies were adopted, and today's color comics have all the benefits of digital processing. Many colorists are too enam-ored of the photorealistic effects that Photoshop has wrought. The movement away from the apparent crudeness of the four-color dot printing technology was not an unalloyed good. The website 4CP | Four Color Process, curated by John Hilgart, cel-ebrates the unique effects and inventive adaptations that charac-terized dot printing, demonstrating that books printed with this process have a texture that other, supposedly superior, processes lack. The site has placed scans made from four-color comics next to reprinted versions using later technologies. The reprints look dismayingly lifeless.[43]

Having established the anarchic, seditious riot of color that marks picture books and comic books alike, I now need to note that *Hellboy's* color is hardly an uncontrolled explosion of chro-matic disruption—but that doesn't mean that it behaves well, either. In online interviews, Stewart has emphasized that Mignola is thinking about color as he produces his black-and-white art; in long telephone conversations, Mignola walks Stewart through the pages, indicating the kinds of effects he wants to achieve with color. More than with his other regular collaborators, Mignola has said that he "tell[s] Dave what to do. Because I look at the color as a soundtrack. I look at the color as part of the storytelling (figures 30 and 31)."[44]

Stewart's description of the collaboration strikes similar chords: "Mike thinks about color in the design of his pages. So it

Overleaf: Figure 30. Mike Mignola, *Hellboy in Hell*, no. 6, p. 2. Dave Stewart, color; Clem Robins, letters. Dark Horse Comics, 2014. Figure 31. Mike Mignola, *Hellboy in Hell*, no. 6, p. 3. Dave Stewart, color; Clem Robins, letters. Dark Horse Comics, 2014.

might not always be a specific hue but maybe value or emotional tone he wants to hit," he has said in an interview, and in another he specifies the kinds of emotional valence in play: "Sad, gloomy, spooky, violent are the type of general terms that he might use to describe a scene."[45] Mignola showed me a sequence from *Hellboy in Hell,* demonstrating how he guided Stewart in the shifting palette from panel to panel, sequence to sequence, across a double-page spread and across a scene. "This is quiet, this is dark, then it'll warm up a little bit here, then we cool off and blah blah blah blah blah. I used to say this scene's blue, this scene's green, and I still do some of that, but now it's mostly about mood and tone.... It's more about the emotion. It's a little more abstract than it used to be."[46] Color is also used to enhance legibility: in *Conqueror Worm,* the action shifts between scenes of Roger's battle, which is washed in olive green, and Hellboy's, which is similarly swathed in violet (figures 32 and 33). Flow, rhythm, counterpoint, mood, legibility—all of this informs the color choices in a *Hellboy* comic. "Mike knows where he wants your eye to fall," Stewart says, "and color helps do that."[47]

Stewart's collaborations take different forms: for the superb *Batwoman: Elegy* by Greg Rucka and J. H. Williams III (2009–10), the palette shift from the pastels of everyday life to the saturated colors of the superhero adventure was part of the instruction to Stewart, though on other projects he has more autonomy (figure 34).[48]

Of course, Hellboy himself is a quintessential comic book character with a design that depends on the vivid red of his skin—not unlike the red costume on, say, The Flash. Stewart has said that "there's a very 'Hellboy World' sort of palette," and

I'd imagine that red would loom large in that palette.[49] Stewart has said that a colored page needs to "have a certain depth and rhythm," and part of the job of the colorist is to move beyond the mimetic. "There's always something to work off of, costume colors, time of day, etc. Sometimes it's just deciding how to play off those elements."[50] If there is a "Hellboy-world" palette, I suspect that *Hellboy in Hell* may involve a palette all its own. The series is the latest move by Mignola to take Hellboy out of the real world and into a landscape of his own devising, one that can accommodate whatever stories he wants to tell—it's actually not unlike the wholly imaginary Coconino county of *Krazy Kat*, which was similarly unconstrained by the real. And Mignola's movement away from the real is signaled first through color and the adoption of a more somber palette. Most obviously, in this series, Hellboy isn't *red*. The sunless world of Hell is one of grays, greens, and browns, a gloom that recasts Hellboy's tones into something more like brick, or leaning in the direction of a green or deep violet.

In the opening pages of the first story arc, *The Descent*, Hellboy's heart is plucked from his body, and while that heart is Hellboy-red, that is Hellboy's color no longer (figures 35 and 36). The color shift becomes even more pronounced on the fifth page, which consists of only three panels. Hellboy plummets to the ground of an abyss ("Not quite Hell. Not yet. This is its outer edge, and you are staring into the bottomless pits of chaos"). The page is divided into two vertical panels—one of Hellboy crashing to the ground at the bottom of a tall Hellboy-red space, and the other the solid black pillar of his unconsciousness. Hellboy comes to in a small panel at the bottom right, wondering just where the heck he is. The panel gives us a close-up of Hellboy,

Figure 32. Mike Mignola, *Hellboy: Conqueror Worm*, no. 3, p. 6. Dave Stewart, color; Pat Brosseau, letters. Dark Horse Comics, 2001.

Figure 33. Mike Mignola, *Hellboy: Conqueror Worm,* no. 3, p. 7. Dave Stewart, color; Pat Brosseau, letters. Dark Horse Comics, 2001.

Figure 34. J. H. Williams III, *Batwoman: Elegy*, no. 1, pp. 8–9. Dave Stewart, color; Todd Klein, letters. DC Comics, 2009.

and red just isn't in it, replaced instead by tones of gray and black (figures 37 and 38).

Here is a fine example not only of Hellboy's recoloring, but of Mignola becoming "a little more abstract": the page resembles nothing so much as a color field painting combining techniques associated with Barnett Newman and Clyfford Still, while the final action—an awakening in the bottom corner—suggests *Little Nemo in Slumberland*. It's quite the mash-up. From this point

on, Hellboy exists in a land of shadows, and the colors, while sustaining some mimetic function, serve to demonstrate that Hellboy isn't just in this world, but *of* it as well.

Stewart can do naturalistic coloring—the first page of *The Crooked Man* lushly and realistically renders the Appalachian Mountain setting of the story (the art is by Richard Corben, whose work is usually anything but naturalistic); things get more Expressionist as the story develops (figure 39). But stories like "The Third Wish," "The Island," and *The Descent* enact a movement away from "the real world" and allow more freedom in the use of color.

Nearly all professional colorists now use digital technology, adding color to high-resolution scans of the original artwork. The technologies allow for all sorts of gradations and textures, including a battery of photorealistic effects, but Stewart's work for Mignola and others eschews much of that, in keeping with Mignola's own handmade ethos. Stewart has said that he treats the screen as a canvas: "I like the warmth of laying in the brush strokes instead of letting the computer do the work of creating the blend. I just paint on the computer."[51] This goes beyond a desire for the warmth of a human touch; it also speaks to the lack of interest in photorealistic art for both Mignola and Stewart.

The flat yet vivid colors of *Hellboy* comics immediately mark them as taking place in a realm apart, and mark the comics themselves as a separate realm of their own. But *Hellboy in Hell* takes our Hellboy, and the comics in which he appears, even further out. The series is bold in its color conceptions, and if Mignola describes color as a soundtrack, then his orchestration has become more florid. Vivid color erupts without warning, providing a jolt

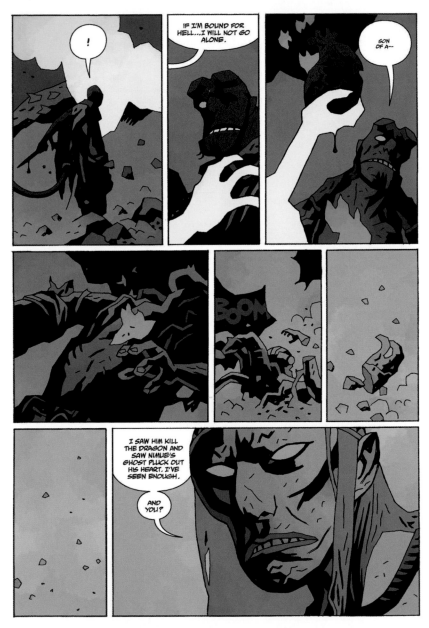

Figure 35. Mike Mignola, *Hellboy in Hell*, no. 1, p. 2. Dave Stewart, color; Clem Robins, letters. Dark Horse Comics, 2012.

Figure 36. Mike Mignola, *Hellboy in Hell,* no. 1, p. 3. Dave Stewart, color; Clem Robins, letters. Dark Horse Comics, 2012.

Figure 37. Mike Mignola, *Hellboy in Hell*, no. 1, p. 4. Dave Stewart, color; Clem Robins, letters. Dark Horse Comics, 2012.

Figure 38. Mike Mignola, *Hellboy in Hell,* no. 1, p. 5. Dave Stewart, color; Clem Robins, letters. Dark Horse Comics, 2012.

Figure 39. Richard Corben, *Hellboy: The Crooked Man*, no. 1, p. 1. Dave Stewart, color; Clem Robins, letters. Dark Horse Comics, 2008.

to the senses. A card game is interrupted by a vampire: the palette shifts from brown to green, with an interpolated narration sequence in blue-violet. The bottom of the right-hand page repeats imagery from the top of the left-hand page, now blood red rather than a muted yellow (figures 40 and 41). The eye bounces around the pages, as the colors provide both continuity and disjunction. A later battle has the vampire sending Hellboy through a plate glass window into an array of marionettes that attack and ensnare him (figures 42 and 43). Greens deepen down the first page and extend through the top of the next, but the appearance of a Lucifer puppet brings with it reds, oranges, and browns. The reader feels the surge and struggle, aided to no small degree by Mignola's layout, which overlaps panels and bleeds off the top and bottom of the pages. Yet another two-page composition uses blues and blacks to gracefully lead the eye from the bottom of the left-hand page to the top of the right.

The coloring in *Hellboy* and all of the other Mignola-verse titles is obviously more sophisticated than that of early comic books or even many children's books, but it nevertheless shares a lineage with them both. I would suggest that the color needs to be sophisticated precisely *because* these aren't works for children; they're directed instead at comics readers who, by definition, haven't disavowed their connection to the kinds of engagements that children have with their coveted picture books. Comics readers have retained a strong relationship to the world of colorful printed images, but they can handle something more refined than the palette of *One Fish Two Fish Red Fish Blue Fish*.[52]

So although color in Hellboy's world doesn't have the anything-goes, primary-color garishness of early comic books, it does fulfill functions that move beyond strict linearity, naturalism, and

Figure 40. Mike Mignola, *Hellboy in Hell*, no. 6, p. 6. Dave Stewart, color; Clem Robins, letters. Dark Horse Comics, 2014.

Opposite: Figure 41. Mike Mignola, *Hellboy in Hell*, no. 6, p. 7. Dave Stewart, color; Clem Robins, letters. Dark Horse Comics, 2014.

Overleaf: Figure 42. Mike Mignola, *Hellboy in Hell,* no. 6, p. 14. Dave Stewart, color; Clem Robins, letters. Dark Horse Comics, 2014. Figure 43. Mike Mignola, *Hellboy in Hell,* no. 6, p. 15. Dave Stewart, color; Clem Robins, letters. Dark Horse Comics, 2014.

SWOK
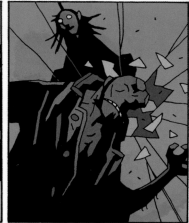
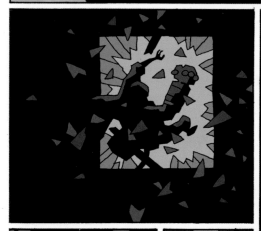

the mimetic. Color's affective power is harnessed by Mignola and Stewart in the service of narrative, atmosphere, and rhythm, but the heightened and continually shifting regions of color manifest as something sensational, even something sensual—but surely, wonderfully, ineffable.

Hellboy and the Codicological Imagination

In *The System of Comics,* Thierry Groensteen valuably reminds us that while comics are not as perceptually immersive as the cinema, they engage us differently, in ways that are pertinent to contemporary culture. "Comics is not a syncretic (total) art such as opera; it does not solicit from the reader the same perceptual deployment that is demanded from the cinematic spectator," he writes. But "comics, which marries the visual and the verbal, demonstrates a discontinuity, a staggering, and the effects of networks, and finally constitutes a sort of image bank." Comics, he adds, "appear to be situated not far from the turning point between the civilization of the book and that of multimedia."[1]

Groensteen emphasizes how comics creators generate nonlinear correspondences upon the page, across a story, or even through a series. "Comics should be apprehended as a *networked mode* that allows each panel to hold privileged relations with any others and at any distance."[2] Recall that Eric Hayot saw the network of connections within and between works, and between works and lived experience, as constitutive of aesthetic worlds

themselves. The networked nature of comics is fundamental to their ability to enworld.

If comics are a network of inter- and intra-textual references, then *Hellboy* foregrounds this "network" to a striking degree.[3] The particular network that comprises the *Hellboy* saga includes not only what goes on in any given issue of a particular comic, but the growing number of stories and story arcs and the interconnected events taking place among the various titles in the Mignola-verse: the *B.P.R.D.* comics, Lobster Johnson's pulp adventures, and the solo tales featuring such characters as Abe Sapien. The 2009 reader of *B.P.R.D.: The Black Goddess* might or might not recognize the decrepit subterranean refuge that Abe, Johan, and Devon are searching through as the now abandoned headquarters of the 1930s action hero Lobster Johnson, seen in better times in 2007's *Lobster Johnson: The Iron Prometheus*. A brief mention of someone or something called the "King of Fear" in a comic from 1998 is explained a decade later in an eponymous story. A mysterious weapon adorns the cover of a *B.P.R.D.* book from 2002; a similar object, now identified as a Hyperborean sword, figures into a 2009 story set in the nineteenth century, and that same sword falls into the hands of the present-day B.P.R.D. in 2013 (it's even intimated that it may be connected to the sword visible on the B.P.R.D.'s insignia since the very first issue of the very first *Hellboy* arc). A single image provides but a glimpse of the city of Pandemonium ("Capital City of Hell") in the "Pancakes" story from 1999, but the accompanying sketchbook pages contain far more detail, detail that will prove crucial to *Hellboy in Hell* in 2012, along with other story elements and images from "Box Full of Evil" (1999)—by this point, Mignola was clearly playing the long game. The absence of Hellboy, who set out to follow his own demons, weighs on the mind of Kate

Corrigan throughout her tenure with the B.P.R.D. and her appearances in *B.P.R.D.* comics. References and allusions intertwine, binding together disparate books, disparate characters, and disparate events. Mignola has produced a set of interconnected stories with characters that grow, develop, leave, return, die, and remember. This is a network (a world, a universe, a Mignola-verse) of comics, stories, characters, histories, and relationships.

But this internal consistency and interconnectedness does not quite get at the core of the network that is *Hellboy* and the Mignola-verse. Situating *Hellboy* and the rest of Mignola's output in the shared universe of Lovecraft's Cthulhu Mythos expands the network beyond the comics to include another network of inter-referential texts, this one multiply authored and largely confined to prose. *Hellboy* becomes part of this network of weird fictions—and, by increasingly incorporating references to multiple folkloric traditions, extends its reach yet further. It's by no means required that the reader of *Hellboy* be versed in the ways of Lovecraft et al., but the aware reader takes great pleasure in seeing these heroic adventures open onto Lovecraft's cosmicist perspective and insert themselves into the history of weird fiction.

But there is still more to this network, and Hellboy's place within it. To understand it more fully, let's turn from the crumbling pages of *Weird Tales* to consider the illuminated manuscripts of the medieval world and methods of reading them that might open onto an understanding of how we read comics—and *Hellboy* comics in particular.

Of course there are formal and structural resonances between comics and manuscripts: in both, text and image combine, sometimes unpredictably. Michael Camille emphasizes the shift from

a single scribe/artist to a division of labor between text-writing and illustration: "increasingly the two activities were practised by different individuals and groups."[4] This suggests a comparison with the rise of the comics "shop" and the now all-but-entrenched division of labor in the production of mainstream comic books. Camille argues that as manuscripts became "polyphonic," the text became a "playground," and these are terms with relevance to the charming cacophony of the Sunday comics supplement.[5]

Medieval scholar Martha Dana Rust's central concept of the "manuscript matrix" seems particularly relevant to *Hellboy*, with regard to both its status as a comic—with its semiotic interplays and animating force—and the bookishness, or the "codicological consciousness," that informs it. Rust defines this latter term as "a preoccupation less with texts—understood as purely linguistic artifacts—than with books and more generally, with all the material realities of late-medieval writing technology." The term refers to a "bibliographic sensibility that is one of the preconditions of the imaginary worlds in books."[6] Substitute comics production for medieval writing technologies, and *Hellboy* has this in spades.

Rust is no stranger to comics: she has written beautifully about the field of white that dominated the farewell appearance in 1995 of Bill Watterson's comic strip *Calvin and Hobbes*, the "magical world" of that snowy expanse that invites the boy and tiger to "go exploring." Rust writes that this unbroken field is also "inviting us to shift in our imaginations between the realm of the snowy day to the space of the page instead, where Watterson presents a parting gift to his readers: a view of the page as a playfield of the imagination for both cartoonists and their readers."[7] Here the materiality of the page asserts itself, peeking

through the field of representation to reveal itself for what it is, a blank slate, an invitation. And it is this materiality that Rust emphasizes in her writing on particular illuminated manuscripts. These works construct what she calls a manuscript matrix—"an imagined, virtual dimension in which physical form and linguistic content function in dialectical reciprocity: a space in which words and pages, 'colours' of rhetoric and colors of ink, fictional characters and alphabetical characters, covers of book and veils of allegory function together in one overarching, category-crossing metasystem of systems of signs."[8]

Rust considers the entwined signifiers of both manuscript and text, relating linguistic and visual signs, semiotics and materiality. Her emphasis is on works that seem to reflexively acknowledge the interplay between book and reader, works that present themselves "as if they bounded a virtual, externalized imaginative faculty."[9] This faculty is not precisely contained by the page or book, but rather alludes to the activation of the reader's imaginative sensibility; in so doing, books "stitch the imagination into a place in the objective world."[10]

The illuminated manuscript, she posits, presents an external analogue to, and is also constitutive of, the interior faculty of the imagination. The "diverse semiotic systems" that constitute the object might be suggested by the interplay of elements upon the page, but they are fully actualized only by the cognitive processes of an involved reader.[11] In the prologue to John Lydgate's fifteenth-century poem "The Fifteen Joys and Sorrows of Mary," for example, the author treats "the act of reading as a comforting alternative to the real world"; the "vnclosyd" book presents a "contemplatiff" space (my spell-checker hates this sentence). Then he encounters a juxtaposition of written text and image that ultimately generates the very poem to be

presented. Rust writes: "As the poet reads the text and sees the image here, he projects a set of graphic images … from his memory into the space before his eyes, and we begin to see that space operating as a workroom for his poetic imagination—a space that is somewhere 'atween' his eyes and the book. As the prologue continues, that dimension becomes more animated.... "[12] While not every reader is also a writer, the same creative space is opened for anyone gifted by what she calls "double literacy"— "the habit of accessing the contents of a book by means of both reading texts and seeing images."[13]

The texts that Rust addresses raise particular issues of theology and engage with the ineffable—topics that lie far afield from my consideration of Hellboy's world—but the textual mechanics that she describes and analyzes are easily extended beyond her chosen objects. Comics demand precisely the kind of "double literacy" that she describes—she echoes any number of comics theorists when she declares that "Written words are presumably for reading and pictures for seeing, but words also conjure mental images, and pictures, in turn, may be 'read' for the stories and lessons they depict."[14]

The activation of the text by a reader who "animates" the world suggested on the page is a process central to comics, which also depend on an interplay of words and images and also require the reader to animate the space of the page, restoring or producing movement—the movement *of* the narrative, the movement (action) *within* the narrative, and the reader's movement *through* the narrative. Tom Gunning situates comics as part of a longer and larger system of "mobile address" that put the gaze in motion in the nineteenth century. "The power of comics lies in their ability to derive movement from stillness—not to make the reader observe motion but rather participate imagina-

tively in its genesis," which dovetails nicely with my own emphasis on reading as a form of play, and with Rust's observation that the final episode of *Calvin and Hobbes* invites the reader's participation.[15] The action conveyed by an issue of *Hellboy* takes place in a region somewhere "atween" the page and brain, and is formed in the interaction between the two. As Gunning writes, comics present "a complex portrayal of movement and succession within a varied practice of reading."[16]

This is perhaps why such comics theorists as Scott McCloud have focused on the "gutter"—the space between panels (and thus between points in space and/or time) that is filled in by the inferential activity of a reader.[17] Precisely because the comic is impoverished in relation to moving-image media and more limited in its use of language than prose, it asks more of its consumers and activates their imaginative sensibilities differently. This work of completion operates on other levels as well: the reader, in a sense, compensates for the sometimes (intentionally or not) schematic artwork, its flatness, its stasis, and the paucity of written or descriptive text, bringing a world into being through the dynamic activity of reading.[18]

The dynamism of reading is thematized in the world of *Hellboy*, which is obsessed with texts and the power they hold. Much gothic horror and weird fiction, at least as far back as Shelley's *Frankenstein* (1818) and Stoker's *Dracula* (1897), make references to other texts (lost, imagined, or fictional), or even purport to *be* those texts. Edgar Allan Poe's "MS Found in a Bottle" (1833) appears to be just that, while Lovecraft's *The Case of Charles Dexter Ward* (1927/1941) takes the form of a legal deposition or debriefing of some sort. "The Call of Cthulhu" (1928) begins with a classic, oft-repeated, premise: the executor of an estate finds something mysterious among the various papers and objects left

behind after some distant relative's demise. Here and in other stories, maps, letters, diaries, newspaper clippings, and books—most famously the apocryphal Necronomicon—are constantly being uncovered or consulted, each text dustier and more arcane than the last. So within this network of weird fictions that share concepts, structures, language, and nomenclatures, there is, within the stories themselves, an additional network of texts and books that interweave, and that pull the protagonists into the thickets of hidden relationships and dangerous knowledges. Into all of this walk Hellboy and the rest of the Bureau for Paranormal Research and Defense, investigating and containing just this sort of arcana.

The first extended *Hellboy* saga, *Seed of Destruction*, serialized across four issues in 1994, opened with excerpts from letters and journals detailing Hellboy's "birth" and development. The story begins with the journal of First Sergeant George Whitman of the U.S. Army, writing in the shadow of a church in East Bromwich, England, in December of 1944. A crew of scientists and army types (and one never-to-be-seen-again superhero, The Torch of Liberty) are gathered to thwart a Nazi program known as Project Ragna Rok; unfortunately they're at the wrong site—to the North, on a small isle off Scotland, Rasputin, with the Nazis, is attempting to summon the (yet unnamed) Ogdru Jahad. Somehow, what is actually summoned (summoned into being, seemingly) is a small red demon that appears at the East Bromwich site,[19] whom Professor Trevor Bruttenholm promptly names "Hellboy." The action then jumps to the present (figure 44).

The first pages incorporate Whitman's journal entries, Rasputin's recited incantations, an old photograph of the 1944 team, a tape recording of Bruttenholm's narration of the Hellboy "incident," and his subsequent narration of an incompletely recalled

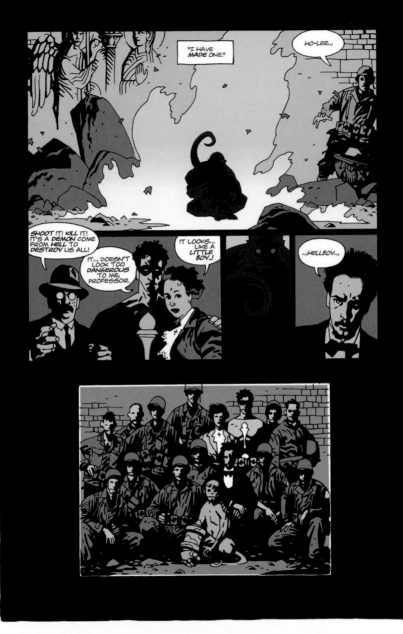

Figure 44. Mike Mignola, *Hellboy: Seed of Destruction*, no. 1, p. 8. Mark
Chiarello, color. Dark Horse Comics, 1994.

Arctic expedition that uncovered ... something ... that has some connection to Rasputin and Ragna Rok (the ancient being Sadu-Hem, newly awakened). Text follows text, story leads into story, until Hellboy's first-person narration takes over (a hard-boiled conceit that Mignola would quickly jettison). The second chapter introduces more narratives of polar expeditions, a search for something "learned of from a scrap of ancient parchment he had acquired in some lost corner of the world," the dossier on B.P.R.D. agent and firestarter Liz Sherman, and a flashback to the discovery of the amphibious being known as Abe Sapien, whose name was taken "from the inscription on a scrap of paper pinned up" near the tube in which he was found. Books, objects, collections—the texts multiply and interconnect.

The chains of events in weird fictions are often activated by the discovery of a text, after which a mystery is posed, a quest is organized, a protagonist sets forth. And of course these hidden texts themselves required some kind of activation—after all, they'd existed for millennia without discovery, without existing in the world. The discovery of a cave, the opening of a box, a mysterious delivery—all of these bring the texts back to the world; they are activated by narrative events. Mignola's absurdist story "The Amazing Screw-On Head" begins with a robbery at "The Museum of Dangerous Books and Paper," a joke that at once satirizes and epitomizes the mechanisms of these tales. Characters in weird fiction are obsessed with texts and often either disappear into a mania generated by the text or use the text to bring something unspeakable into the world. In a long echo of Benjamin's invocation of the "demonic aspect" of book collecting, these are characters who are, to say the least, heavily invested in acts of reading, collating, collecting, researching. Issues of provenance and scarcity loom large.

As Benjamin himself might argue, there is something more than intertextuality at work here, something more like Rust's "codicological imagination" that speaks to a fascination with the materiality and object-ness of books and other documents. Texts in weird fictions are something more than merely words or images on paper.

This mutual activation of material texts and actants that I've been describing further recalls the phenomenology of reading proposed by Wolfgang Iser, who seems to acknowledge a latent animism within the written text. "The text only takes on life when it is realized"—that is, read—and the form of that life has something to do with the disposition of the reader (which is to a degree conditioned by the form of the text). "The convergence of text and reader brings the literary work into existence," that is, *to life,* but Iser notes that "this convergence can never be precisely pinpointed...."[20] In these weird fictions, however, the convergence of (diegetic) text and (diegetic) reader is often very precisely mapped, as characters continually narrate how such and so a text has come to fall into their hands, how it has led them to this or that other text, and the strange hold these have come to have upon them and the terrible secrets they ultimately reveal.

I do realize this isn't the kind of convergence that Iser had in mind, but I think these weird fictions and gothic horrors actually thematize the profound encounter between readers and texts. The found text jolts the infra-diegetic reader into an awareness of another plane of existence, one in which eldritch horrors lurk. "[I]t is only by leaving behind the familiar world of his own experience," Iser writes, "that the reader can truly participate in the adventure the literary text offers him."[21] He describes one's encounter with a particularly impressive literary work as a surrender: "It follows that the work itself must be

thought of as a consciousness, because only in this way is there an adequate basis for the author–reader relationship—a relationship that can only come about through the negation of the author's own life-story and the reader's own disposition."[22] The texts that pepper weird fictions are (apart from the odd police deposition or scientific note) largely unauthored and even date from a time before authors—and they almost literally manifest a most malevolent consciousness. Weird fiction surely describes a particularly intense engagement between readers and texts, and thus presents to us an allegory of particularly intense adventures of reading.

The text as/has a consciousness; in weird fictions, texts have desires, and often what they desire is our subjugation. Iser notes that "when we have been particularly impressed by a book, we feel the need to talk about it."[23] In weird fiction, that reader-in-the-text might find a cult or found one, or perhaps set out to destroy one—texts have power in the world. In that they circulate and connect with other texts, they function not just as a network, but as an ancient conspiracy. One of the B.P.R.D.'s core members is Kate Corrigan, whose previous job was professor of history at New York University. Her character biography indicates that she has published sixteen books on folklore and the occult. In *B.P.R.D.: The Universal Machine* (2006), Corrigan's search for an edition of the *Flamma Recondita,* attributed to the alchemist John Isaac Hollandus, is traced to a mysterious bookstore in a remote corner of rural France that turns out to be a huge cabinet of curiosities—a seemingly unstoppable proliferation of books and objects—that is far bigger on the inside than it appears from the outside. Corrigan is guided around corners and into unexpected rooms, constantly encountering new marvels. In this endless opening onto an imagined space, it is almost

as though she has entered a book rather than a bookstore; thus, this book not only manifests a consciousness but possesses a body as well.

The literal *body* of the text brings us back to that codicological imagination. Rust provides one of the best models that I've encountered for understanding how readers and texts mutually activate one another within a "particular bibliophilic sensibility," but she goes further than Iser and other reader-response theorists in her attention to the materiality of the object being read, not just the abstract semiotic system that constitutes the text. When I look at the books on my shelves, they are clearly more than just containers of information. They are as much, or more, the experience I've had of them: handling them, flipping through them, reading them, and—even in their inert presence on my bookshelves—looking at them. In her valuable book on children's literature—so much useful theorizing on the nature of the book, not to mention comics, comes to us from theorists of children's lit—Nathalie op de Beeck writes that "the text's cloth, paper, thread, glue, and ink contribute to the narrative experience as well, given that the text is made to be handled." Mass-produced though it might be, "it is also a special belonging for one person in particular."[24]

A full codicological consciousness, as Rust describes it, moves beyond the words and pictures on the page to encompass the materiality of the book. "The initiating situation involves an element of material textuality and a reader or writer; this person will be the tale's main character."[25] Several of her examples give us a narrator or character *within* the book whose purpose is to present or engage *with* the book. Again, this is a hallmark of weird fiction: a manuscript is discovered that narrates events that strain credulity; nevertheless, our narrator/guide will

present it to us with minimal commentary and perhaps a post-script that deepens the mysteries described within. "[T]he narrator winds up also assuming a place in a bookish dimension; indeed as a reader captivated not only by a story but also by a book."[26]

I should here note that in medieval studies, "manuscript matrix" refers to particular, unique manuscripts, so my borrowing of the term to analyze objects of mass print culture is, strictly speaking, wrong. But the concept nevertheless seems valuable in considering not only the medium of comics, but the particular bookishness of *Hellboy* and the network of author, collaborators, and readers. It allows us not only to consider the semiotics of the medium, but to begin to attend to the materiality of the book.

The book (including the comic book) is a material form that demands a physical interaction. The page is not just held and regarded, it is *turned* by a reader in an act fundamental to the encounter with books (even e-books require a tap or a swipe). Abelardo Morrell has produced a series of lustrous photographs of books that emphasize their materiality as objects, but do more than that as well.[27] The books in Morrell's photographs are opened, their pages riffled (figures 45 and 46). Light reflects from their pages, obscuring the image while enhancing the paper's texture. Images on the pages of two separate books seem to regard one another. Shallow focal lengths bring some elements of the page into sharp relief as others recede into the indistinct distance. The page becomes an imaginative space of play not in what it depicts, but in how it is handled.[28] As the page turns, the images bend and light reflects off them in unexpected ways. There is a pleasure to be had in the turn of a page—not only does it reveal something to the gaze, but it places my body in eager service to the book and its sequential revelations. My imagination is engaged

by narrative and narration, but my body experiences a parallel, more tactile, engagement. The reading of a book, but perhaps even more, a comic, is a continual act of opening, of unfolding. Each act of reading is unique, and uniquely physical.

In a preface to a book of these photographs (*A Book of Books*), Nicholson Baker ruminates on the physicality of reading: "As we read or look, we pretend that a page is an ideally flat and code-bearing plane, with a measurable height and width but no thickness and no curvature. But a page is almost never flat except when a book is closed; opened, Its surface rises up slightly toward the inside margin and then veers south into the binding, like a mounding wave."[29] He points to our awareness of the thickness or delicate thinness of the page, the history inscribed in water stains and tears and other mishaps that befell you or a prior reader,[30] the feel of embossed letters. Studies already demonstrate that e-reading doesn't lodge in the memory as does the reading of books—our muscles and eyes remember where in the book and even where on the page things occurred; our bodies can recall us to the proper section in ways that e-readers haven't begun to equal. Groensteen argues that the shift to e-reading "entails the loss of a very strong, affectively charged object relation: the physical handling of the book.... There is certainly a loss, in relation to motivity, participation, tactile (and occasionally olfactory) sensations, and even interactivity." And, by the way, the e-reader "page" is, quite literally, a "flat, code-bearing plane."

Morrell's bibliophilia connects him to Benjamin's early writings on books, libraries, and collections. For both, it is their presence on the shelf, on the table, and in the hand that matters. And, as Benjamin reminds us, books have special importance for us as children: not only are they material objects—"special

Figure 45. Abelardo Morrell, "Diversi Ornati Di Pompeia, by Piranesi # 1," 1994.

belongings" (op de Beeck)—but they become portals to other worlds that have so strong an imagined presence as to constitute another materiality altogether (and we shouldn't forget the materiality of the "snow" of the child's reading). In a passage that resonates with Benjamin's evocation of a child's experience of reading, Baker wonderfully gets at the way we "enter" books: "You press your mind, your forehead, against the beginning of a book, the cool cover of it, appreciating its impenetrability. It is rectangular and thick, heavy enough to stop a bullet or press a

Figure 46. Abelardo Morrell, "Don Quixote," 2005.

leaf flat. It will, you think, never let you through. And then you begin to lean into it, applying a little attentive pressure, and the early pages begin to curl back with a soft, radish-slicing sound, and you're in. You're in the book."[31] Benjamin's reading child, remember, "overcomes the illusory barrier of the book's surface and passes through colored textures and brightly painted partitions."[32]

The contemporary children's book author–illustrator David Wiesner has played with the picture plane in several of his works.

Figure 47. David Wiesner, *Free Fall,* pp. 10–11. Lothrop, Lee & Shepard, 1988.

In *The Three Pigs* (2001), an all-too-familiar retelling of the classic tale takes another turn when the wolf accidentally huffs and puffs the first pig not only out of his house, but off the page and beyond the story.[33] Moving with new freedom between panels and across page breaks, the pig rescues the others and they sail off to new adventures of their own choosing. Pages become windows, allowing egress and ingress to multitudinous realities. This Morrisonian romp (see Grant Morrison's *Animal Man, Doom Patrol, The Filth, Zatanna, Flex Mentallo, Final Crisis,* and *Multiversity* for his ver-

sions of such inter-meta-textual travels)[34] was preceded by *Free Fall*, discussed earlier in relation to its Slumberland poetics. At one point, as the reader's eye moves from left to right across the extended panorama that constitutes the book, the striated trees in a forest almost invisibly morph into a series of upright books entered into by the dream characters (figure 47). On the next page, the books' flat pages take on a Morrellian dimensionality— pages are seen in the process of turning—and become a porous field through which characters emerge and submerge (figure 48).

Figure 48. David Wiesner, *Free Fall*, p. 13 (detail). Lothrop, Lee & Shepard, 1988.

Peter Mendelsund writes: "When you first open a book, you enter a liminal space. You are neither in this world, the world wherein you hold a book (say, this book) nor in that world (the metaphysical space the words point toward). To some extent this polydimensionality describes the feeling of reading in general—one is in many places at once."[35] Mendelsund is here referring to the complicated coexistence of multiple consciousnesses—reader's, author's, and characters'—but I think this polydimensionality can also encompass the coexistence of the stubborn materiality of the book and its status as a signifying system. Wolfgang Iser's phenomenology of reading doesn't engage with the materiality of the book, while Georges Poulet holds that its

materiality dissolves in the act of being read: "Books are objects. On a table, on bookshelves, in store windows, they wait for someone to come and deliver them from their materiality, from their immobility."[36] But, pushing this "polydimensionality" of Mendelsund's slightly in the direction of materiality, we can foreground the fact that the book I'm reading continues to exist in my hands, its weight and tactile presence an ongoing part of my experience, even as the language of the book steers me elsewhere.

How does this differ for comics? First, we might argue that the comic transports its readers quite quickly: images ground the reader with more seeming immediacy than prose, but the materiality of its form is also more evident—there are pictures on the page, rendered in a particular style, organizing space and time before my eyes. At the same time, comics don't inundate the reader with that relentless flow of naturalistic images that is the province of the cinema—as transporting a medium as there is. An authorial voice remains present in the style of drawing, the level of visual detail, the density of the world being presented. The world is more open to our perusal than in a work of prose, thanks to both the iconicity of the comics and the tabular arrangement of its pages, and more open to perusal than in a film because the movement through time is entirely a function of the reader's activity, rather than an unceasing flow of continually replaced images.[37] Comics really are all about being "in many places at once." Mendelsund, referring to the transparency of the linguistic signifier, writes: "To read is: to look through; to look past ... though also, to look, myopically, hopefully, toward.... There is very little looking *at*."[38] Comics, though, are all *about* looking at. The polydimensionality of the comics experience, then, is more pronounced than for either literature or cinema.

Comics readers are captivated not only by stories but by books—and comics, too, are something more than their textual content. What they *are* is fundamental to what they *say*—the particular concatenation of words, panels, and images on the page is something that resists translation. Comics may be scaled up or scaled down (with varying degrees of success), but the page as material unit remains. And with comics' new respectability has come ever more sumptuous treatments of the book as an aesthetic, tactile object.

The world of comics has been, for the past two decades, deeply invested in the book as a beautiful, satisfying, sensual hunk of inky-smelling goodness. Whether it's Chris Ware's meticulously and variously designed comics, the reproductions of early comics in their original Sunday broadsheet size, DC's lush Absolute Editions and the Library Editions of *Hellboy*, the lovingly reproduced artist retrospectives and sketchbooks, the facsimile "artist's editions" shot from the original art and presented at their full size complete with visible emendations, the gold embossing on Gary Panter's oversized *Jimbo in Purgatory*, the complete reprint collections of newspaper strips as well as such comic book properties as Jack Kirby's Fourth World series—and, yes, the list goes on and on—comics culture is dedicated to the book. Perhaps only children's books rival what the world of comics has put forth in this recent past, which I hope will survive the transition to e-readers, which render color beautifully but which force all these heterogeneous formats to appear at the same scale, with the same (absence of) tactility.

However much comics and cinema differ, the scale of the image matters for both: large screens and large pages are more effective portals to the worlds they present. The Sunday Press commitment to reprinting early color comics in their full size

reshaped our understanding of Winsor McCay, and numerous studies of McCay (including mine) have followed in its wake. The *Hellboy* Library Editions don't operate on that scale, but their reprinting at a larger size proved transformative for me: it's no accident that my conversion experience occurred around those large-scale and weighty Editions. While a regular "floppy" comic book measures 6⅝ × 10¼ inches, the Library Editions are sized more generously at 9 × 12 inches. (This may not sound like a significant difference, but it is. It's more useful to compare their sizes when opened—then it becomes a matter of 18 inches wide versus 13 inches.) They are both sumptuous and readable—comfortable in the hands (with the help of a lap) while enhancing the art.[39]

As with any number of lush comics editions, a large part of the pleasure of opening up these Library Editions is encountering the thick smell of ink. Swathes of black envelop the reader, while the weight of the paper provides no small tactile pleasure as well. While Mignola recognizes that people may be reading his work on iPads or laptops, as far as his creative decisions are concerned, for him "ultimately, it's the book" that matters, and this is borne out by my own experience of reading *Hellboy*. It was the Library Editions that "ultimately" grabbed me and made a *Hellboy* believer of me, and it was the rereading of the Library Editions that inspired much of the thinking in this book. *Hellboy in Hell* is the first *Hellboy* series that, using the Dark Horse app, I initially read on my iPad rather than in either "floppy" comic or collected form, which means that I read it single page by single page—not the way Mignola or God intended. Not until the trade paperback collection appeared did I see the double-pages arrayed properly, with the flow of colors and compositional logics on display. I can only imagine and hungrily anticipate how *Hellboy in Hell* will look when upscaled to Library Edition.[40]

Mignola has other means of directing the reader to the materiality of comics reading.[41] In *Hellboy in Hell,* panels are dedicated to sound effects both dramatic and ambient—and unlike most mainstream comics artists, Mignola letters (or draws—both words are appropriate) his own sound effects, a task usually left to the letterer. The sound made by a denizen of Hell engaged in the endless act of building Pandemonium is a KANG-KANG-KANG that appears across a series of three panels, orange letters on a red background (figures 49 and 50). That same red sits behind the BANG of a gunshot later in the story, while a more subdued DRIP shows up in a small panel, olive letters over blackness. Much has been written about Chris Ware's treatment of pictorialized text, with panels given over to words (captions and sound effects) that draw attention to their status as images, a writing to be looked at as much as read.[42] Mignola is doing the same thing, at least with sound effects, in the pages of *Hellboy,* and while his use of it predates *Hellboy in Hell*—a TING TING of a bell is heard/read/seen in "The Third Wish" (2002), for example—it has become a major stylistic element in this later work (perhaps even inspired by Ware). And Mignola occasionally ends a page with a blank panel, usually black, perhaps mimetic of a character's state of unconsciousness, but also a small rupture of the text, complicating the act of reading and directing attention to the surface of the page.

It seems to me that *Hellboy* is both the product and the producer of something like Rust's "codicological consciousness." As Hellboy engages with paranormal activities that stem from both folkloric and Lovecraftian traditions, the book—the *Hellboy* comic—becomes an extension of imaginary worlds, a place where they are reanimated (as are the Elder Gods that lurk behind many of the stories), and a meeting ground in which they

entwine and ensnare. Mignola builds an archive around Hellboy (and his fellow B.P.R.D. members), one dense with texts and mysterious interconnections.

There have been occasions when Mignola has wanted to tell a story away from the *Hellboy* world, but he realized that "the *Hellboy* world is so much richer. You come up with something and you go 'Yeah that's great, but you know what that's missing … ?'"[43] The rich history of Hellboy enriches other stories; they "become richer and it makes the world [of Hellboy] richer." A good example might be "The Nature of the Beast" (2000). The short story is derived from a sixth-century English folktale about "Saint Leonard the Hermit," who was wounded fighting a dragon and "because of the nature of the place, and the nature of the man, wherever his blood fell … lilies grew." Hellboy, too, fights a dragon in this story, and in the aftermath of the battle we learn—as Hellboy does not—that his blood has a similar effect. These are the "flowers" referred to in Hellboy's conversation with Kate near the end of *Conqueror Worm:* their significance has shifted from an indicator of a man's purity to another clue in the mystery of Hellboy's place in the world. Not to mention the future of that world: the flowers will take up a place in a richer cosmology when, at the conclusion of *The Storm and the Fury* (2010–11), London is decimated as a result of the apocalyptic confrontation in which Hellboy was killed and dispatched to Hell—but amid the ruins, those lilies bloom.[44]

Mignola realized that comics could be a vehicle for personal expression when he produced the Batman story "Sanctum" in 1993. It was the "first time I'd done something that was intended to be something that I'd *read,* and not just something that was easy to draw." Mignola is proudly a reader, one who enters texts, and it's clear that Hellboy is his surrogate.[45]

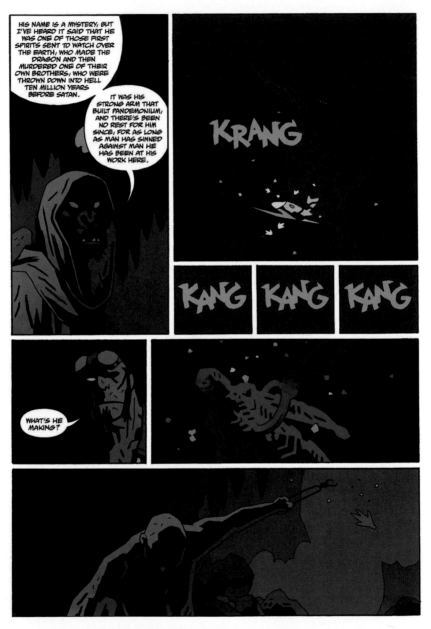

Figure 49. Mike Mignola, *Hellboy in Hell*, no. 2, p. 14. Dave Stewart, color; Clem Robins, letters. Dark Horse Comics, 2013.

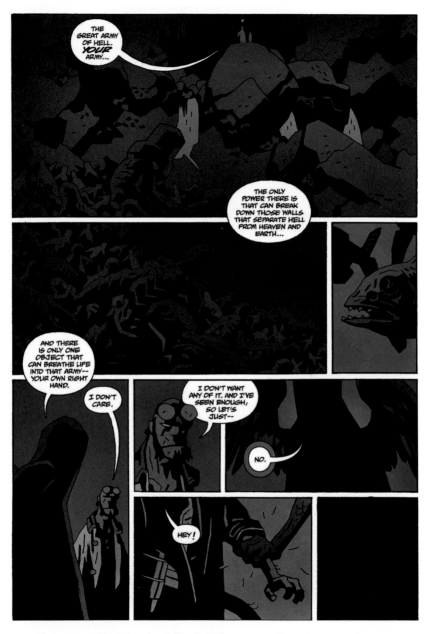

Figure 50. Mike Mignola, *Hellboy in Hell,* no. 2, p. 15. Dave Stewart, color; Clem Robins, letters. Dark Horse Comics, 2013.

Hellboy's task is to enter other narratives and reanimate them. Rust describes the movement "from fictional world to graphic space," and Hellboy becomes the vehicle of that very translation from prose or oral tradition to the animated and animating imaginative space of the comic. He is Mignola's surrogate, and as his saga intersects the conceptual realms of Lovecraft, Clark Ashton Smith, Manly Wade Wellman, and the folkloric traditions of Africa, Appalachia, and Europe, those works and energies are put back into play. But as much as stories, books animate Mignola.[46] What Mignola creates—narratively and, as I'll demonstrate in the following chapter, aesthetically—is indeed a *book* of sophisticated semiotic interplays and material richness. Rust argues that "a physical book held in a reader's gaze would function to 'bring forth' the kind of space Martin Heidegger has termed a 'locale': a space that enables being and thinking." The various texts collected and reanimated by Mignola and Hellboy are part of the construction of this locale—a locale which, in the totality of its effects, could be understood as a "contemplatiff" space that allows a meditation upon the imaginative adventure of reading.

Hellboy at the Gates of Hell

Sculpture, Stasis, and the Comics Page

Comics can be understood as something of a moving-image medium. Scott McCloud's champion analysis, *Understanding Comics,* points to the battery of devices that comics artists have used to depict motion—motion lines, blurring of moving objects or backgrounds, multiples of the same figure indicating the progress of movement within a single panel (see Carmine Infantino's rendering of the Flash), the lines of force and seething energies associated with Jack Kirby, and plenty of others.[1] McCloud's very definition of comics hinges upon movement, upon the change that occurs between one panel and the next. My own writing has explored how early comics mocked the disciplinary aspirations of chronophotography, and I've celebrated the kineticism of the superhero. Recall that Tom Gunning sees comics as a form of mobile address that encourages the reader to "participate imaginatively" in the genesis of movement.[2] Sequence, change, movement: this is the foundation of the medium. Comics emerged as a mass medium in the late nineteenth century, nearly contemporaneously with the cinema, and both spoke to

the frequently observed sense that modern life was, excitingly as well as disturbingly, speeding up. The continuing confluence of comics and the cinema aligns them both as dynamically moving media, each a neat complement of the other.

Hellboy was one of the earliest comics-to-film adaptations in the current superhero genre cycle. Jocular action with epic undertones and unceasing opportunities for all the visual imagination that digital special effects can put forth positions *Hellboy* as seemingly destined for the screen. To date, *Hellboy* has served as the basis of two feature films (directed by Guillermo del Toro) and a few animated ones produced for the DVD market. Mignola has served in some creative capacity for all these projects and seems happy enough with them. Reviews and box office returns attested to the success of both films, and their strong showing undoubtedly helped cement Hollywood's romance with super-hero/comics adaptations.

I, on the other hand, was less enchanted: other than a few lovely "hang out" scenes in the first film (*Hellboy,* 2004) the adaptations are dominated by bombastic action more informed by del Toro's aesthetic sensibility than Mignola's (I will say they have their moments, not least of which is the casting of a pitch-perfect Ron Perlman as Hellboy). What was lost, and what I missed, was Mignola's aesthetic, which epitomizes much that is interesting about comics, and which is more proper to the stasis and status of the printed page. Even del Toro seems aware of this: he has noted that Mignola's "hyperexpressionistic lighting is—I found out—almost impossible to reproduce in a 3-D world."[3] The adaptations actually provide a clear example of the gulf that separates film and animation from comics.

Space, figure, and, yes, even demon-stomping are treated differently in the comics and the films in ways that speak to the

affordances and constraints of both media. Mignola's *Hellboy,* while emphatically remaining an action comic, is steeped in a stasis that could indeed be called contemplative (that "contemplatiff" field discussed in the previous chapter). That this innovative exploration of page, movement, sequence, and figure takes place in the pages of a monster-adventure-action comic is remarkable. *Hellboy* creates something of a ruminative and intertextual space for the reader to occupy.

Getting away from comics' presupposed propensity for movement, change, and metamorphosis reveals how the innate stasis of the medium can be exploited to different ends: narrative, certainly, but also formal, conceptual, and even theoretical. Here, film might yet provide a useful analogy. The field of film studies has recently witnessed a turn to the theorization of stasis: Laura Mulvey's *Death 24× a Second,* Karen Beckman and Jean Ma's collection *Still/Moving,* and Elvind Rossaak's *Between Stillness and Motion* are all indicative of this shift.[4] For the most part, however, film theory proves less helpful than one might want in finding analogous operations in comics; the analyses are, for the most part, deeply connected with the technological bases of the medium: the materiality of the film strip, the automatism of the camera, the illusion of life, the indexicality of the photograph. Stasis in cinema is almost inevitably the *cessation* of movement. Mulvey has gone so far as to argue that the static image is the repressed content of the cinema—the still image partnering with narrative closure to return cinema to its original, inanimate state of discrete, static, images printed on a strip of flexible celluloid. Borrowing from Peter Brooks's work on Freud's *Beyond the Pleasure Principle,* Mulvey writes that "movement, inherent in the death instinct, jostles with its aim to return, to rediscover the stillness from which it originally departed."[5]

Stasis in comics, though, doesn't speak to the same issues or conditions as stasis in cinema. First of all, there is no need to *rediscover* stillness—static images are fully on display from the get go. Nor does the comic image speak to what is no longer there, as in the frozen moment of the photograph. Stasis in the comics is neither the freezing nor the cessation of motion; it is, more simply, the *absence* of movement. How, then, does stasis in comics become significant, and what are the terms of its significance?[6]

Before considering the surprising stillness in Mignola's work, it might be helpful to explore stasis in the works of two other comics-makers. Jerry Moriarty and Chris Ware both stay far from the kind of genre comics with which Mignola is associated. Their work emphasizes the quotidian more than the heroic or supernatural, and stasis in their work is deeply connected to duration, to the experience of passing time.

Moriarty's *Jack Survives,* a series that began appearing in the pages of Art Spiegelman's *RAW* in 1980, uses stasis tellingly.[7] His comics are painted, sometimes more or less monochromatically, other times with full, flat swathes of color (figure 51). The paint freezes the action: whether it's the smoke rising from Jack's cigarette or the action-packed moment when his shoelaces snap simultaneously, the moment is one that is captured and frozen in place—the ephemeral made epic. Paint also directs attention to the surface of the image and its materiality as an image—there's nothing like rendering a word balloon in paint to give it material presence and weight (as Roy Lichtenstein and Andy Warhol demonstrated some decades before). Other elements direct attention to the picture plane: word balloons arbitrarily distorted and/or hidden behind elements of the scenery, a logo that spills over and behind the panels of the page/canvas, white paint that

Figure 51. Jerry Moriarty, *The Complete Jack Survives* (no page number). Buenaventura Press, 2009. Used with permission.

almost but not quite obscures the palimpsest of text beneath it. A pale blue marks the places where white acrylic has been used to cover black ink, preserving the traces of what was before.[8] In some of his later work, the space between panels is eliminated, and radically different perspectives abut one another, undermining the perspectival illusion of any one of them.

Inspired by Moriarty's father, Jack is a middle-aged man with an indistinct past; he wears a hat and tie, seemingly even on weekends, and is, if not a stoic, at least a man who expresses minimal emotion. He is, on a psychological level, somewhat closed to us, and Moriarty entraps him on the surface of the picture plane—there is no depth, no point of access, no behind. This is not implying that Jack *has* no inner life, just that we're not privy to it. Greice Schneider, comparing Moriarty to Edward Hopper, refers to the sense of suspended time in each, a "temporal impression of a time that accumulates"[9] rather than passing in the steady drumbeat of resolved events.

Looking at the heavily worked surfaces of Moriarty's earlier works in black, white, and pale blue, I'm reminded of the animated films of William Kentridge as well as Rosalind Krauss's analysis of them: Kentridge works through continual modifications of a single drawing rather than photographing a series of discreet drawings. Each frame of Kentridge's films bears the traces of the drawing that was and clues to the drawing that will be. For Krauss, this profoundly undermined the plasmatic freedoms that animation traditionally promised. Far from the magical environs governed by the internal laws of "cartoon physics," in Kentridge's work "weight makes its appearance through his sense that this transformative power needs to have a certain drag placed on it, a certain resistance or pressure exerted against its weightless fluidity."[10] Moriarty's technique, with its

thickly laid paint, its palimpsests, and its sense of time in sus-
pension, introduces a similar drag, an inertial power that forces
us to remain in place before the work, with no possibility of
going further.

For Moriarty, it is painting that provides both the material
and the rhetoric to work against the movement of comics, while
for Moriarty's great admirer, Chris Ware, graphic design com-
plicates that same linear momentum. Ware's emphasis on text as
a pictorial form arrests the gaze and transfers language from the
plane of transparent narration to a constituent element of a
world that demands, above all, to be *read*.[11] *Acme Novelty Library*
number 16 (2005), part of the ongoing *Rusty Brown* saga, features
Ware's characteristic typographical display and play as well as
his characteristic treatment of time. The characters are pinned
in place by the geometric precision of Ware's line and the iso-
metric projections of his space. His characters are richly psy-
chologized, but our access to them is not aided by a naturalistic
style of illustration that would encourage us to recognize their
humanity from the first. Instead, Ware's characters are schemat-
ically designed, minimalist machines that the reader must ani-
mate. Their precise, flat forms[12] are situated in panels that are
often carefully balanced across the double-page spread; sym-
metries and even rhythms dominate. Moment-to-moment tran-
sitions are indulged to an almost parodic degree (figure 52). Sta-
sis becomes an existential condition; time seems to expand
infinitely, as does the time it takes for every incident to unfold.

This issue has two stories unrolling simultaneously: most of
the page is devoted to Rusty and his father, a teacher at the
school where much of the "action" takes place, while a small tier
at the bottom relates the overlapping story of Rusty's childhood
friend Chalky White and his sister beginning new lives in

Figure 52. Chris Ware, *Acme Novelty Library*, no. 16. Pantheon, 2005. Used with permission.

Omaha. Ware pays homage to the Sunday funnies of another era, which often paired a smaller "topper" strip with the main strip by the same creator, but here it introduces new problems for the reader, who must choose to either juggle two narratives simultaneously, page by page, or read first one and then the other.

In the more recent *Building Stories* (2012), Ware introduces the trope of a central image around which the double-page spread is organized. Its position in the reading sequence is not clearly marked, but its placement and size are emphatic—these images are emblematic or even allegorical. It is not clear, when faced

with a central image of a room, unconnected by lines, arrows, or gutters, how to proceed through the page that flows around it, and in fact it's largely immaterial in what order one proceeds (this strategy, writ large, obviously informs the box o' comics that constitutes the epic *Building Stories* itself). In the monumental sequence originally produced for the oversized *Kramers Ergot* 7 in 2008, the central spread opens to reveal a life-sized image of a toddler asleep in the center space; other examples in other components include images of money, masks, birth control pills, an old photograph, and the toddler, now a few years older. The image of the child speaks to the central importance the child occupies in her mother's life, but also, and more ambivalently, to the irresistible gravitational pull that she has exerted on the shape of that woman's life.

Hellboy comic books don't speak to the quotidian experiences of child rearing or aging as do the work of Ware and Moriarty; what they emphasize is adrenaline-pumping, demon-stomping *action*. Stasis does not immediately suggest itself as an appropriate aesthetic strategy for *Hellboy,* and yet it, too, is marked by an aesthetic of stillness and stasis.

"The Island," a two-part story from 2005, was produced in the wake of the production of the two *Hellboy* films and was the first story Mignola had both written and drawn in three years. Somber and barren and lush, it's one of his most striking works. Much of the cosmology that underlay the *Hellboy* comics, elements that had been hinted at in earlier tales, were finally explicated. Mignola has written that he was apprehensive about the way the films changed that cosmology, and wanted to reclaim his territory by making certain his version would be "canon" by the time the second film was released. But there may be something more in "The Island" than Mignola acknowledges, and

that is a move to reclaim Hellboy for the *comics,* to reassert his aesthetic upon Hellboy's world—to, in other words, take Hellboy back to the world of the page, and the book.

Contemporary superhero comics have evolved a grammar that derives heavily from action cinema, a style that has, in fact, come to be called "cinematic." "Widescreen" panels (often bleeding off the page); digital coloring with plenty of modeling; heavy photo-referencing (or appropriating) for characters, scenography, and props; abundant Photoshopped effects; and a general tendency toward a kind of photorealism permit an Iron Man film and an Iron Man comic book to share attributes. Mignola's comics have little of this. The colors are largely flat; the palette is more Expressionist than naturalistic; the art remains tidily framed within panel boundaries; the heavily stylized artwork is far from the realist norm; the devices for representing movement, such as motion lines or digital blur, are absent; and dialogue is comparatively minimal.

"The Island" begins decidedly not with a bang (figure 53). Two panels of pale seagulls against a pale sky, followed by a wide panel of ancient, wrecked ships. Sky and sea are unmarked areas of negative space, and only the darker grays of timbers and hulls assert themselves. The next panel brings us closer to one of the ships, deep violet hues draw the eye, and an inset caption contains one enigmatic word, "Hellboy...." The bottom panels give us Hellboy himself, seemingly adrift beneath the waves, and a close-up of a pendant in the shape of a head, stained a dark blue and set against a black background. The reader may assume spatial contiguity—the darkness seems the darkness of the sea—but this isn't certain. Captions recapitulate a conversation the reader might remember from an earlier tale: "Where are you going?" "Africa." "And after that?" The question is unanswered.

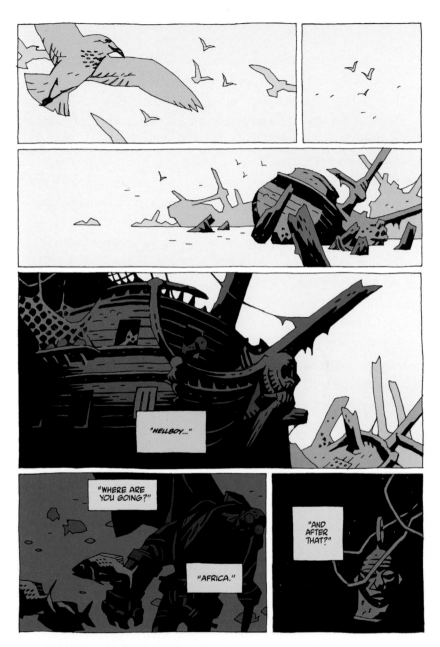

Figure 53. Mike Mignola, *Hellboy:* "The Island," no. 1, p. 1. Dave Stewart, color; Clem Robins, letters. Dark Horse Comics, 2002.

The next page brings us back to one of the shipwrecks (figure 54). "Hellboy..." is repeated. A narrow panel returns us to Hellboy, yellow eyes visible now and open, looking upward. The last panel on the top tier frames an almost abstract interplay of rocks, debris, sky, and sea. "Wherever the wind blows" seems to be the belated answer to the hanging question of the previous page. Two vertical panels present the submerged portion of the wreck, with the skeletal remains of its crew trapped eternally below. The final panel is roughly two-thirds of the page tall and two-thirds of the page wide: seen from shore, the distant figure of Hellboy emerges from the water, his red body and brown coat the only relief from the grays and blacks of this Sargasso.

If there is one thing missing from this opening tableau, it's movement. Not only is the action about as minimal as could be, but the myriad cues that comics use to indicate motion are absent—everything is quite still. Indeterminate time passes, and sequentiality itself is presented in a weakened form: those two vertical panels of the undersea wreck exist in no evident temporal relation to the "action" of the scene. They have been there; they continue to be there. That there are two panels would seem to indicate some diachronic movement, but a closer look suggests that this might be a single image, bisected by an arbitrary panel division—a synchrony instead.

This is all a far cry from, say, the finale of the second *Hellboy* movie (*Hellboy and the Golden Army,* 2008), as a digital multitude (70 × 70) of mechanical demons assault Hellboy and company from all directions.[13] Explosions, metallic clanking, assorted thuds, gunfire, and endless crashing define the sequence. The camera flies and glides amid the action—all is kinetic and sonic overload, a sensory immersion with its own attendant pleasures. Admittedly, I'm comparing the somber start of one story with

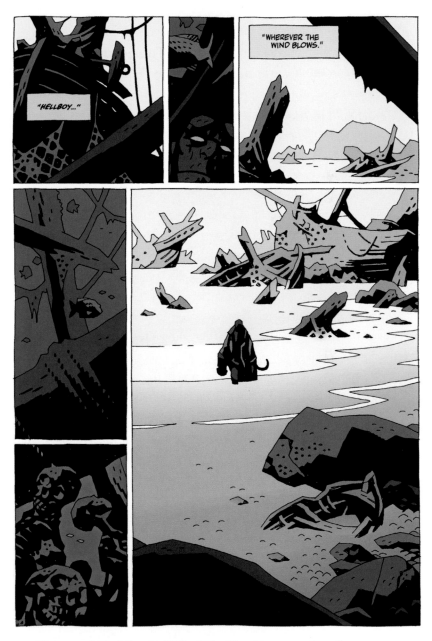

Figure 54. Mike Mignola, *Hellboy:* "The Island," no. 1, p. 2. Dave Stewart, color; Clem Robins, letters. Dark Horse Comics, 2002.

the exuberant climax of another, but as I'll demonstrate, Mignola's action scenes feature many of the same elements.

It would be unhelpful, not to mention inaccurate, to simply state that "The Island" is less "cinematic" than the *Hellboy* films. But the style of the comic and the style of the film are not congruent. One is all flash and quickness, the other is measured, perhaps even stately. The viewer is propelled through the film scene but detached from the comics sequence. There are film styles that would be more appropriate to Mignola's *Hellboy* pages—after all, the story begins with a couple of shots that establish atmosphere before gradually revealing setting, followed by character, and, on subsequent pages, by action. Perhaps, given those two nonsequential panels on the second page, the ideal director to transfer this scene to film would not have been Guillermo del Toro, but rather some alternate-world Yasujiro Ozu.[14]

Or perhaps *Hellboy* would lend itself to the *Sin City* (2005) treatment, wherein directors Robert Rodriguez (and, in one sequence, Quentin Tarantino) lovingly recreated the aesthetics of Frank Miller's comics. Shots were both longer and more static, movement more measured, physiognomies exaggerated à la Miller, and, as in the original comics, the palette was restricted to black and white with splashes of digitally added color. It's tempting to imagine a lustrously red Hellboy moving through his worlds of darkness, but it must be said that *Sin City* and its imitators *evoke* the stasis and stillness of the comics rather than give us the thing itself; an approximation of and homage to the source material that nevertheless barrels along at a rate of twenty-four frames a second. The viewer is no more able to take in more than a single image or linger longer on any particular one than in any other film. As an homage and a stylistic experi-

ment, *Sin City* works wonderfully; as a model for cinema or as a comics equivalent, less so.

In considering stasis in Mignola's comics, I guess I might as well begin with the death drive—the character is called "Hellboy," after all. If stasis = death, and if the manifestation of stillness speaks to the desire to return to an inanimate state, I don't have to look very far to find this in *Hellboy*, for *Hellboy* is steeped in death. He's the spawn of a demon; his destiny is to bring about the end of everything; the mise-en-scène is abundant with corpses, cemeteries, and tombs; and such inappropriately animate figures as zombies, vampires, and the resurrected provide the action. Kinetic battle sequences, often to the death, are followed by stases that are often closures (just as in nearly every action comic book out there).

But there are more idiosyncratic evocations of stasis in *Hellboy* that allow us to reflect more usefully upon the medium of comics and its possibilities. Rather than working within or around a cinematic paradigm, I think that Mignola draws heavily on sculptural principles (his aesthetic is further informed by German woodcuts, Japanese prints and manga, Renaissance stained glass, and medieval iconostasis).[15]

One finds in Mignola's art, to a degree unusual in comics of all sorts, a de-emphasis on line in favor of mass (see figure 1 in the Introduction). Jack Kirby is an acknowledged influence on Mignola, and indeed some of this emphasis on mass comes from there, but the battle sequences in Kirby's comics are also riots of force lines pulling the eye in all directions (figure 55). To take another example from genre comics, the combination of line and expressive brushwork in Gene Colan's art on such titles as *Daredevil* or *Tomb of Dracula* creates a less frantic, more sensuous movement that subtends or structures the whole page—his

pages are as fluid as Mignola's are static. Figures in comics from Kirby and Colan to Charles Schulz and Chris Ware are defined by outlines, while in Mignola's work blocks of color do more to define areas and bodies. To be clear, Mignola doesn't eschew the outline, but it does less work than in the art of many of his peers, and this contributes to what we might see as a *sculptural sensibility* that emerges in the work.

A cursory glance at a pile of *Hellboy* comics quickly reveals Mignola's investment in the sculptural.[16] Funerary sculpture litters the landscape, and cover images often favor posed tableaux replete with gravestones, sepulchers, and sculpted figures (figure 56). Small marks pepper the surfaces, be they stone, cloth, or flesh, endowing the whole world with a chiseled quality.[17] Mignola pays sustained attention to the figuration of a powerful body, one that embodies physical force and dynamism in a static pose. And in the action scenes, backgrounds and subsidiary elements vanish, focusing attention on what the art historian Alex Potts refers to as an "abstract ideal of formal purity" in which expressivity is entirely focalized through the figure's form and attitude.[18] This claim could be extended to much superhero action art, perhaps, but here the treatment of color, absence of motion lines, de-emphasis of line in general, reduction of background detail, and the sense of forms frozen mid-movement lends itself particularly well to the comparison.[19] The blocky figure of Hellboy seems especially sculptural, carved from some mysterious red stone—more statue-*like* than *statuesque* (the massive Hercules figure from Antonio Canova's *Hercules and Lichas* [1796] makes an apt comparison). But sculpture serves as a useful touchstone even moving beyond the posture of bodies and their placement among sepulchral forms. Here we must turn our attention to Mignola's construction of the space of the page, and

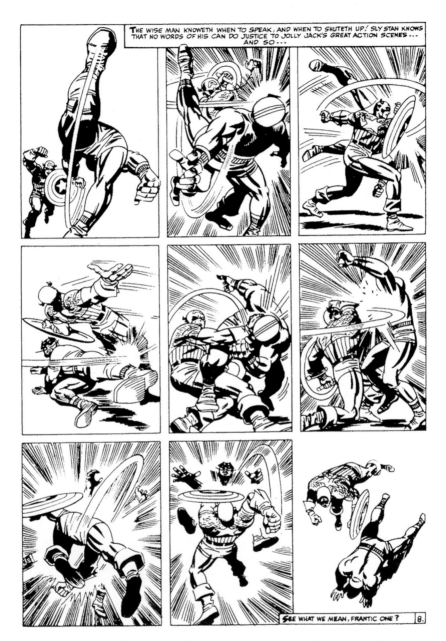

Figure 55. Jack Kirby, *Tales of Suspense*, no. 85, p. 8. Frank Giacoia, inks; Sam Rosen, letters. Marvel Comics, 1967.

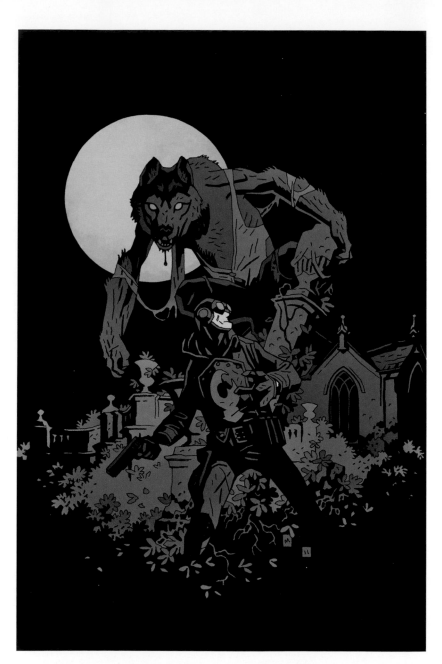

Figure 56. Mike Mignola, *Lobster Johnson: The Burning Hand,* no. 4, variant cover. Dave Stewart, color. Dark Horse Comics, 2012.

the significance of the page in comics, before returning to a fuller consideration of the sculptural imagination at work.

Mignola's pages nearly always hew to a grid formation, but almost never to a symmetrical grid of equally sized panels. Look back at any of the pages from *Conqueror Worm* or "The Island." The balance among panels of different sizes could be understood as an elaborate stack of elements balanced within the ultimate bounding unity of the page, or one might go a step further and suggest that the space looks to be *carved from* the block of space represented by the blank page, or as blocks cemented into place to *construct* the page. In both cases, the page reads as something built.

As noted earlier, the comics page can be encountered in two ways: as a planar, diachronic form and as a tabular, synchronic unity. The reader moves back and forth between these modes of apprehension. Mignola's pages lend themselves to the synchronic view more than most: they invite a contemplation of the whole before (and/or after) one has absorbed the narrative content of the scene. Elaborate balancing of such elements as panel shape and size; a unifying palette; minimal use of speech balloons, motion lines, or other emanata; and a nonrealist flatness all invite an apprehension of the page as surface. Forward movement is thus balanced, if not exceeded, by the stasis of the page as a synchronic unit.

This is furthered through the use of Mignola's most characteristic structural element. Mignola's pages are often punctuated with small panels that contribute nothing to the action or forward movement of the narrative. Usually these are close-up views of elements of the mise-en-scène: a crumbling stone face, a bird on a branch, an array of lilies. They are often foreboding: the space is not completely known, and danger could come from

any direction. The stasis they present within the narrative, then, is a pause, literally a moment of suspense. What's more interesting, though, is what they do to the process of reading. From the days when Winsor McCay numbered the panels of *Little Nemo in Slumberland,* comics creators have struggled with effectively guiding the reader's eye across the array of panels in the proper sequence.[20] The placement of speech balloons and captions, the protocols of reading directionality, the use of overlapping panels—all these can dictate sequence so that the reading flows easily. When in doubt (or when Chris Ware is importing diagrammatic conventions), one can impose arrows and other external cues, but as comics protocols have become codified, the need for such brutish devices has receded. Rare are the comics that are not arranged to overdetermine the proper sequence of reading. Mignola's, though, do it all the time.

I will call Mignola's inserted panels "pillow panels" in homage to the similarly inserted static shots of inanimate (or minimally animate) objects that Noël Burch dubbed "pillow shots" in the films of Ozu.[21] The question becomes: *When* are these pillow panels? It's difficult to insert them into the narrative sequence— their placement seems more decorative than narrative. They seem to exist apart from sequence and instead are simultaneous with the unfolding narrative events. The seventh page of "The Island" is a particularly good example (figure 57). Hellboy is realizing that this night's drinking companions are, er, dead and desiccated. Taking in the scene, he grabs the bottle of rum and seemingly heads out of the room (he is exiting the panel and page, in any case). The narrative panels here include the large half-page image above, with Hellboy discovering that his buddies aren't what he thought they were; the central panel displaying the RUM label; and the final panel (the eighth) where he

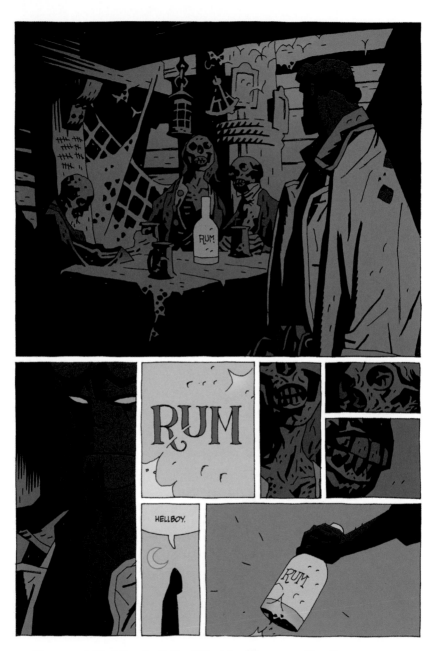

Figure 57. Mike Mignola, *Hellboy:* "The Island," no. 1, p. 7. Dave Stewart, color; Clem Robins, letters. Dark Horse Comics, 2002.

grabs the bottle. The panel to the left of the RUM is a long, narrow image of Hellboy; the three small panels arranged in a grid to the right of the RUM give us some close-up details of his decayed compadres. No new narrative information is conveyed in any of these panels. There is a mysterious panel below the RUM with a crescent moon and a shadowy figure intoning, "Hellboy." This panel is not part of the rest of the scene, and it's unclear when or where it is situated—is it a foreshadowing? A memory? Imagined?

That mysterious image aside, what does the page accomplish? It's atmospheric, most certainly, introducing and emphasizing a weary, bleary scene of death and decay. On a narrative level, it effectively communicates Hellboy's increasing alienation from the world and confusion about his role within it. But what's most striking is the way that Hellboy's ennui is figured for the reader by a sequence that refuses its status *as* sequence. The forward flow of the comics reading experience is blocked, the only anchor point a bottle of (presumably well-aged) RUM. The layout of the page is mimetic of Hellboy's experience, an experience the reader, bereft of definite guidance, can share. Stasis thus operates narratively (Hellboy's ennui), formally (the absence of cues of movement), and structurally (the disruption of the forward momentum of the narrative). There is, then, a strange and strangely fascinating stasis operating in Mignola's *Hellboy* comics that extends from the layout of the page, through the use of color and the "flat" style of drawing, to the depiction of bodies that are in motion but deprived of the codes of movement characteristic of comics.

To be sure, the sequence could easily be read linearly: establishing shot, Hellboy looking, RUM that he's looking at, a series of cutaways to the faces of his buddies, a mysterious something

that presumably foreshadows or recalls another scene, and Hellboy's hand grabbing the bottle as he exits the scene. It could certainly serve as a storyboard for the film version. But just because it *can* be read as a linear sequence doesn't mean that it *is*. I showed this page to a group of student filmmakers who began trying to figure out whether the small detail panels are meant to be read as temporally brief or extended—assuming, with some justification, a correlation between panel size and shot length. Of course, the answer is that those images are neither "long" takes nor "short" shots —they're just *there*. They are there before one begins to read the page, and they remain after one has finished.[22]

While comics appear to give us an atomistic conception of time as something that can be broken into discrete units, they actually present an interlacing of multiple temporalities. Motion lines imply the time that the movement takes; and even if the characters are frozen in place, it's evident that their speech must be taking time; a longer panel often implies extended time—a beat in the rhythm of the page; and the time elapsed between one panel and another can be infinitesimal or cosmic. As Tom Gunning has stated, "Rather than ignoring time, comics open up new modes of representing it."[23]

In the cinema, time leaves its indexical trace upon the filmstrip (or other material substrate), a duration that is then recreated through projection, where it becomes an analogous (or identical) lived time for the spectator. Comics can't do this, but duration makes itself known nevertheless. Gunning has further emphasized—and I completely concur—that comics do not just represent time, they *take* time: the time of reading is thus the relevant "lived time" in play around comics.

Some of the terms deployed by Gilles Deleuze in his books on cinema seem appropriate to comics. "Movement images" are

easily found in any action genre, most evidently in the muscular action sequences of sensorimotor propulsion found in any super-hero comic. But they are found as well in the three- or four-panel comic strip, with setup and punchline dependent upon linearity, causality, and closure. And yet "time images" figure into the comics as well. The archetypal scenario with Linus and Charlie Brown standing at a wall in some indeterminate location, exchanging words and sharing meaningful but immeasurable pauses, gives us what Deleuze might label an any-space-whatever and any-time-whatever, a strategy utterly appropriate to the rhythm and tone of *Peanuts* and one put to good use by such later creators as Chris Ware and Jason.[24] These images have duration, as do the images on the opening pages of "The Island." The panels do not represent moments of frozen time, but rather moments of *implied* time.

A distinction thus needs to be made between stasis and stillness, though both are at work in "The Island." All the images are static—that's the sine qua non of the comics—but some present what appear to be frozen moments in time (a panel during a battle scene, for example) while others present us with images of duration (the cluster of dead heads).

Back to the RUM. The page follows a three-page sequence of Hellboy drinking with his boon companions. The color outside the window is a deep, chilly blue, but the yellow light of fiery flagons of rum gives the interior a warm red and orange glow that doesn't quite keep the shadows at bay. Hellboy looks out of a reddish window at a bluish exterior, then turns back. The warm colors are gone, Hellboy's dulled red visage the only vaguely warm color. On the following page, with the RUM at its center, all trace of warmth is gone, Hellboy now the only vivid presence, his attention now on the dregs of the RUM, which not

only occupies the center of the page but is its brightest presence. Boisterousness is abruptly replaced by the silence of death, and Hellboy's feeling of being unmoored in both time and place is manifest. The page itself constitutes a time image: minimal action occurs; space and time become oppressive; and while duration may be indeterminate, it is undeniably present. Here the stasis of the comics page and the stillness of the scene complement one another.

The first panel sets the scene, and the next five present details of the tableau from different perspectives—again, one might see storyboarding at work, but it would be as easy to understand this space as a three-dimensional area through which the reader/viewer moves as around a sculptural object. Herder has written of the engagement with sculpture as fundamentally mobile; the viewer "glides around" in a scenario where no single point of view will suffice. The relevance to the engagement with a comics page is evident, especially in pages as still as this one.[25] Mignola has constructed a contemplative space in which the reader is encouraged to, not simply dwell, but glide around—despite the lack of action.

But the fact remains that *Hellboy* is no sterile exercise in stasis, but an action comic featuring a big red demon hunter who pounds the heck out of monster after monster. Full pages of one, two, or three panels are given over to Hellboy in midair—slugging, for example, a cyborg gorilla to an accompanying BOOM! sound effect (sometimes he *says* "BOOM!"). Yet, even here, as on this page from *Conqueror Worm* (figure 58), there are none of the cues that commonly connote movement in comics. While there's enough going on for any action junkie, Mignola maintains a dispassionate formal rigor in his approach to the page. The placement of the word balloons and sound effects on the

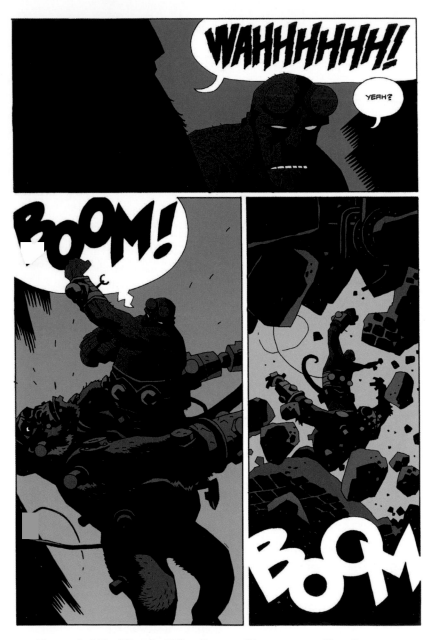

Figure 58. Mike Mignola, *Hellboy: Conqueror Worm*, no. 2, p. 31. Dave Stewart, color; Pat Brosseau, letters. Dark Horse Comics, 2001.

page have a balance and precision that Roy Lichtenstein would envy: a screamed "WAHHHHHH!" occupies the top right of the page, Hellboy's shouted "BOOM!" the center left, and a final BOOM at the bottom right (rendered in white rather than the black of the words above) form an elegant zig-zag that not only moves the eye down the page but is most satisfying to just contemplate in itself. The page also moves from a close shot of Hellboy to a medium full shot to a more distant view as Hellboy finishes off his adversary ("So much for *you*," he comments on the next page—*Hellboy* really can be defined as the intersection of an aesthetic and an attitude). The page works as narrative and as design. It hums with kinetic energy while maintaining a formal stasis.[26] (Mignola may be drawing fewer comics lately, but his recent work is, if anything, more stylized and more boldly abstract, as that three-panel page with Hellboy crashing down in the abyss in the first issue of *Hellboy in Hell* demonstrates; see figure 38 in chapter 3.)[27]

What we find in Mignola, then, is an ostensible classicist—giving us superheroic bodies in action, presented in service to a narrative propelled by enigmas, investigations, and slugfests—who's behaving a lot like a modernist. The treatment of page as page, the attention to surface, the de-emphasis on linear sequence, the move toward abstraction—all of this is less traditional than innovative (or we might say that it recovers some of the modernist impulse found in the earlier work of McCay, Herriman, King, and Feininger).[28] A traditionalist who is actually something of a modernist—in the scholarship on sculpture, one finds Auguste Rodin referred to in similar terms. Begging your indulgence, let's see where this comparison can take us.

The Stanford University campus is lousy with Rodin sculptures, from studies of hands to the full-size *Gates of Hell*. My

colleagues and I tend to give them a wide berth. Some have just lived with them for too long, others are uninterested in Rodin's mimeticism or his return to classical principles, some think we got stuck with inferior casts, and most of us are just sick of all the tourists. But Rainer Maria Rilke's writing on Rodin identified an intriguing tension between movement and its subsidence; he found in Rodin's sculpture something approaching abstraction. "When we cease to envisage" these statues, explains Alex Potts, "as actors caught up in a drama, then we might find that the represented movement of the figures is absorbed by a 'circulation' of movement in the surfaces that has a certain undisturbed 'calm' and 'stability.'"[29] For Rilke, in other words, another way of seeing a Rodin was possible in which dynamic movement and change would yield to an experience of soothing balance as one contemplated the play of light and shadow instantiated by the sculpture's contours (figure 59). Potts, following Rilke, refers to "a still state of absorption at odds with the restless animation of the anxieties and drives rendered by the drama depicted."[30] Forgive me, but something similar is at work in *Hellboy*. The rendering of muscled bodies, mid-movement, becomes, when looked at differently, a play of sensuous abstractions of light, mass, color, stillness, and balance. Figures emerge from the negative space of an inky blackness as they emerge from the negative space of Rodin's pediments.

Rosalind Krauss's extended discussion of the *Gates of Hell* can shed further light on Mignola's strategies, given her attention to issues of spectacle, narrative time, surface and depth, and corporeal identification (not to mention, you know, *HELL*). But we have to begin with the major proviso that Mignola's work is neither as radical nor as opaque as Krauss argues for Rodin's.[31] It *complicates* rather than *confounds* the experiences of reading and seeing.

Figure 59. Auguste Rodin, *Falling Man*, 1882. Cantor Arts Center at Stanford University, Gift of the B. Gerald Cantor Collection.

Figure 60. Auguste Rodin, *The Gates of Hell*, 1880–1900. Cantor Arts Center at Stanford University, Gift of the B. Gerald Cantor Collection.

Krauss argues that while most nineteenth-century reliefs organized themselves for the eye so as to permit a linear narrativity to emerge, Rodin's "impulse was to dam up the flow of sequential time," a strategy that resonates with Mignola's arrangement of panels on the page. *The Gates of Hell* "resists all attempts to be read as a coherent narrative," she argues; it instead displaces viewer attention onto issues of process and production.[32] "Space in the work is congealed and arrested; temporal relationships are driven toward a dense unclarity (figure 60)." Further, the "almost perverse vein of opacity" in Rodin's *Gates* figures "aborts" the usual communication, in sculpture, "between the surface and the anatomical depths." Unable to refer these postures to memories of our own, "we are left with gestures that are unsupported by appeals to their own anatomical backgrounds, that cannot address themselves logically to a recognizable, prior experience within ourselves."[33]

Rodin creates an encounter that constitutes a powerful experience in the moment, rather than one that evokes the familiarity of our own corporeal past. Thus, the viewer is "intellectually and emotionally dependent on the gestures and movements of figures as they externalize themselves. Narratively ... one is immersed in a sense of an event as it coalesces, without the distance from that event that a history of its causes would bestow."[34]

I've already pointed out how Mignola works to "dam up the flow of sequential time"—that is, the time of reading. The pillow panels and panel clusters complicate linear sequence. I'd also say that Mignola short-circuits direct corporeal identification from the start, by concentrating on the physicality of nonhuman characters that include a demon, a fish-man, and a homunculus, as well as human characters with hugely different corporeal experiences (Liz Sherman, a firestarter). These are

bodies that move differently, that exist in a different relation to the world than (most of) the rest of us. And while Hellboy isn't invulnerable, his body can take an awful lot of punishment: we see it engulfed in flames, falling from great heights, wrestling monsters, and wrestling more monsters. Expressivity trumps plausibility, and while we can see something of ourselves in Hellboy, corporeal identification is not, I think, Mignola's goal. Hellboy's is a body made to be taken to, and almost beyond, its limits. There is hardly a story in which that body is not pushed to extremes, in which the postures don't perform an exaggerated corporeality that we must understand on some level other than identification through our own embodied knowledge.

A six-page battle in "The Island" that pits Hellboy against a giant wormy-caterpillary beastie absorbs the reader in an experience that unfolds in the present time of reading. A page turn exposes a largely unsuspecting Hellboy to the emergence of this hulking guardian that's shown in a large panel on the top two-thirds of the page (figures 61 and 62). The final three panels on the page give us Hellboy struggling to regain his equilibrium. The next page of seven irregularly sized panels allow Hellboy the discovery of a sword ("All right!" he yells, "I'm god damn mad *now!* *Come on!*").[35] The scene is drenched with an almost palpable yellow that serves as both an abstract ground for the battle and an aesthetic focus for the reader. The corporeal limits of the monster are never revealed, and it's never clear exactly what Hellboy is standing on (when he's standing—he's also variously posed as flying upside down through the air and being punctured by one of the beast's sharp legs). In other words, there isn't much ground here for identification on the basis of our corporeal memory; what we have instead is an intensely involving experience that occurs in and through an act of aesthetic engagement, which in comics we call "reading."

Of course, unlike most of Rodin's figures, Hellboy is immersed not only in yellow goo, but in a *narrative*, as he and the beast slug it out across several pages. Narrative—with its implication of time past or passing—intrudes in a way that it just doesn't for *The Gates of Hell*. But (and this is a big but) this narrative is anything but linear: the sequence is punctuated by some of the same interruptions/disruptions as the opening pages of this same story (figures 63 and 64). "Where are you going?" is asked yet again, and a pillow panel of an African shaman recalls earlier stories. In fact, of the thirteen panels arrayed across these two pages, only seven, or perhaps eight, depict the struggle that's occurring in the here and now; the other panels reference other characters, other moments, other places. The connections among these images are, to say the least, oblique—or perhaps we should say, following Krauss, "opaque" (and that suffusing yellow contributes greatly to the scene's opacity). And, one could also ask, is there some relation between Mignola's fondness for nonchronological stories and his use of nonlinear narrational devices?

There is a formal complexity here marked by fragmentation, enigma, and incompleteness—something approaching an illegibility—and this is replicated within the narrative structure itself. For if "The Island" will finally offer up some answers to long-standing mysteries in the Hellboy series—the origin of his right hand (The Right Hand of Doom) will be revealed—more enigmas remain. Krauss noted of the *Gates* that one was "immersed in a sense of an event as it coalesces, without the distance from that event that a history of its causes would bestow."[36] Even after twenty years, Mignola has yet to reveal the complete "history of causes" that underlies the *Hellboy* mythos, opting instead for immanence and immersion, a "dense unclarity," if you will.[37]

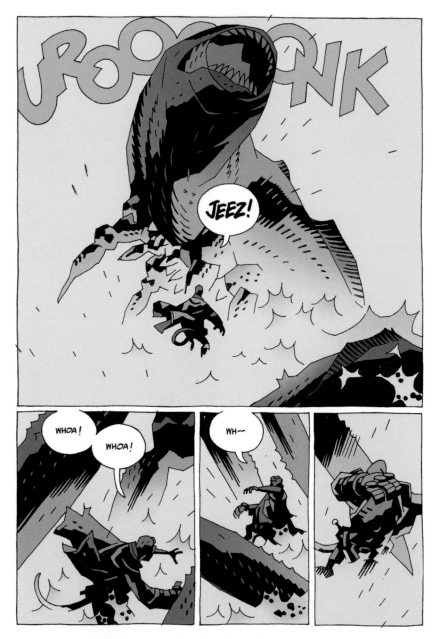

Figure 61. Mike Mignola, *Hellboy:* "The Island," no. 1, p. 18. Dave Stewart, color; Clem Robins, letters. Dark Horse Comics, 2002.

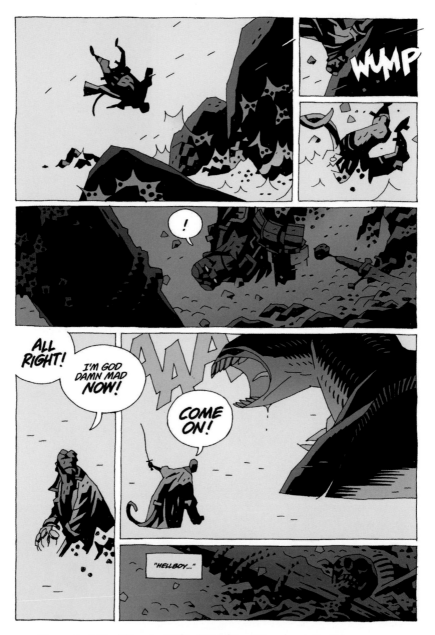

Figure 62. Mike Mignola, *Hellboy:* "The Island," no. 1, p. 19. Dave Stewart, color; Clem Robins, letters. Dark Horse Comics, 2002.

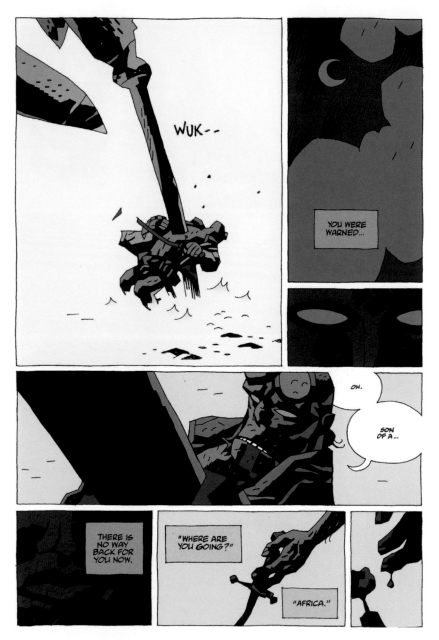

Figure 63. Mike Mignola, *Hellboy:* "The Island" no. 1, p. 22. Dave Stewart, color; Clem Robins, letters. Dark Horse Comics, 2002.

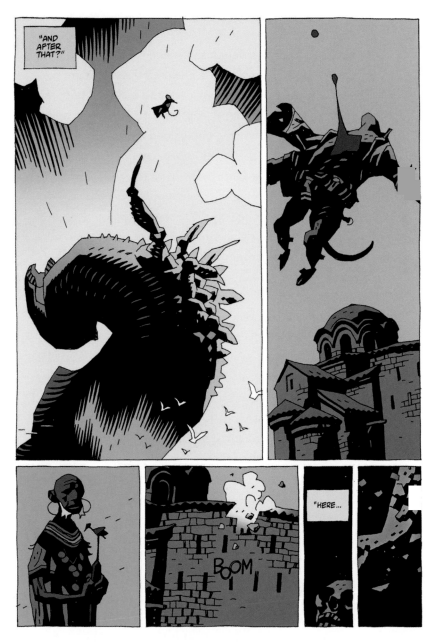

Figure 64. Mike Mignola, *Hellboy:* "The Island," no. 1, p. 23. Dave Stewart, color; Clem Robins, letters. Dark Horse Comics, 2002.

As I noted above, Krauss argues that some of the figures destined for the *Gates of Hell* make little anatomical sense or are rendered so incompletely as to deny that "communication" between "the surface and the anatomical depths,"[38] and here we might note the absence of interiority—understood now as psychological rather than anatomical—in the *Hellboy* comics. Comics have emerged as a singularly powerful vehicle for the communication of subjective states, and some of the medium's most characteristic forms are uniquely suited to that communication. Running narration in caption boxes places us firmly in a first-person perspective; thought balloons literally anchor thoughts to the character that thinks them; nonverbal emanata demonstrate that a character is dizzy, drunk, sleeping, astonished, unconscious, or in love. Mignola tends to keep us on the outside, however, denying us any privileged access to Hellboy's interior state (figure 65). Mignola quickly moved away from first-person narration: "I'd much rather have a silent shot of Hellboy looking at something and let the reader imagine what he might be thinking."[39] Such a strategy, to invoke Krauss-on-Rodin once more, "leaves one intellectually and emotionally dependent on the gestures and movements of figures as they externalize themselves."[40]

Ultimately, what Krauss finds enacted in the *Gates of Hell* is the collision, or collusion, of two senses of process that are played out upon the surface of the work/body: "the externalization of gesture meets with the imprint of the artist's act as he shapes the work." One doesn't find this struggle in Mignola's drawing—there is less of a sense of material and corporeal resistance in Mignola's line than in Rodin's casts—but it speaks nicely to the diegetic struggle that undergirds Hellboy's history: his apocalyptic destiny versus his willful rejection of that destiny. It makes perfect sense that the reader doesn't have access to

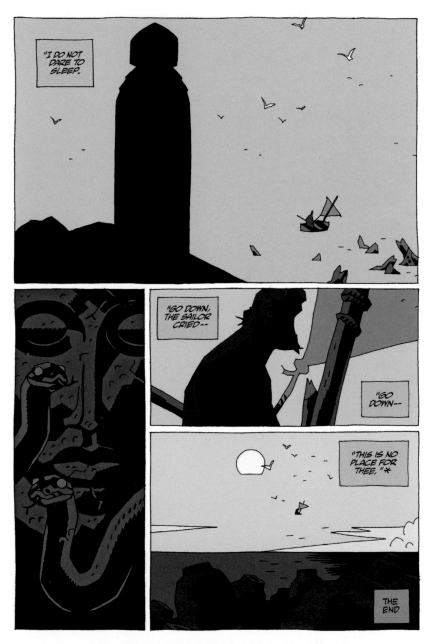

Figure 65. Mike Mignola, *Hellboy:* "The Island," no. 2, p. 30. Dave Stewart, color; Clem Robins, letters. Dark Horse Comics, 2002.

Hellboy's innermost thoughts and being—the narrative entirely depends upon his refusing that access to *anyone,* thereby retaining a sense of privacy and independence. His is a closed form, and his state of being is indicated almost solely through posture and gesture.

So the sculptural analogy proves surprisingly useful in relation to Mignola's accomplishment. But let's not forget that Hellboy is *not* a statue (though there are collectible Hellboy statues), he's a *comic book character.* Beyond aesthetic accomplishment for its own sake (which I've got nothing against), why should the action adventures of Hellboy be rendered in such rich but somewhat counterintuitive terms? I think it has to do with what I've been calling the "bookishness" of *Hellboy. Hellboy* is not a movie-in-waiting or a future miniseries; it's not seen to best advantage on a laptop screen or an iPad—it's a *comic book,* which is to say a bound work on paper. Originally a two-part comic book, "The Island" was reprinted as part of the *Strange Places* trade paperback collection (2006), and more recently (and most alluringly) as part of the third volume of the oversized and sumptuously printed Library Editions (2009).

The flatness of the compositions and the flatly applied colors, the adherence to the comics grid, the motionless figures given life by the imaginative engagement of a reader—all contribute to the "bookishness" of *Hellboy.* It might also be worth pointing out that the *Hellboy* comic books are free of advertisements within the span of the story—most superhero comics put ads on nearly every other page, repeatedly interrupting the reading experience. Thus, what one encounters in reading *Hellboy* is not just one impeccably composed page, but two—and it's quite obvious that Mignola has fully considered the way the two pages work together.[41] In many comics, the page seems like the basic

unit of composition—for Mignola it's the double-page, as the examples scattered throughout this book demonstrate. The reader is thus allowed to sink into a *Hellboy* comic, to engage with it and play by its rules across its twenty-or-so pages, and this effect is amplified in the upscaling to trade paperback (around 150 pages) or hardcover Library Edition (over 300 pages). Recall that for Mignola, "ultimately, it's the book" that matters, that constitutes the proper object, the proper world for Hellboy. Mignola began our conversation by saying, unprompted, that when he's finished doing stories with the character, he wants to leave Hellboy someplace with a really great library.

The book is therefore Hellboy's natural habitat, and if this is so, then we can also connect the aesthetics of stasis and stillness to a ruminative mode of reading. The pillow panels operate as pauses, blockages to linear flow, encouraging the eye to move more slowly and less predictably. For Mignola, the book constructs a world, and he wants the reader to—as Benjamin put it—give herself over to "the soft drift" of the work rather than rush headlong through its "swirling" spaces—the reader should indeed be "covered over and over by the snow of his reading."

Earlier, I noted that what we might call "the film theory of stasis" proved less than helpful in considering the stasis of the comics. But there is one concept, an early one, that does carry over from film to comics: the irruption of spectacle that brings narrative to a halt. Of course, Mulvey's example of gendered spectacle in Hollywood film is the ur-text here, and there are those writers (such as myself) who have spearheaded the "return to the cinema of attractions" around issues of special effects, musical numbers, and the like. Laura Mulvey's and Tom Gunning's germinal essays both theorize spectacle as at odds with narrative, as narrative's other, and I have often celebrated how

spectacle breaks with the linearity, causality, and closure of classical narrative models.[42] Comics have the splash page (often an action scene) or—and these are the ones I lived for as an adolescent—those double-page spreads doled out by Jack Kirby and Jim Steranko. Mignola has plenty of such arresting images—see the aforementioned large-paneled pages of Hellboy either whomping or being whomped by some virulent, violent thingie. But it's also interesting to see that the pillow panels—which function, at least in part, to push back against the relentless linearity of sequential art—are in every sense the least spectacular elements on the page. They are miniature rather than giant, static rather than kinetic, subdued rather than insistent. The disruption they perform is small and brief. I'm sure that no *Hellboy* reader has experienced head-scratching confusion in the encounter with a small inset detail. Nevertheless, they do break the flow and wreak some havoc on comics' headlong *rush,* encouraging the eye to, however briefly, linger.

It could be argued that the pillow panels conform to McCloud's "aspect-to-aspect" transition, which "bypasses time for the most part and sets a wandering eye on different aspects of a place, idea, or mood."[43] But this still presupposes that the reader processes these panels in a predetermined linear sequence, while I'm proposing that in the page presenting Hellboy's encounter with those deceased drinkers, Mignola solicits a gaze that grasps the page as a whole—obviating, to some extent, the need to move through each panel in its turn. Those three panels on the right, with Hellboy's moldering comrades, work as a cluster rather than a sequence, and things like clusters have no place in McCloud's linear model of reading (see figure 57).[44] Tom Gunning's contention that comics encourage varied practices of reading that do more than simply coexist, that actively

complicate each other, comes closer to what I'm describing here.[45]

Mignola has acknowledged his interest in Japanese comics, and manga are replete with images that break from the action but do something more than simply mark a scenic transition. In Mitsuru Adachi's baseball manga, *Cross Game* (2005–10), for example, an atypically lush realism renders places of recurring significance to the main characters and also marks the passage of seasons as they, and we, move through those endless years of high school. These images speak to a different experience of place and time, one that wells up recurrently but inconsistently; it's an experience latent in the landscape, though not always experienced by the characters themselves.[46] Mignola's images don't offer up an equivalent shift in the aesthetic register, and they tend to be narrower in scope than the scenic long shots of manga. Ultimately, the manga images speak more to an experience of being in the world, whereas Mignola's connect us more fundamentally to the aesthetics of the work and the act of reading. Narratively and aesthetically, Mignola's pillow panels represent less of an ontological break than the images in manga, but their emplacement on the page does more to complicate sequentiality and the act of reading. Stasis serves more than one function in the world of comics.

If Mignola's pillow panels exist outside of sequence, they also raise some questions regarding "the gutter" as McCloud has conceptualized it. The gutter is where a reader's inferential activity occurs, in order to account for the change from one panel to the next. A reader must discern whether time and space are continuous; if not, determine how great the disjunction is; and—most importantly—"fill in" the missing information. This continual act of creating closure defines the act of reading comics for McCloud. The reader, following a set of pictorial,

structural, and linguistic cues, constructs the sequence, just as the film viewer stitches together conjoined shots to construct meaningful relations between them.

It's surprising, in fact, how indebted to film theory (from Eisensteinian montage theory through suture theory) the "gutter" actually is. For McCloud, "closure" in film viewing occurs as the sequence of individual film frames fuses into an experience of continuous motion, but surely the "space between" one *shot* and the next is the more relevant comparison. McCloud argues that where "comics panels fracture both time and space, offering a jagged, staccato rhythm of unconnected moments ... closure allows us to connect these moments and mentally construct a continuous, unified reality."[47] Certain transitions demand more closure, more active engagement, than others: in both film and comics, cut and gap can demand either much or scarcely any inferential action. The intercutting of striking workers being gunned down with the slaughter of a steer in Eisenstein's *Strike* (1925) demands some active participation from the viewer to make it meaningful; conversely, a conventionally edited move from medium shot to close-up, with no change of location and perhaps continuous speech carrying from one shot to the next, can hardly be misconstrued. The same coexistence of radical disjunction and smooth continuity exists in comics, which present both hugely challenging and engagingly straightforward reading experiences.

But what of the pillow panels in *Hellboy* that exist outside of sequence, or at least outside of a single, linear sequence? Are these assimilated to construct "a continuous, unified reality" or do they preserve something of the "jagged staccato rhythm"? While they surely contribute to the aesthetic unity of the page, they trouble the linear act of narrative synthesis.

Andrei Molotiu has introduced to comics studies the concept of *iconostasis,* which derives originally from the arrayed icons on Greek Orthodox choir screens, in which "icons are arranged in a grid, yet they are not intended to be read sequentially."[48] Molotiu finds in the work of numerous comics artists "an impulse toward the iconostasis, yet an impulse which is never fulfilled, or else the narration would stop dead in its tracks." Sequence and stasis exist in tension (see figure 54). Molotiu argues that "iconostatic perception, rather than conflicting with sequential dynamism, is a prerequisite for it,"[49] and his own interest lies in discovering how artists manage to avoid that stasis that would stop the narrative "dead." The page becomes a dynamic arrangement in which sequence prevents ossification. Molotiu has done us a great service by finding in the work of venerated superhero-comics artists an attention to the page as a unit that provides the occasion for iconostatic perception, and a play with form and movement that borders on abstraction. But Mignola does something different than Jack Kirby, Steve Ditko, Neal Adams, and the other artists that Molotiu considers—he includes elements that are intended to slow down the reading process, to *complicate* more than *complement* it.

I'm therefore sympathetic to Thierry Groensteen's account of the experience of comics and its gutters when he writes: "We would be mistaken to want to reduce the 'silences' between two consecutive panels by assimilating the ellipse to a virtual image. On the contrary, this silence often speaks volumes. It has nothing to introduce, no gap to suture." Writing in praise of the void, he argues, "Reading a comic, I am here, then I am there, and this jump from one panel to the next (an optical and mental leap) is the equivalent of an electron that changes orbit. In other words, an intermediate state between the two panels does not exist."[50]

Uneasily connected to the panels that neither precede nor succeed them, Mignola's pillow panels speak to a void, which is why they are so often evocative of a sense of foreboding or suspense (suspension). Not all gutters demand—or allow—closure.

McCloud's insistence on the importance of closure has the unintentional consequence of bringing comics *closer* to film in the way they engage the reader/spectator. Groensteen and Mignola present something different, something that respects the void between the panels, that accepts the "jagged" nature of the medium, and that sees (or prefers) that jaggedness as something incompletely contained. In the context of *Hellboy*, we might say that the reader does perform the inferential work of connecting panels and constructing sequence (and therefore meaning), but that even as this work occurs, the jaggedness lingers on—the experience of these as static panels in an array remains. The first reading, the one that privileges sequence and closure, leads to the production of *Hellboy* movies, but the other, the one that can't be completely sutured—*that* gives us comics.

By stepping away from the gutter, Groensteen is able to foreground the page as a more "pertinent unit" than the transition between one panel and the next, and recognize how comics creators construct elaborate, nonlinear correspondences on the page or across a story (or even a series) that speak more to the condition of networked information—a database aesthetics— than the film-like sequence of successive shots.[51] *Hellboy*—with its inclusion of panels that foreshadow or recap, captions that belong to a different temporality than the images that surround them, and elaborate, epic backstory—foregrounds this "network" of inter- and intra-textual reference to a striking degree.[52]

Recall Groensteen's contention that comics "appear to be situated not far from the turning point between the civilization of

the book and that of multimedia."[53] Groensteen is correct about comics in general, but despite its multimedial existence as a property (comics, novels, films, cartoons, statues, drink coasters, t-shirts), *Hellboy* the *comic* leans heavily toward the book. The relevant network to consider is the network of literary and visual references that informs *Hellboy* on all levels.

Jerry Moriarty and Chris Ware use comics to explore the quotidian. The slowing down of the reading process, the elevation of observational detail over action, a sense of deliberateness, an enframing of the moment, and an evenness of pace: all open comics to the exploration of the mundane.[54] Stasis and quietude are appropriate to the material, and Moriarty's turn to painting has its equivalent in Ware's exploitation of elements of graphic design. *Hellboy* is something else, and therein lies its audacity. Within the context of pulp adventure stories, Mignola, too, emphasizes the static and finds some of his vocabulary in textual, painterly, and sculptural imaginations. Moriarty, Ware, and Mignola all emphasize the materiality of the comics object—primarily, the book—but in the pages of *Hellboy*, the book becomes both object and network: a thing to hold, and a complex space for the reader to activate and inhabit in an adventure of reading. Ultimately, it's the book.

Mignola, Goya, and the Monsters

I hope this book has demonstrated how *Hellboy* can be encountered as a particular adventure of reading, a meditation upon the imaginative space afforded by the comic book. Through the richness of its universe, the complexity of its continuing narrative, its treatment of character and generic tradition, the materiality that points to its codicological imagination, and its heightened emphasis on its own aesthetic principles, the *Hellboy* comic becomes something of an imaginary world that activates and is activated by a reader. More than just the story it tells, the material form of the comic is fundamental to its effects; the "fictional world" and "graphic space" of Hellboy are entirely interdependent.

Eric Hayot points to the ways in which literary or aesthetic worlds open onto our own, situations in which our experience of the world permits us to understand the world of a work, and the pleasurable means by which a work provides us a world that seems to exist entirely in its own space, to constitute a world that isn't ours. Are there relevant overlaps between Hellboy's world and ours that can tell us something about one or the other? It's surely

significant that the worlds Hellboy moves through are, on the level of the diegesis, moving away from ours. The earlier stories of occult detection involved eldritch horrors bleeding into "our" reality, but such tales have given way to fantastic stories set in fantastic worlds of Mignola's devising—the one under the sea in "The Third Wish," for example, or the version of Hell where he now finds himself. Understood this way, Hellboy's world has become more distant, its intersections with our reality less pervasive, less meaningful.

Perhaps the very real emotionalism of Hellboy is one continuing point of contact. We may not have access to Hellboy's interiority, but—as with the middle-aged protagonist of Moriarty's *Jack Survives*—that we don't have access to Hellboy's thought doesn't mean that he isn't thinking. Hellboy's behavior continually points to inner states that waver between melancholic and despairing (we still don't know *everything* that went on during his massive bender in Mexico during the mid-1950s). Hellboy may exist in a world that doesn't resemble our own, but there is something deeply human about his melancholy, something deeply warm in his interpersonal relations.

But such emotional identification isn't specific to Mignola's work, or even to comics in general, and I don't think it constitutes the most meaningful engagement of Hellboy's world with ours. Something *else* happens in the world that Mignola has created, on the page and within the book. If Hellboy resists our ability to fully identify with him, if he remains physically and psychologically apart, then the reader's attention must be deflected and invested elsewhere, and that "elsewhere" is precisely the world that Mignola builds. Rather than a figure of identification, Hellboy becomes our surrogate, our conduit and emissary to Mignola's aesthetic world (figure 66). Our interest is deflected or dispersed into the world itself.[1]

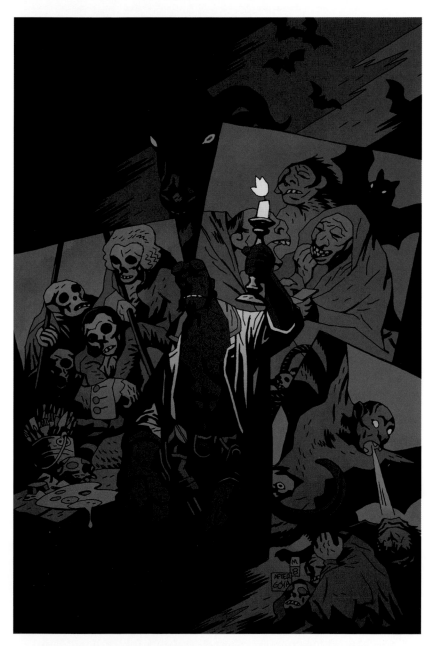

Figure 66. Mike Mignola, *Hellboy:* "In the Chapel of Moloch," cover. Dave Stewart, color. Dark Horse Comics, 2008.

As the comics move toward creating a self-contained world, a "completely formed alternative" of the sort that Hayot categorizes as "pure romance," and are increasingly marked by abstraction, extraordinary landscapes, and oblique storytelling, they emerge ever more strongly as objects that foreground their aesthetics. *That* is the more relevant experience of world here.

Hayot wrote that "Aesthetic worldedness is the form of the relation a work establishes between the world inside and the world outside the work," but here the aesthetic *is* the world. Hellboy's world opens onto the reader's lived experience of aesthetic encounters, and this could occur through the inter-textual references to Manly Wade Wellman, Jack Kirby, Carlo Collodi, or Francisco Goya, or through Mignola's emphasis on the page as surface and the book as object. It could occur simply through the beauty of Mignola's artwork—as I've presented pieces of this study at various venues and institutions, non-comics readers have been dazzled by the images I've lovingly presented. So *Hellboy*'s world intersects our "real world" experiences of art and stories, as Hellboy becomes our conductor into aestheticized worlds that remind us, finally, of the pleasures to be had in our obsessive encounters with worlds that meet us somewhere "atween" eye and page and that leave us "covered over and over by the snow" of our reading.

· · ·

I'd like to conclude by considering a different representation of an imaginative space, this one found in the work of Francisco Goya, one of Mignola's acknowledged influences. The first *Hellboy* story he'd written and drawn in three years, the single-issue "In the Chapel of Moloch" (2008), gave him, he said in an interview, "an excuse to copy a bunch of Goya ink drawings."[2] In what might be some comment on his own creative anxieties, the

story focused on an obsessed artist (who turns out to be more possessed than obsessed) whose paintings, were, in Hellboy's dismissive words, "ripping off Goya" (see figure 66).[3]

Goya's work, the *Caprichos* aquatints in particular, informed Mignola's work long before "Moloch." Goya was a successful portraitist to the Spanish nobility until he was made an invalid in 1792–3 by an illness that left him deaf and, by all accounts, withdrawn and introspective. In this period of physical and mental breakdown, which perhaps involved some form of dementia, he began experimenting with darker subjects and new techniques, producing, among other things, the set of eighty aquatints that he published under the title *Los Caprichos*. These "emphatic caprices" satirized, caricatured, and allegorized the follies and wrongs of contemporary Spanish culture. As Goya described them, they depicted "the innumerable foibles and follies to be found in any civilized society, and from the common prejudices and deceitful practices which custom, ignorance or self-interest have made usual." The pieces were small—each about 8 ½ × 6 inches—and intimate, restricted to a limited number of figures and elements and designed to be looked at from a proximate position. These images do not yield up their meanings easily, and Goya produced an explanatory text that make his meanings clearer.

Mignola's cover designs owe much to compositional strategies used in the *Caprichos* aquatints.[4] A Mignola cover is typically a tableau, an array of some of the characters and story elements. Some covers might present a moment of frozen action—Hellboy ensnared in the coils of a serpent—but others arrange story elements around the central, posed figure of Hellboy. The fourth *Caprichos* print is echoed by Mignola's cover for the third issue of *Baltimore: The Curse Bells* (2011) (figures 67 and 68). Goya presents a seemingly spoiled and possibly helpless child, yet bearded, who

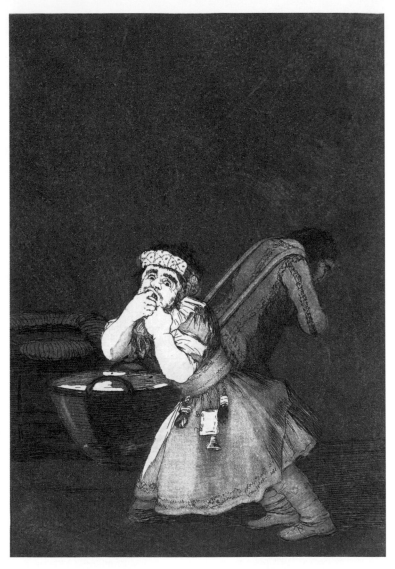

Figure 67. Francisco de Goya y Lucientes, plate 4 from *Los Caprichos:* "Nanny's boy" *(El de la rollona).* The Metropolitan Museum of Art, Gift of M. Knoedler & Co., 1918.

Opposite: Figure 68. Mike Mignola, *Baltimore: The Curse Bells,* no. 3, cover. Dave Stewart, color. Dark Horse Comics, 2011.

looks out at us with imbecilic eyes, posed against a dark background with a pot of food, an enormous toilet, and a servant (who is holding the child up with a harness) arrayed behind. Mignola depicts a diminutive witch, naked and hunched against a dark background; stubs of burning candles surround her, and demonic masks (or actual demons' faces) are stacked above her.

Goya's images illustrate the shortcomings of society through myriad distorted and disturbing forms, be they monsters, bent and aged bodies, prostitutes, anthropomorphized animals, or grotesque members of the clergy. Exaggerated physiognomies reveal the depravity lurking below the surface—whether the surface of the skin or the surface of polite society—and there are few innocents in this collection. Here be dragons. So, beyond the proportional similarities shared by comics and *Caprichos,* the imagery itself is replete with the kinds of grotesque physiques that would be perfectly appropriate to *Hellboy.*

But where Goya is allegorical, Mignola is literal. Those things that look like werewolves? They're werewolves (see figure 56 in chapter 5). The brutish physiognomies that pepper the *Caprichos* are manifestations of the ugliness that lurks within this society, allegories of social or personal corruption and abuses of power. The same moral/physiognomic link does not hold in Hellboy's world, in which the main characters—Hellboy, Roger the Homunculus, Abe Sapien, Lord Baltimore, Joe the Golem— grotesques all—are the noblest creatures in this realm.[5]

The cover of the fifth issue of *The Wild Hunt* (2009) features Hellboy in a dramatic posture, perched atop an unmoored hunk of rock that seems to float in midair (figure 69). In the bottom foreground, a bee with a curious crown appears, and, in an overt nod to Goya's "The Sleep of Reason Produces Monsters," winged demonic creatures rise from behind Hellboy's central figure,

stretching away to the top right corner and beyond. "The Sleep of Reason" is one of two self-portraits in the *Caprichos* series—the first, also the first of the series, is an image of a very smug and self-satisfied bourgeois. But this image, the first of the second part of the *Caprichos,* presents something altogether different. The figure depicted is more than just asleep (this is an allegorical image, after all); he seems defeated, frightened, helpless. Animals signifying ignorance and folly swarm about him. The image is dark, heavy with menace and a sense of doom (figure 70).

"The Sleep of Reason," and Mignola's appropriation, could be understood as a Benjaminian allegory—an immersion in that dreamlike experience that is the very act of reading. The imaginative space of the dream, then, becomes an extension of the imaginative space generated "atween" reader and book. But there is more than one way of understanding what Goya presents in this image. Most typically, "The Sleep of Reason" is taken as emblematic of Enlightenment values. When reason sleeps, trouble follows. But this is not an image of any man, it's the self-portrait of a particularly tormented artist, and the other way of understanding this is through the values of a then emergent Romantic sensibility. Art was now understood as emerging from the psychic sensibilities of artists who were tapping into their own imaginative power, rather than drawing from the canons of political or religious power. As Stephen Eisenman writes, "Without the measured psychic release that these once revered narratives provided, the violence and eroticism that are part and parcel of the creative process (and which exist as the mirror of Enlightenment itself) were now liable to pour forth in a flood. The price to be paid for this artistic *genio* (genius), therefore, could be high indeed.... [I]t could include madness."[6] Terry Castle has written brilliantly about the underside of

Opposite: Figure 69. Mike Mignola, *The Wild Hunt,* no. 5, cover. Dave Stewart, color. Dark Horse Comics, 2009.

Figure 70. Francisco de Goya y Lucientes, plate 43 from *Los Caprichos:* "The sleep of reason produces monsters" *(El sueño de la razon produce monstruos).* The Metropolitan Museum of Art, Bequest of Grace M. Pugh, 1985.

Enlightenment values: "The more we seek enlightenment, the more alienating our world becomes; the more we seek to free ourselves, Houdini-like, from the coils of superstition, mystery and magic, the more tightly, paradoxically, the uncanny holds us in its grip." The uncanny emerged, she argues "like a toxic side effect" of the new faith in the powers of pure Reason.[7]

This particular uncanny image, then, proclaims the *need* for monsters, for the nonrational, the unreasonable. How resonant, then, that Mike Mignola should repurpose this image with Hellboy at its center. The Romantic sensibility of Francisco Goya bubbles up within the mass medium of the comics, a medium that, as we've seen, exceeds the rationalism of linear, phonetic language and allows the imagination access to other worlds, to other modes of reading and of reading the world. "Monsters exist in margins," Allen Weiss reminds us, and are "avatars" of such things as "chance, impurity, heterodoxy; abomination, mutation, metamorphosis; prodigy, mystery, marvel." They pose a threat to established order and orderliness.

Hellboy's destiny is to bring about the end of the world—as he is written in prophecy he is the very incarnation of Nightmare, of Monster. But this is a destiny that he refuses. Hellboy accepts who he is, but not what he is destined to be. He is determined to matter in some other way, to be a different *kind* of monster, bent on something more than complete destruction (cf. Sikoryak's "I yam *not* what I yam"). And so I finish this book with a declaration: We need this kind of monster in the world, and now I'm speaking not just of Hellboy, Abe Sapien, Roger the Homunculus, and the rest, but of *Hellboy* the comic, and comics in general, with their riotous color and other pleasures, both linear and not. We need Hellboy because we need these monsters, these "verminous whimsies," in the world; we need them to help

us exceed the pedants and pedagogues that so bothered Benjamin, and the world of mere words that they extolled.

Hellboy and I seem to have the same catch-phrase, and it seems as good a way to conclude as any:

Figure 71. Mike Mignola, "Heads," p. 10. Dave Stewart, color; Pat Brosseau, letters. Dark Horse Comics, 1998.

Appreciations

Man, for a short book, I have a *lot* of people to thank. First, of course, thanks to Mike Mignola for being just *the nicest guy in comics!* Things Mike did: answered emails (promptly!), met me for what turned into a fun, wide-ranging, and strikingly useful discussion (which he acknowledged was "not unpleasant!"), and allowed me to use dozens of his images (with one on the cover, no less). I'm the envy of other comics scholars—so, Mike, a huge thank you! Thanks also to all of Mike's collaborators—artists, writers, colorists, letterers, and editors—who have had a hand in the creation of so much wonderful work. And to Dark Horse Comics Editor-in-Chief Scott Allie and Editorial Assistant Shantel LaRocque, who provided me a cornucopia of high-resolution images with nary a grumble. A swell guy (as he keeps telling me), Howard Chaykin, vouched for me to Mignola, and I've appreciated his friendship ever since our days in Flatbush.

Mary Francis, my editor at University of California Press, was completely on board with my desire to write a book about *Hellboy* that would have equal appeal to readers interested in

comics more generally. She also understood the need for color images throughout the book (other university presses take note). She's helped me strike the right balance throughout, and her support has been unceasing. Sorry we couldn't get you the *Christina's World* parody cover you were dreaming of, but we did alright.

Hillary Chute and Patrick Jagoda edited the special Comics and Media issue of *Critical Inquiry* in which I brought the first pieces of this to light; their suggestions and support were *enormously* helpful. My manuscript reviewers, Ben Saunders and an anonymous someone (although I *totally* know who you are! I think.) were sympathetic readers who pointed me in intriguing new directions. And Dana Polan produced a detailed reader's report of his own, unbidden (what *is* it with him?); his mind-boggling enthusiasm for the project buoyed me considerably. Charles Hatfield, Bart Beaty, and Corey Creekmur are other comics scholars whose interest, input, and camaraderie were critical (in the good way).

Vanessa Chang, my comrade in running Stanford University's Graphic Narrative Project, heard a lot of this along the way, and was both a welcome supporter and a strong interlocuter. And my other friends from the GNP—Mia Lewis, Helen Shin, Angela Vidergar, Andrea Lunsford, and Max Suechting—gave me a comics community at Stanford. Students in my graduate seminar on comics in the winter of 2013 helped shape my thinking, and thanks are also due the students in my 2014 "Reading Comics" lecture course, where I test drove much of this book's conceptual and methodological approach.

Audiences at two meetings of the International Comic Arts Forum (in Portland and Columbus) and the 2014 International Conference of Graphic Novels and Comics in London were

patient and challenging. The all-star audience that turned out to see me at the University of Chicago gave me a lot to work with, as scattered endnotes will attest. I greatly appreciated and enjoyed the groups to which I presented at the University of Oregon, the University of Calgary, the University of Washington, and Duke University (a special thanks to the folks at Duke, who somehow allowed me to filibuster for seventy minutes— sorry, guys).

Jerry Moriarty, John Porcellino, and Chris Ware generously allowed me the use of their images. Allison Akbay of the Cantor Art Center at Stanford University was generous with high-resolution images of Rodin's works. Jay Williams and Richard Neer were terrific to work with over at *Critical Inquiry*, but I mostly want to thank them for letting me have the best abstract in the history of abstracts: "Hellboy awesome. Read comics."

And my usual friends and family: Pavle Levi, Jean Ma, Henry Lowood, all the Kesslers, my brother Kevin. My fabulous wife and co-scholar Beth Kessler gave me feedback, encouragement, and time to write (no small thing). Our sublime son Linus is three and a half as I write this, and he knows who Hellboy is, along with Superman, Batman, Mickey Mouse, and Donald Duck, not to mention Lightning McQueen, Kid Creole and the Coconuts, and Judy Garland. I'm very proud. I would say that he put me in touch with my inner child, but I don't think I needed help with that. So I'll thank him for being sweet, and funny, and for making my life better and more meaningful in all ways. I'm very glad that, as Professor Bruttenholm did with Hellboy, we decided to raise him as a real boy.

List of Works by Mike Mignola

HELLBOY COLLECTIONS AND GRAPHIC NOVELS

This is a chronological list of Mignola's *Hellboy* collections to date, all published by Dark Horse Comics and edited by Scott Allie (except where noted). I have decided not to provide a full bibliography of all the interrelated titles of the "Mignola-verse." The *Hellboy* books are referenced more frequently and consistently throughout this book and constitute the primary objects of my study; the other works (which include *B.P.R.D., Edward Grey: Witchfinder, Lobster Johnson, Abe Sapien,* and others) are not as central. They are, however, in their own right, indispensable and thoroughly entertaining. Thanks to the *Hellboy* Wiki.

Hellboy: Seed of Destruction (October 1994)—Story and art by Mike Mignola. Script by John Byrne. Color by Mark Chiarello, Matthew Hollingsworth, and Dave Stewart. Edited by Barbara Kesel. Collects *Seed of Destruction* 1–4; the *Mike Mignola's Hellboy* promo (from *San Diego Comic-*

Con Comics 2); the *Mike Mignola's Hellboy: World's Greatest Paranormal Investigator* promo (from *Comics Buyer's Guide* 1070); sketchbook and art gallery.

Hellboy: Wake the Devil (May 1997)—Story and art by Mike Mignola. Colors by James Sinclair. Letters by Pat Brosseau. Collects *Wake the Devil* 1–5.

Hellboy: The Chained Coffin and Others (August 1998)—Story and art by Mike Mignola. Colors by Dave Stewart. Letters by Pat Brosseau. Collects "The Chained Coffin" (from *Dark Horse Presents* 100–2); *Hellboy Christmas Special;* "Almost Colossus" 1–2; "The Corpse and the Iron Shoes"; "The Wolves of Saint August" (from *Dark Horse Presents* 88–91).

Hellboy: The Right Hand of Doom (April 2000)—Story and art by Mike Mignola. Colors by Dave Stewart. Letters by Pat Brosseau. Collects "Pancakes" (from *Dark Horse Presents Annual 1999;* "The Nature of the Beast" (from *Dark Horse Presents* 151); "King Vold"; "Heads" (from *Abe Sapien: Drums of the Dead*); *Goodbye, Mr. Tod* (from *Gary Gianni's The MonsterMen*); "The Vârcolac"; "The Right Hand of Doom" (from *Dark Horse Presents Annual 1998*); "Box Full of Evil" 1–2.

Hellboy: Conqueror Worm (February 2002)—Story and art by Mike Mignola. Colors by Dave Stewart. Letters by Pat Brosseau. Collects *Hellboy: Conqueror Worm* 1–4.

Hellboy: Strange Places (April 2006)—Story and art by Mike Mignola. Colors by Dave Stewart. Letters by Clem Robins. Collects "The Island" 1–2; "The Third Wish" 1–2.

Hellboy: The Troll Witch and Others (November 2007)—Story and art by Mike Mignola. Additional art by P. Craig Russell and Richard Corben. Colors by Dave Stewart and Lovern Kindzierski. Letters by Pat Brosseau and others.

Collects "The Penanggalan" (from *Hellboy Premiere Edition*);
"The Hydra and The Lion" (from *The Dark Horse Book of
Monsters*); "The Troll Witch" (from *The Dark Horse Book of
Witchcraft*); "Dr. Carp's Experiment" (from *The Dark Horse
Book of Hauntings*); "The Ghoul" (from *The Dark Horse Book
of The Dead*); "The Vampire of Prague"; "Makoma" 1–2.

Hellboy: Darkness Calls (May 2008)—Story and cover by Mike
Mignola. Art by Duncan Fegredo. Colors by Dave Stewart.
Letters by Clem Robins. Collects *Darkness Calls* 1–6.

Hellboy: The Wild Hunt (March 2010)—Story and cover by Mike
Mignola. Art by Duncan Fegredo. Colors by Dave Stewart.
Letters by Clem Robins. Collects *The Wild Hunt* 1–8.

Hellboy: The Crooked Man and Others (June 2010)—Story and
cover by Mike Mignola. Additional story by Joshua Dysart.
Art by Mike Mignola, Richard Corben, Jason Shawn
Alexander, Duncan Fegredo. Colors by Dave Stewart.
Letters by Clem Robins. Collects *The Crooked Man* 1–3;
"They That Go Down to the Sea in Ships"; *The Mole* (from
Free Comic Book Day 2008); "In the Chapel of Moloch."

Hellboy: The Bride of Hell and Others (October 2011)—Story and
cover by Mike Mignola. Art by Mike Mignola, Richard
Corben, Kevin Nowlan, Scott Hampton. Colors by Dave
Stewart and Kevin Nowlan. Letters by Clem Robins.
Collects "Hellboy in Mexico"; "Double Feature of Evil";
"The Sleeping and the Dead" 1–2; "The Bride of Hell";
"The Whittier Legacy"; "Buster Oakley Gets His Wish."

Hellboy: The Storm and The Fury (March 2012)—Story and
cover by Mike Mignola. Art by Duncan Fegredo. Colors
by Dave Stewart. Letters by Clem Robins. Collects *The
Storm* 1–3; *The Fury* 1–3.

Hellboy in Hell: The Descent (May 2014)—Story and art by
Mike Mignola. Colors by Dave Stewart. Letters by Clem
Robins. Collects *Hellboy in Hell* 1–5.

Hellboy and the B.P.R.D.: 1952 (August 2015)—Story by Mike
Mignola and John Arcudi. Art by Alex Maleev. Colors by
Dave Stewart. Letters by Clem Robins. Collects *Hellboy
and the B.P.R.D.: 1952* 1–5.

HELLBOY ORIGINAL GRAPHIC NOVELS

House of the Living Dead (November 2011) Story and cover by
Mike Mignola. Art by Richard Corben. Colors by Dave
Stewart. Letters by Clem Robins.

The Midnight Circus (October 2013) Story and cover by Mike
Mignola. Art by Duncan Fegredo. Colors by Dave
Stewart. Letters by Clem Robins.

HELLBOY LIBRARY EDITIONS

Each volume includes extensive supplemental materials, includ-
ing previously unreleased sketches and designs.

Hellboy: Library Edition Volume I (May 2008)—Collects *Seed of
Destruction* and *Wake the Devil.*

Hellboy: Library Edition Volume II (October 2008)—Collects
The Chained Coffin and Others and *The Right Hand of Doom.*

Hellboy: Library Edition Volume III (September 2009)—Collects
Conqueror Worm and *Strange Places.*

Hellboy: Library Edition Volume IV (July 2011)—Collects *The
Troll Witch and Others* and *The Crooked Man and Others,*
without "The Mole."

Hellboy: Library Edition Volume V (July 2012)—Collects
Darkness Calls and *The Wild Hunt*, with "The Mole."

Hellboy: Library Edition Volume VI (June 2013)—Collects *The
Storm and The Fury* and *The Bride of Hell and Others.*

ADDITIONAL MIGNOLA TITLES REFERENCED IN THE TEXT

B.P.R.D.: The Universal Machine (January 2007). Story by
Mike Mignola and John Arcudi. Covers by Mike
Mignola. Art by Guy Davis. Colors by Dave Stewart.
Letters by Clem Robins. Collects *B.P.R.D.: The Universal
Machine* 1–5.

Lobster Johnson: The Iron Prometheus (June 2008). Story and
cover by Mike Mignola. Art by Jason Armstrong. Colors
by Dave Stewart. Letters by Clem Robins. Collects *Lobster
Johnson: The Iron Prometheus* 1–5 (2007).

B.P.R.D.: The Black Goddess (October 2009) Story by Mike
Mignola and John Arcudi. Covers by Mike Mignola. Art
by Guy Davis. Colors by Dave Stewart. Letters by Clem
Robins. Collects *B.P.R.D.: The Black Goddess* 1–5.

B.P.R.D.: King of Fear (November 2010). Story by Mike
Mignola and John Arcudi. Covers by Mike Mignola. Art
by Guy Davis. Colors by Dave Stewart. Letters by Clem
Robins. Collects *B.P.R.D.: King of Fear* 1–5.

B.P.R.D.: Hell on Earth:. New World (August 2011). Story by Mike
Mignola and John Arcudi. Art by Guy Davis. Colors by
Dave Stewart. Letters by Clem Robins. Collects *B.P.R.D.:
Hell on Earth: New World* 1–5 (2010).

BOOKS ILLUSTRATED BY MIGNOLA

Mignola, Mike, and Christopher Golden. *Baltimore; or, The Steadfast Tin Soldier and the Vampire.* New York: St. Martin's Press, 2012.

Mignola, Mike, and Christopher Golden. *Father Gaetano's Puppet Catechism: A Novella.* New York: St. Martin's Press, 2012.

Mignola, Mike, and Christopher Golden. *Joe Golem and the Drowning City: An Illustrated Novel.* New York: St. Martin's Press, 2012.

Notes

INTRODUCTION

1. Walter Benjamin, "Unpacking My Library: A Talk about Book Collecting," in *Illuminations,* ed. Hannah Arendt (New York: Schocken Books, 1969), 66.

2. Ibid.

3. Walter Benjamin, "Old Forgotten Children's Books," in *Selected Writings, vol. 1,* 410.

4. Walter Benjamin, "A Glimpse into the World of Children's Books," in *Selected Writings, vol. 1,* 435.

5. Benjamin, "Old Forgotten Children's Books," 409.

6. Lynda Barry, *What It Is* (Montreal: Drawn & Quarterly, 2008), 51.

7. See chapter 1, "Drawn and Disorderly," in Scott Bukatman, *The Poetics of Slumberland: Animated Spirits and the Animating Spirit* (Berkeley: University of California Press, 2011).

8. Jules Feiffer, *The Great Comic Book Heroes* (Seattle, WA: Fantagraphics Books, 2003), 77. (Originally published in 1965.)

9. The Nazis in Mignola's comics are evil, but they're comic book Nazis, stock villains engaged in nefarious comic book evils. Comics critics Ben Schwartz and Tucker Stone have both praised Mignola's way with Nazis: in an interview, Schwartz commented that Mignola

strikes the appropriate tone for an entertainment medium: "I don't need to hear about Auschwitz in a monster comic" (www.comicsreporter.com/index.php/cr_holiday_interview_06/). In a comment I've been unable to track down, Stone wrote that genre comics creators should just stay away from Nazis—unless they're Mike Mignola.

10. Those titles include *Abe Sapien, Baltimore, Lobster Johnson, B.P.R.D., B.P.R.D.: Hell on Earth, Edward Grey: Witchfinder, Hellboy and the B.P.R.D.,* and *Sledgehammer 44.*

11. Gary Gianni, "Introduction," in *Hellboy: Strange Places* (Portland, OR: Dark Horse Comics, 2006), no page number.

12. I will thus treat Mignola as a comics *auteur,* because I think this cinema-studies term has some relevance to the creative control exercised in the field of comics. Distinctions can be made among creators with full authorial control (those published by, say, Fantagraphics Books or Drawn & Quarterly, as well as those self-publishing in print or online); creators working for a paycheck under a work-for-hire contract with a major mainstream comic book publisher (Marvel and DC most obviously) but who are either unable or unwilling to have substantial creative input; and those working with mainstream publishers (either as work-for-hire or with some sort of profit-sharing) whose creative voice can be clearly distinguished. This isn't always the way that the world of comics defines the "auteur"—often the term is reserved for those with full creative control, as opposed to those toiling in the trenches with their names below the title. But this really is to misunderstand the term and lose some important nuance. At a panel on authorship and comics (International Comics Art Forum, Portland Oregon, 2013), Kelly Sue Deconnick said something to the effect of not wanting to be an auteur, preferring to just go off and make comics. This, of course, is precisely what Howard Hawks and John Ford said when the label was attached to them. Auteurs need to do more than proclaim themselves; historically, it's a label applied to someone retrospectively, when the unity of the work reveals the vision that binds it. Kelly Sue is absolutely an auteur.

13. Charles Hatfield, "The Vessel Shaped by Its Contents, or, Form in Superhero Comics," talk given at Stanford University, May 2014.

14. It's well worth noting that many of the figures on this list either wrote or at least coplotted their own stories, but collaborated with letterers, colorists, and editors.

15. Art Spiegelman, *Co-Mix: A Retrospective of Comics, Graphics, and Scraps* (Montreal: Drawn & Quarterly, 2013), 90.

16. As does Roald Dahl's *Matilda*.

17. Guillermo del Toro, "Mike Mignola Is a Genius: An Unapologetically Subjective Introduction," in *Hellboy: Conqueror Worm* (Portland, OR: Dark Horse Comics, 2002), no page number.

18. Christopher Brayshaw, "Between Two Worlds: The Mike Mignola Interview," *The Comics Journal* 189 (1996): 65.

19. Thanks to Mary Francis for this nice summation.

20. I'll admit that my treatment of comics as art isn't terribly Benjaminian.

21. Benjamin, "Unpacking My Library," 67.

22. "Now and then, every passion lifts the veil on its demonic aspect; the history of book collecting might tell a few tales about this with the best of them." (Benjamin, "Old and Forgotten Children's Books," 406)

23. Michael Camille, *Image on the Edge: The Margins of Medieval Art* (Cambridge, MA: Harvard University Press, 1992), 9.

24. Ibid., 26.

25. Ibid., 22.

26. Ibid., 18. Camille reserves this luscious term for certain illustrations, but I'm going to employ it more categorically.

27. M. Christine Boyer, "The Place of History and Memory in the Contemporary City," in *The City of Collective Memory: Its Historical Imagery and Architectural Entertainments* (Cambridge, MA: MIT Press, 1994), 27.

28. Walter Benjamin, "Children's Literature," in *Selected Writings, vol. 2, part 1*, ed. Marcus Bullock and Michael W. Jennings (Cambridge, MA: Harvard University Press, 2005), 255.

29. Anthony Enns, "The City as Archive in Jason Lutes's *Berlin*," in *Comics and the City: Urban Space in Print, Picture, and Sequence*, ed. Jörn Ahrens and Arno Meteling (New York: Continuum Books, 2010);

Nathalie op de Beeck, "Found Objects: (Jem Cohen, Ben Katchor, Walter Benjamin)," *Modern Fiction Studies* 52, no. 4 (2006): 807–30; Jared Gardner, "Archives, Collectors, and the New Media Work of Comics," *Modern Fiction Studies* 52, no. 4 (2006): 787–806.

30. Gardner, 801.

31. Ibid., 801–2.

32. Ibid., 800. He continues: "The desire to possess comics—to hunt down every stray work by a favorite creator, to contain and reassemble the scattered pieces of a fragmentary comics universe—is a familiar one for many readers.... It is the compulsive need to fill in the gaps ... that drives the 'collector' in search of missing issues. Indeed, the archival drive that motivates the form's production and reception is a forge for the (always uneasy) collaboration between reader and writer that is central to the comics form."

CHAPTER ONE

1. Mignola is aware of that uniqueness. In conversation, he said, "Something that my editor and I have been talking about for the last couple of years is ... we look at each other and go 'Has anybody done this ...?' We get really excited, especially when it's [John] Arcudi, and Scott [Allie], and me comparing notes on the phone, and plotting things out, and we start kinda going, 'Holy shit, we're doing something here!'" Interview with the author, March 27, 2014.

2. Eric Hayot, *On Literary Worlds* (New York: Oxford University Press, 2012), 24–5.

3. Ibid., 47.

4. Peter Mendelsund, *What We See When We Read: A Phenomenology with Illustrations* (New York: Vintage Books, 2014), 302. Where Hayot's emphasis is on the epistemology of reading (and the "epistemological engine" that the text produces; p. 50), Mendelsund engages with it, as his subtitle tells us, phenomenologically.

5. Ibid., 403. This aligns intriguingly with André Bazin's championing of such filmic techniques as the shot in depth and the long take, both of which privilege ambiguity and incomplete knowledge.

6. Wolfgang Iser, "The Reading Process: A Phenomenological Approach," *New Literary History* 3, no. 2 (1972): 279.

7. Ibid., 146.

8. Ibid.

9. Ibid., 180–1. "What do we see during the unillustrated part of the story?" (182).

10. And even single-panel cartoons can be richly "enworlded." A *Dennis the Menace* cartoon by Hank Ketcham (May 13, 1977) has Dennis and Joey in cowboy outfits, playing in the yard. Dennis's Mom is leaning out a side window, evidently calling her son. "You're right, Joey," Dennis is saying in the bottom caption. "She DOES sound a little like a coyote howling at the moon." We enter into a scene *in medias res:* the twilight setting of a suburban neighborhood is evident on the left side of the frame, receding into the distance. The boys are accoutered in the Platonic ideal of cowboy costuming, clearly invested in their fantasy. A wisp of cloud emerges from the panel border to cover a part of the crescent moon. I could live in this comic—the world has such specificity, such presence; it feels remarkably complete. Sadly, today it's the rare panel cartoon that privileges aesthetics so strongly.

11. Christiansen refers to this as *foregrounding the enunciator.* Hans-Christian Christiansen, "Comics and Film: A Narrative Perspective," in *Comics & Culture: Analytical and Theoretical Approaches to Comics,* ed. Anne Magnussen and Hans-Christian Christiansen (Copenhagen: Museum Tusculanum Press, 2000). See Hillary Chute's *Disaster Drawn: Visual Witness, Comics, and Documentary Form* (Cambridge, MA: The Belknap Press, 2016) for the most thorough treatment of this subject.

12. It's interesting that book designer Mendelsund's book is designed to the hilt, yet he does not really consider the effect of book design in his exploration of the experience of reading.

13. R. Fiore, "Days of Yesteryear," www.tcj.com/days-of-yester-year/, February 27, 2013.

14. Interview with the author, March 27, 2014.

15. I'll have more to say about aether in chapter 2.

16. See Tom Gunning, "Narrative Discourse and the Narrator System," in *Film Theory and Criticism: Introductory Readings,* ed. Leo Braudy and Marshall Cohen (New York: Oxford University Press, 1999).

17. Hayot, 47.

18. Ibid., 50.

19. Ibid., 50–1.

20. Ibid., 50.

21. Kate Fitzsimons, "Does the Man Have a Point?" http://comicsbeat.com/does-the-man-have-a-point/.

22. See Umberto Eco, "The Myth of Superman," in *Arguing Comics: Literary Masters on a Popular Medium,* ed. Jeet Heer and Kent Worcester (Jackson: University Press of Mississippi, 2004).

23. My adolescent self was quite taken with two stories. One of them wondered where the Norse god Thor was before Dr. Donald Blake found the stick that transformed him into the hero (*Thor* 158, Stan Lee and Jack Kirby). The other explained who the 1950s incarnation of Captain America really was, given that the character was supposedly frozen in a block of ice between 1945 and 1964 (*Captain America* 153–6, Steve Englehart and Sal Buscema).

24. The "canon" in the world of comics is generally defined by the owners of the property—the comics publishers in this case—but it must be accepted by the community of readers. Reboots of characters, titles, or entire universes can retroactively alter what is, and is not, canon.

25. Mike McKone, one issue; Phil Noto, two issues; Julian Totino Tedesco, three issues; and finally, Dave Williams, one issue.

26. It took two pencilers (Brad Walker and Rags Morales), three inkers (Andrew Hennessy, Mark Propst, and Cam Smith), and two colorists (Gabe Eltreb and Brad Anderson).

27. I don't want to suggest that this recent frenzied game of artistic musical chairs is the sole cause of the emergence of writer-as-star; one might more profitably look to the influx of British writers in the early 1980s (Alan Moore, Neil Gaiman, Grant Morrison, and Peter Milligan—and, a bit later, Warren Ellis, Jamie Delano, and Garth Ennis), but many of these writers worked in close collaboration with artists.

Many of their series were penciled by a single artist, apart from an occasional spin-off series or special issue—see, for example, Moore's collaboration with Dave Gibbons on the twelve-issue *Watchmen* (DC, 1986–7) series or Steve Dillon's full run of *Preacher*'s sixty-six issues (DC–Vertigo 1995–2000; it helped that artists such as Dillon were frequently given cocreator status). Meanwhile, the artists who broke away from Marvel and DC to form Image Comics in 1992 surely demonstrated that artists had some residual clout.

28. Geoff Johns was one such writer at DC, and his mania for continuity was rather brilliantly parodied in the webcomic *Comic Critics!* Johns's editor pitches a book about Santa Claus—"Really make it a lot of fun." Johns immediately sees ways of tying all of Santa's whimsical appearances in DC comics over the years into a larger continuity ("We can safely call *The Lobo Christmas Special* non-canon, I think"). After a few panels of this, his editor finally catches his eye: Johns realizes, "Oh, you mean something *other* people find fun" (http://comiccritics.com/2008/12/17/santa-year-one/).

29. For more, see Ben Saunders, "Superheroes after 1986," in *The Cambridge Companion to Comics,* ed. Bart Beaty (New York: Cambridge University Press, forthcoming).

30. The downside of this was a speculator's market that exploited fans by flooding the market with first issues, variant covers, and other marketing gimmicks.

31. As Saunders puts it.

32. Mike Mignola, "Introduction," in *Hellboy Library Edition, vol. 3: Conqueror Worm and Strange Places* (Portland, OR: Dark Horse Comics, 2009).

33. In our conversation, Mignola confessed that his hands were "tied a lot by the way I draw." For example, he said, "I'm terrible at drawing women. I felt the team needed a woman, but I couldn't draw her." But the move into other books also allowed him to expand the *Hellboy* universe. Interview with the author, March 27, 2014.

34. Stories include those published in the *Weird Tales* anthology title, early issues of *B.P.R.D.,* and prose novels featuring Hellboy and Lobster Johnson.

35. When artists or writers make a strong contribution to the emergence of a new character, Mignola tries to reserve that character (or at least the character's development) for that creator.

36. Interview with the author, March 27, 2014.

37. Mike Mignola, *Hellboy: The First 20 Years* (Portland, OR: Dark Horse Comics, 2014).

CHAPTER TWO

1. Howard Phillips Lovecraft, "Supernatural Horror in Literature," in *Dagon and Other Macabre Tales,* ed. S. T. Yoshi (Sauk City, WI: Arkham House, 1965).

2. 13th Dimension, "Hellboy Week: Mike Mignola Talks Literary and Pulp Influences," http://13thdimension.com/hellboy-week-mike-mignola-talks-literary-and-pulp-influences/.

3. "The Dunwich Horror."

4. I was tickled to find Peter Mendelsund discussing this aspect of Lovecraft's prose in a book that appeared after I'd written this section: he refers to a passage describing "impossible geometries" as well as "terror unutterable and unimaginable." He continues: "Sometimes when we are reading, we are asked explicitly to imagine the unimaginable.... Are we being asked not to see?" Mendelsund, 241.

5. A *New York Times* article (July 31, 2014) by Dana Jennings about the pleasures of Marvel Comics on the occasion of the release of *The Guardians of the Galaxy* was titled "Imax? Try a Cosmos between Covers."

6. Charles Hatfield, *Hand of Fire: The Comics Art of Jack Kirby* (Jackson: University Press of Mississippi, 2012), 146.

7. Ibid., 154.

8. Srdjan Smajić, *Ghost-Seers, Detectives, and Spiritualists: Theories of Vision in Victorian Literature and Science* (Cambridge, UK: Cambridge University Press, 2010).

9. Ibid., see chapter 10, "Light, Ether, and the Visible World."

10. Ibid., cited 151.

11. Ibid., 152.

12. 13th Dimension, "Hellboy Week: Mike Mignola Talks Literary and Pulp Influences."

13. Scott Allie, "Introduction," in *Hellboy Library Edition, vol. 2: The Chained Coffin, The Right Hand of Doom, and Others* (Portland, OR: Dark Horse Comics, 2008).

14. Mike Mignola, "Story Notes," in *Hellboy Library Edition, vol. 2*.

15. Ibid.

16. Allie, "Introduction."

17. Mike Mignola, "Afterword," in *Hellboy Library Edition, vol. 2*.

18. The flatness of affect in Mignola's work strongly reminds me of the fantastic comics by the Norwegian cartoonist Jason.

19. Walter Benjamin, *The Arcades Project*, trans. Rolf Tiedemann (Cambridge, MA: The Belknap Press of Harvard University Press, 2001), 439. Thanks to Dana Polan for this connection.

20. Hellboy finally gets a look at these "lifeless soldiers," mentioned in this 1998 story, in 2013's *Hellboy in Hell*, no. 2.

21. This is a theme that I explored in *The Poetics of Slumberland* through works, like cartoons, that fall outside the genre of horror. Thanks to Mike Metzger for pointing out this continuity.

22. R. Sikoryak, "Black Press Review Daily: Color Comics Fun," in *Hellboy: 20th Anniversary Sampler* (Portland, OR: Dark Horse Comics, 2014).

23. Walter Benjamin, "Fate and Character," in *Selected Writings, vol. I*, 202.

CHAPTER THREE

1. Thierry Groensteen, *Comics and Narration*, trans. Ann Miller (Jackson: University Press of Mississippi, 2013), 52.

2. Ibid.

3. Ibid., 53.

4. Ibid.

5. Charles Hatfield and Craig Svonkin, "Why Comics Are and Are Not Picture Books: Introduction," *Children's Literature Association Quarterly* 37, no. 4 (2012): 431.

6. Ibid., Mitchell cited 431.

7. David Wiesner, *Free Fall* (New York: HarperCollins, 1991).

8. Bukatman, *The Poetics of Slumberland*, 1.

9. David Wiesner, *Art & Max* (New York: Clarion Books, 2010). Coconino County being, of course, the home of George Herriman's Krazy Kat and the brick-throwing Ignatz Mouse. *Mr. Wuffles* (2013) uses word balloons (mostly to render the pictographic speech of some alien visitors) and sequential panels. David Wiesner, *Mr. Wuffles* (New York: HarperCollins, 2013).

10. There are so many other ways to map the overlapping territories of comics and children's literature. One might consider the number of writers and artists who work in both, a list that would include Crockett Johnson (*Barnaby, Harold and the Purple Crayon*) and Jules Feiffer (*Feiffer, Bark George*). One might note the use of sound effects in such books as *Go Dog, Go!*, or the overtly acknowledged influence of Winsor McCay on Maurice Sendak's *In the Night Kitchen*. I've barely scratched the surface here, but it should be enough to demonstrate their continuing proximity to one another.

11. Email, July 22, 2013. There are exceptions: the climactic image in *Joe Golem and the Drowning City* is a darkly sublime vision of an interdimensional cephalopod wreaking havoc upon the city.

12. These editions feature Moser's illustrations: Mary Wollstonecraft Shelley, *Frankenstein; or, The Modern Prometheus* (Berkeley: University of California Press, 1984); Lewis Carroll. *Alice: Alice's Adventures in Wonderland* (North Hatfield, MA: Pennyroyal Press, 1982); Herman Melville, *Moby-Dick; or, The Whale* (Berkeley: University of California Press, 1981).

13. Benjamin, "A Glimpse into the World of Children's Books," 435.

14. Ibid.

15. Ibid.

16. Benjamin, "Children's Literature," 251.

17. Julie Bosman, "Picture Books No Longer a Staple for Children," *The New York Times,* October 7, 2010.

18. Peter Mendelsund muses, "Children read picture books, preteens read chapter books with pictures; eventually young adults graduate to books made up entirely of words. This process exists because we learn to read a language slowly, in stages, though I wonder if we also need, over time, to learn how to picture narratives unassisted." Mendelsund, 190–1.

19. Many thanks to Eric Ames at the University of Washington for raising this issue of color in contemporary culture.

20. For the most powerful overview of this history, see Martin Jay, *Downcast Eyes: The Denigration of Vision in Twentieth-Century French Thought* (Berkeley: University of California Press, 1994).

21. David Batchelor, *Chromophobia* (London: Reaktion Books, 2000), 22.

22. Ibid., 46.

23. Benjamin, "A Glimpse into the World of Children's Books," 435.

24. Batchelor, 22–3.

25. This is discussed more fully, with reference to work by Alex Nemerov and Bryan Wolf, in my *Poetics of Slumberland*.

26. Batchelor, 41.

27. Ibid., cited 32. For discussion of color and the limits of language, see Batchelor, chapter 4, "Hanunoo."

28. Stan Brakhage, *Metaphors on Vision* (New York: Film Culture, 1976).

29. Mario made this comment during an appearance featuring all three brothers at Stanford University, October 9, 2014.

30. Occasionally an artist will either color his or her own work, as does Kevin Nowlan (who also letters his pages), or bring a favored colorist on board, as with Lovern Kindzierski coloring the art of P. Craig Russell. But Stewart is responsible for nearly all of the many dozens of comics that constitute the Mignola-verse.

31. Debi Moore, "Guest Blog: Dark Horse Editor-in-Chief Scott Allie Interviews Artist Dave Stewart," www.dreadcentral.com/news /60960/guest-blog-dark-horse-editor-chief-scott-allie-interviews-_artist-dave-stewart#ixzz3C62r597p.

32. There are plenty of earlier examples of colored comics in Europe and elsewhere, but those appeared more rarely—the Sunday supplement brought color to the comics with weekly regularity.

33. Cited in Batchelor, 112.

34. Cited in Brian Walker, "Disrespecting the Comics," in *Society Is Nix: Gleeful Anarchy at the Dawn of the American Comic Strip, 1895–1915*, ed. Peter Maresca (Palo Alto, CA: Sunday Press Books, 2013), 12.

35. Cited in Batchelor, 104.

36. Gilbert Hernandez is most often associated with his realist, black-and-white comics about the fictional Latin American town of Palomar, but his 2012 zombie comic *Fatima: The Blood Spinners* (Dark Horse Comics) was motivated, in part, by his desire to recapture the lurid pleasures of the comics in the more respectable era of "the graphic novel" (comment made during his appearance at Stanford University, October 9, 2014). The color covers for the miniseries were "riotous" with bright red spurts of blood, blood, and more blood.

37. Tom Gunning, "The Art of Succession: Reading, Writing, and Watching Comics," *Critical Inquiry* 40, no. 3 (2014): 37.

38. Ibid, cited 49.

39. Ibid., 50.

40. Ibid., 46.

41. Mendelsund, 88, 168.

42. Thierry Groensteen, *The System of Comics*, trans. Bart Beaty and Nick Nguyen (Jackson: University Press of Mississippi, 2007). Camille (42) writes that an "important aspect of the way marginal motifs work is not by reference to the text, but by reference to one another—the reflexivity of imagery not just across single pages but in chains of linked motifs and signs that echo throughout a whole manuscript or book," while Hayot (76) proposes the term "networkedness" to refer to the "collective intensity of relations between actors within a work."

43. http://facweb.cs.depaul.edu/sgrais/comics_color.htm. Batchelor has also pointed to Warhol's off-register color, a Pop appropriation of a printing glitch that also helped define the four-color aesthetic.

44. Conversation with the author, March 27, 2014.

45. Brian Salvatore and David Harper, "Mignolaversity: A Colorful Conversation with Dave Stewart," http://multiversitycomics.com /interviews/mignolaversity-a-colorful-conversation-with-dave-stew- art/. Gregory Manchess, "An Interview with Colorist Dave Stewart," www.tor.com/blogs/2010/08/ an-interview-with-colorist-dave-stewart.

46. Conversation with the author, March 27, 2014.

47. Moore, "Scott Allie Interviews Artist Dave Stewart."

48. "We talk over his personal books pretty thoroughly. On other books in the B.P.R.D. universe that's a little more up to me and the creative team." Salvatore and Harper, "Mignolaversity."

49. Alex Carr, "Emerald City Comicon 2011: Interview with Dave Stewart," www.omnivoracious.com/2011/03/emerald-city-comicon-2011 -interview-with-dave-stewart.html.

50. Manchess, "An Interview with Colorist Dave Stewart."

51. Chris Arrant, "Conversing on Comics with Dave Stewart," http://robot6.comicbookresources.com/2013/01/ conversing-on-comics-with-dave-stewart/.

52. Of course, many children's books have astonishingly sophisticated coloring (see the works of David Wiesner, for examples), just as many comic books don't. Again, thanks to Eric Ames for pushing me on this point.

CHAPTER FOUR

1. Groensteen, *The System of Comics,* 160.
2. Ibid., 126 (emphasis mine).
3. Thanks *again* to Mike Metzger.
4. Camille, 22.
5. As I've done in *The Poetics of Slumberland.* Camille, 29 and 22.
6. Martha Dana Rust, *Imaginary Worlds in Medieval Books: Exploring the Manuscript Matrix* (New York: Palgrave Macmillan, 2007), 14.
7. Martha [Dana] Rust, "'It's a Magical World': The Page in Comics and Medieval Manuscripts," *English Language Notes* 46, no. 2 (2008): 25 (emphasis mine).
8. Rust, *Imaginary Worlds.* Rust is borrowing and modifying a term introduced by Stephen Nichols, who used it to refer to the intersection of the work of scribe, illuminator, and rubricator.
9. Ibid, 5.
10. Ibid.
11. Ibid., 9.
12. Ibid., 20.
13. Ibid., 9.

14. Ibid, 17.

15. Gunning, "The Art of Succession," 40.

16. Ibid., 44.

17. Scott McCloud, *Understanding Comics: The Invisible Art* (Northhampton, MA: Tundra, 1993), chapter 3, "Blood in the Gutter."

18. Here is another overlap between the medieval manuscripts of Rust's study and the comics. Rust points to a textual element she calls the "catch word"—"instructions to the binder, words that are not directed to the reader and which don't belong to the diegesis." In comic books, the diegesis contained within (and implied between) the panels is often accompanied by nondiegetic paratextual instructions: "Continued after next page," "See last issue," and the like.

19. In stories to come, it will turn out that this church was where Hellboy was conceived some three hundred years earlier—the progeny of a witch and a demon prince. Hence the strong psychic energy in the East Bromwich location.

20. Iser, 279.

21. Ibid., 287.

22. Ibid., 298.

23. Ibid., 295.

24. Nathalie op de Beeck, *Suspended Animation: Children's Picture Books and the Fairy Tale of Modernity* (Minneapolis: University of Minnesota Press, 2010), x–xi.

25. Rust, *Imaginary Worlds,* 24.

26. Ibid., 25.

27. Many thanks to Richard Neer for turning me on to this wonderful artist, as well as for reminding me that *pages are turned.*

28. The paintings of Xiaoze Xie betray a similar fascination with the materiality of the book, but with a less varied visual engagement and a different purpose. The painted view is almost always of a stack of works, often piled, spines outward. When he writes, "I see books as a material form of something abstract, such as ideology," he has already moved far from Morrell's investment in the bookishness of the book (see http://jsma.uoregon.edu/sites/jsma1.uoregon.edu/files/Xiaoze%20Xie%20Curriculum%20Packet.pdf).

29. Nicholson Baker, "Preface," in *A Book of Books* (New York: Bullfinch, 2002).

30. In 2011, I had Anders Nilsen sign a copy of *Big Questions,* his wondrous comics volume, and apologized for the stain along the edge of its pages. He said that books *should* be stained.

31. It's nicely appropriate that the source of this image for Baker is Superman pushing through a wall in the old TV show with George Reeves.

32. Benjamin, "A Glimpse into the World of Children's Books," 435.

33. David Wiesner, *The Three Pigs* (New York: Clarion Books, 2001).

34. I discuss these more fully in the last chapter of *The Poetics of Slumberland.*

35. Mendelsund, 61.

36. Georges Poulet, "Phenomenology of Reading," *New Literary History* 1, no. 1 (1969): 53–68.

37. Alan Moore makes much the same point in an interview from 1988: "The relationship between films and comics has been over-emphasised to a degree.... What I'd like to explore is [sic] the areas that comics succeed in where no other media is capable of operating. Like in *Watchmen,* all that subliminal shit we were getting into the backgrounds. You are trapped in the running time of a film—you go in, you sit down, they've got two hours and you're dragged through at their pace. With a comic you can stare at the page for as long as you want and check back to see if this line of dialogue really does echo something four pages earlier, whether this picture is really the same as that one, and wonder if there is some connection there. *Watchmen* was designed to be read four or five times; there's stuff in there Dave had put in that even I only noticed on the sixth or seventh read." John Coulthart, "Alan Moore Interview, 1988," www.johncoulthart.com /feuilleton/2006/02/20/alan-moore-interview-1988/.

38. Mendelsund, 334–5, final emphasis mine.

39. The books are clothbound and stitched, whereas the single issue is usually stapled and the paperback collection glued. The paper is clearly heavier. Each volume reprints two of the trade paperback collections—about ten issues, give or take. Each collection has an

introduction by some luminary Hellboy fan—the film director Guillermo del Toro, for example, or the horror author Robert Bloch, and these are included, along with a new introduction specific to the Library Edition. Each trade included a few pages of backmatter in the form of sketches, pencil roughs, character designs, or, in the case of "The Island," unused pages (some inked and colored, some rough page layouts). The sum total of the backmatter pages in the two trades (*Conqueror Worm* and *Strange Places*) total some twenty pages, whereas the Library Edition provides over fifty pages of material, along with an afterword by Mignola. So these books are generously sized, lavishly printed, and come with a cornucopia of supplementary materials.

40. The original art for the first issues of the *Hellboy in Hell* series has been published in facsimile form. The boards are presented at their original size, scanned in full color to capture any and all emendation marks, and have no color or text—those elements that were not proper to the original art pages. Mike Mignola, *Mike Mignola's Hellboy and Other Stories: Artist's Edition* (San Diego, CA: IDW, 2014).

41. Michael Joseph has written about the "bookness" of comics and ways that the materiality of the book is brought to the fore. But he seems to think this only occurs in the work of such graphic novelists as Chris Ware and Dan Clowes, who produce books in different sizes and whose treatment of text emphasizes its material aspect. He likens the experience of reading them to "a child's earliest solo encounters with the picture book" but never maps his ideas onto comics in their entirety. Not only do I think that Mignola is doing nearly as much as Ware in bringing the materiality of reading to the fore, I think comics as a medium is deeply imbricated in these practices. Joseph also writes that "when one looks at something, one is not reading," but I think comics readers do both at once all the time. See Michael Joseph, "Seeing the Visible Book: How Graphic Novels Resist Reading," *Children's Literature Association Quarterly* 37, no. 4 (2012): 454–67. Yasco Horsman more provocatively proposes: "Comics therefore invite their readers to look at the page, rather than away from it to ponder its 'deeper' meanings. Precisely this highlighting of the material dimension of the page

is what the vulgar comics share with the 'high' modernist writers, who also focus on the material dimension of writing." Yasco Horsman, "Infancy of Art: Comics, Childhood and Picture Books," *Journal of Graphic Novels and Comics* 5, no. 3 (2014): 329.

42. See, for example, Gene Kannenberg, Jr., "The Comics of Chris Ware," in *A Comics Studies Reader* (Jackson: University of Mississippi, 2009).

43. Interview with the author, March 27, 2014.

44. Not a richer mythology than Irish culture, but richer than any one-off story adaptation.

45. At his home he practically *hugged* a small bookcase of pulp fiction reprints and noted that if he could harness the energy in those books he could power a small city.

46. I'll have more to say about this later, but it's worth noting here that when I asked Mignola about how he conceives of comics now that they're increasingly read online, he said that he still formats his material for print: "Ultimately," he said, "it's the book." Interview with the author, March 27, 2014.

CHAPTER FIVE

1. Scott McCloud, *Understanding Comics: The Invisible Art.*

2. Gunning, "Art of Succession," 40.

3. del Toro, "Mike Mignola Is a Genius"

4. Laura Mulvey, *Death 24× a Second: Stillness and the Moving Image* (London: Reaktion Books, 2006). Karen Beckman and Jean Ma (eds.), *Still Moving: Between Cinema and Photography* (Durham, NC: Duke University Press, 2008). Elvind Rossaak (ed.), *Between Stillness and Motion: Film, Photography, Algorithms, Film Culture in Transition* (Amsterdam: Amsterdam University Press, 2012).

5. Mulvey, 71.

6. This is not the first time I've considered stasis in the comics. In an extended discussion of the relation of comics to the chronophotographic experiments of Muybridge and Marey, I located a parodic function that systematically mapped movements that led to either

chaos or stasis. The neatly stacked cans that are sent flying by the ejaculation of Winsor McCay's *Sammy Sneeze* (not to mention the carefully ladled soup, the meticulously reconstructed Dinosaurus, and yeah, the very panel boundaries themselves, all of which are reduced to shambles of various kinds) stage a resistance to the imposition of order and measurement imposed on the bodies within chronophotographs and the disciplinary societies which they serve. Narrative is characterized by movement, while stasis represents its closure, its termination. See Scott Bukatman, *The Poetics of Slumberland*, chapter 1.

7. Jerry Moriarty, *The Complete Jack Survives* (Oakland, CA: Buenaventura Press, 2009).

8. Thanks to Jerry Moriarty for clarifying the effect of white acrylic on black (email, March 10, 2015). He added a great distinction: "That is a painter's sensibility where over painting is always expected. Because I have no need to preserve the white of the paper I am free to get 'smart with art' and … the later stages of the picture are the result of many changes. I think a good 'graphic artist' tries to not destroy the initial white of the paper but to preserve it throughout."

9. Greice Schneider, "Jack Survives—Jerry Moriarty," www.comicsgrid.com/2011/02/jack-survives-jerry-moriarty-2/.

10. Rosalind Krauss, "'The Rock': William Kentridge's Drawings for Projection," *OCTOBER* 92, Spring (2000): 17.

11. A similar effect to that produced by Moriarty's materialization of text.

12. In *Building Stories* (2012) and some later *New Yorker* covers, Ware has begun to introduce modeling and a greater individuality to his portraits.

13. Kristen Whissel's term: see "The Digital Multitude," *Cinema Journal* 49, no. 4 (2010): 90–110.

14. From quite early in his filmmaking, the Japanese director Yasujiro Ozu eschewed camera movement and reframing in his wondrous family melodramas; his characters undergo the most massive of life changes—aging, marrying, child-rearing, dying—within an aesthetic marked by an almost unvarying formal restraint and precision.

15. Thanks to Eduardo Vivanco and Beth Kessler for the stained glass connection. I discuss Andrei Molotiu's invocation of iconostasis below.

16. And I wrote this well before the appearance of the first *Hellboy in Hell* collection (*The Descent*, 2014), which has many pages of statuary studies in the Sketchbook section, one under the heading "Statues," the next labeled "More Statues," and a final three pages headed "Still More Statues."

17. Many thanks to Benjamin Woo for reminding me of this characteristic Mignola technique, which was actually what led me to the sculptural connection in the first place. Ben notes that these marks have a tactile quality, while Bart Beaty has seen in them a grittiness reminiscent of the art of Hugo Pratt and Jacques Tardi (of whom Mignola is surely aware).

18. Alex Potts, *The Sculptural Imagination: Figurative, Modernist, Minimalist* (New Haven, CT: Yale University Press, 2000), 25.

19. The work of Frank Miller is perhaps most comparable to Mignola's in its emphasis on mass, blocky forms, and powerful bodies, but his treatment of page and color could not be more different from Mignola's. Further, Miller's comics of the 1980s were often steeped in cinematic or even chronophotographic treatments of temporal flow, as in the traumatic flashback to the murder of Bruce Wayne's parents in *The Dark Knight Returns* (1986). See my discussion of this sequence in *The Poetics of Slumberland*, pp. 206–7. Mignola's work never atomizes time in this way.

20. The practice of numbering panels provides a case study in uneven development—some practitioners of early newspaper comics did, some didn't. McCay numbered the panels in *Little Nemo in Slumberland* from its start in 1905, but didn't on the concurrently running *Dream of the Rarebit Fiend*. Was numbering *Nemo* a courtesy to younger readers? I don't know.

21. Noël Burch, *To the Distant Observer: Form and Meaning in the Japanese Cinema* (Berkeley: University of California Press, 1979), 160–1. Burch himself loosely derived his term from the "pillow words" of classical Japanese poetry. My use of the term should not be taken as an endorsement of Burch's argument regarding the movement away from anthropocentrism in Ozu's work, but "pillow shot" has become the accepted nomenclature for these shots. David Bordwell reads these shots very differently, finding in them a narrational overtness that owes more to

Hollywood than to Japanese poetry. While I don't fully buy these shots as constituting as radical a break in the narrative as Burch posits, they do shift the emphasis from a narrative time of ongoing action to a more contemplative experience of time as duration, an experience entirely in keeping with the narrative events and life transitions at the center of Ozu's films. See David Bordwell, *Ozu and the Poetics of Cinema* (Princeton, NJ: Princeton University Press, 1988), 104–6.

22. Of course, Ozu's pillow shots have a definite duration, but they often imply a still longer stretch of time.

23. Gunning, "Art of Succession," 44.

24. See *Poetics of Slumberland,* pp. 92–3, for a slightly more developed version of these ideas.

25. Johann Gottfried Herder, *Sculpture: Some Observations on Shape and Form from Pygmalion's Creative Dream,* trans. Jason Gaiger (Chicago: University of Chicago Press, 2002). Cited in Potts, 30.

26. Jean Ma, in conversation, detects some rather noir lighting at work here as well, which, given Hellboy's trenchcoat and role as a paranormal investigator, makes a lot of sense.

27. "... one of my ballsier moves," Mignola commented in conversation (March 27, 2014).

28. Bill Watterson (creator of *Calvin and Hobbes*) has remarked that the history of newspaper comics seems to run in reverse, from the sumptuous full-page layouts and bold experiments in form that characterized the work of McCay, Feininger, King, and Herriman (to name only the most prominent) in the first decades of this century to the cramped formulaic gag-writer strips of our time. "The early cartoonists, with no path before them, produced work of such sophistication, wit, and beauty that it increasingly seems to me that cartoon evolution is working backward. Comic strips are moving toward a primordial goo rather than away from it." (Speech at the Festival of Cartoon Art, Ohio State University, October 27, 1989.)

29. Potts, 99.

30. Ibid., 100.

31. Rosalind Krauss, *Passages in Modern Sculpture* (Cambridge, MA: MIT Press, 1981). Vast thanks to Bill Brown for this suggestion.

32. Ibid., 15.

33. Ibid., 23, 27.

34. Ibid., 28.

35. I'm not sure what to make of this, but Popeye makes the same taunt in a comic strip published in 1936. R. Sikoryak has done a mash-up of Hellboy and Popeye, discussed elsewhere in this book.

36. Ibid.

37. Krauss writes of the sculpture of Paul Gauguin that it "makes reference to narrative only to generate a sense of irrationality, or mystery. Gauguin presents the pieces of a story but without a sequence that would give the viewer a sense of accurate or verifiable access to the meaning of the event to which the artist alludes" (*Passages,* 34). This works nicely for Mignola as well.

38. Ibid., 27.

39. Email, September 30, 2013. When the Hernandez Brothers visited Stanford University in 2014, they pointed out that readers never have access to the thoughts of two of their most compelling characters—Luba and Hopey.

40. As I mentioned earlier, this recalls John Ford's *The Searchers,* where we are forced to grapple with the "gestures and movements" of John Wayne's Ethan Edwards without the privileged access to his motives or mental state that most films would provide.

41. Mignola, in our conversation, confirmed this, saying, "I always design two pages side-by-side. . . . And this is just my, you know, super-fussy thing—the panels on this page, if they don't line up with this [next] page, they've got to be off by a significant amount. They can't be almost lining up. That shit'll drive me crazy." Interview with the author, March 27, 2014.

42. See Scott Bukatman, "Spectacle, Attractions, and Visual Pleasure," in *The Cinema of Attractions: 1986–2006,* ed. Wanda Strauven (Amsterdam: Amsterdam University Press, 2006), and "The Ultimate Trip: Special Effects and Kaleidoscopic Perception," in *Matters of Gravity: Special Effects and Supermen in the 20th Century* (Durham, NC: Duke University Press, 2003).

43. Ibid., 72.

44. Of course, such a reader might exist; but while McCloud seems to assume a single mode of reading a comics page, I'm allowing for the possibility of multiple paths, multiple approaches.

45. Tom Gunning, "The Art of Succession." I cited this earlier, but it's worth repeating that Gunning further notes that "the power of comics lies in their ability to derive movement from stillness—not to make the reader observe motion, but rather participate imaginatively in its genesis" (p. 40), which complements my argument here quite nicely and also connects to the discussion of reading as playing that I advanced in *The Poetics of Slumberland.*

46. See, for example, Mitsuru Adachi, *Cross Game,* vol. 1 (San Francisco: Viz Media, 2010).

47. McCloud, 67.

48. "Based on the writings and teachings of art historian Werner Hofmann, I will use the term 'iconostasis' for the perception of the layout of a comics page as a unified composition; perception which prompts us not so much to scan the comic from panel to panel in the accepted direction of reading, but to take it in at a glance, the way we take in an abstract painting." Andrei Molotiu, "Abstract Form: Sequential Dynamism and Iconostasis in Abstract Comics and in Steve Ditko's *Amazing Spider-Man,*" in *Critical Approaches to Comics: Theories and Methods,* ed. Matthew J. Smith and Randy Duncan (New York: Routledge, 2011), 91.

49. Ibid., 93

50. Groensteen, *The System of Comics,* 113.

51. Ibid., 126.

52. Thanks still again to Mike Metzger for this observation.

53. Groensteen, *The System of Comics,* 160.

54. Much of the proliferation of autobiographical comics deploys at least some of these elements to similar ends.

CODA

1. Thanks to Inga Pollmann for this. This is *not* true of *B.P.R.D.,* which is arguably more character driven, and which more consistently emphasizes relationships. And, yes, in Chapter 4 I suggested that Hellboy was actually Mignola's surrogate—I think he serves both functions.

2. Shaun Manning, "Going to the Chapel: Mignola Returns to Drawing Hellboy," www.comicbookresources.com/?page=article&id=18580.

3. In what might make an interesting footnote to the discussion of sculpture in the last chapter, Mignola actually made a small sculpture of the Moloch statue that dominates the artist's studio so that he could accurately draw it from different angles.

4. I'm driven to point out that many of the aquatints in *Los Caprichos* would make *dandy* comic book covers all by themselves. Their sizes are not that different—a comic book is a bit larger, about 10.2 × 6½ inches (the *Caprichos* images are closer to 8 ½ × 6 inches), but the proportions are quite close; both use vertical (portrait) orientation; and both distill their pictorial elements into dramatic but highly readable tableaux. Compare, for example, *Caprichos* plate 3, usually translated as "Here Comes the Bogey-Man," with Jack Kirby's cover for *Fantastic Four* vol. 1, no. 32 (1964)—and big thanks to Craig Fischer for spotting this oh-so-perfect rhyme.

5. One should also note that where Goya is literal, as in his *Disasters of War* series, Mignola is allegorical. The *Baltimore* series is the only one of Mignola's books not connected to the Hellboy cosmos. In the gruesome aftermath of a World War I battle, Lord Baltimore is attacked by a vampire, whom he slashes and wounds. In retaliation, the vampires no longer feed solely on the dead, but on the living as well. The "plague" of vampirism is at the heart of the novel and series, a clearly allegorical approach to the inhumanity of the battlefield and its legacies. In these stories, Lord Baltimore bears witness as much as anything else, echoing Goya's caption, "I saw this," from plate 44 of the series. See *Disaster Drawn: Visual Witness, Comics, and Documentary Form* (Cambridge, MA: The Belknap Press, 2016) for more on this series of Goya's images.

6. Stephen Eisenman, "The Tensions of Enlightenment: Goya," in *Nineteenth Century Art: A Critical History* (London: Thames & Hudson, 1994), 79.

7. Terry Castle, *The Female Thermometer: 18th-Century Culture and the Invention of the Uncanny* (New York: Oxford University Press, 1995), 80.

Bibliography

Adachi, Mitsuru. *Cross Game*, vol. 1. San Francisco: Viz Media, 2010.

Allie, Scott. "Introduction." In *Hellboy Library Edition, vol. 2: The Chained Coffin, The Right Hand of Doom, and Others.* Portland, OR: Dark Horse Comics, 2008.

———. "Introduction." In *Hellboy Library Edition, vol. 3: Conqueror Worm and Strange Places.* Portland, OR: Dark Horse Comics, 2009.

Arrant, Chris. Conversing on Comics with Dave Stewart. http://robot6.comicbookresources.com/2013/01/conversing-on-comics-with-dave-stewart/. January 25, 2013.

Baker, Nicholson. "Preface." In *A Book of Books.* New York: Bullfinch, 2002.

Barry, Lynda. *What It Is.* Montreal: Drawn & Quarterly, 2008.

Batchelor, David. *Chromophobia.* London: Reaktion Books, 2000.

Beckman, Karen, and Jean Ma, eds. *Still/Moving: Between Cinema and Photography.* Durham, NC: Duke University Press, 2008.

Benjamin, Walter. *The Arcades Project.* Trans. Rolf Tiedemann. Cambridge, MA: The Belknap Press of Harvard University Press, 2001.

———. "Children's Literature." In *Selected Writings, vol. 2, part 1,* ed. Marcus Bullock and Michael W. Jennings, 250–6. Cambridge, MA: Harvard University Press, 2005.

————. "A Child's View of Color." In *Selected Writings, vol. 1: 1913–1916,* ed. Marcus Bullock and Michael W. Jennings, 50–1. Cambridge, MA: Harvard University Press, 1996.

————. "Fate and Character." In *Selected Writings, vol. 1: 1913–1916,* ed. Marcus Bullock and Michael W. Jennings, 201–6. Cambridge, MA: Harvard University Press, 1996.

————. "A Glimpse into the World of Children's Books." In *Selected Writings, vol. 1: 1913–1916,* ed. Marcus Bullock and Michael W. Jennings, 414–43. Cambridge, MA: Harvard University Press, 1996.

————. "Old Forgotten Children's Books." In *Selected Writings, vol. 1: 1913–1916,* ed. Marcus Bullock and Michael W. Jennings, 406–13. Cambridge, MA: Harvard University Press, 1996.

————. "One-Way Street." In *Selected Writings, vol. 1: 1913–1916,* ed. Marcus Bullock and Michael W. Jennings, 444–88. Cambridge, MA: Harvard University Press, 1996.

————. "Unpacking My Library: A Talk about Book Collecting." In *Illuminations,* ed. Hannah Arendt, 59–67. New York: Schocken Books, 1969.

Bordwell, David. *Ozu and the Poetics of Cinema.* Princeton, NJ: Princeton University Press, 1988.

Bosman, Julie. "Picture Books No Longer a Staple for Children." *The New York Times,* October 7, 2010.

Boyer, M. Christine. "The Place of History and Memory in the Contemporary City." In *The City of Collective Memory: Its Historical Imagery and Architectural Entertainments,* 1–29. Cambridge, MA: MIT Press, 1994.

Brakhage, Stan. *Metaphors on Vision.* New York: Film Culture, 1976.

Brayshaw, Christopher. "Between Two Worlds: The Mike Mignola Interview." *The Comics Journal* 189 (1996): 64–5.

Bukatman, Scott. "The Artificial Infinite: On Special Effects and the Sublime." In *Matters of Gravity: Special Effects and Supermen in the 20th Century,* 81–110. Durham, NC: Duke University Press, 2003.

————. "Comics and the Critique of Chronophotography, or 'He Never Knew When It Was Coming!'" *Animation* 1, no. 1 (2006): 83–103.

————. *The Poetics of Slumberland: Animated Spirits and the Animating Spirit.* Berkeley: University of California Press, 2011.

———. "Spectacle, Attractions, and Visual Pleasure." In *The Cinema of Attractions: 1986–2006*, ed. Wanda Strauven, 71–82. Amsterdam: Amsterdam University Press, 2006.

———. "Taking Shape: Morphing and the Performance of Self." In *Matters of Gravity: Special Effects and Supermen in the 20th Century*, 133–56. Durham, NC: Duke University Press, 2003.

———. "The Ultimate Trip: Special Effects and Kaleidoscopic Perception." In *Matters of Gravity: Special Effects and Supermen in the 20th Century*, 111–30. Durham, NC: Duke University Press, 2003.

Burch, Noël. *Life to Those Shadows*. Berkeley: University of California Press, 1990.

———. *To the Distant Observer: Form and Meaning in the Japanese Cinema*. Berkeley: University of California Press, 1979.

Burke, Edmund. *On the Sublime and the Beautiful*. Charlottesville, VA: Ibis Publishing, no date.

Camille, Michael. *Image on the Edge: The Margins of Medieval Art*. Cambridge, MA: Harvard University Press, 1992.

Carr, Alex. Emerald City Comicon 2011: Interview with Dave Stewart. www.omnivoracious.com/2011/03/emerald-city-comicon-2011-interview-with-dave-stewart.html. March 9, 2011.

Carroll, Lewis. *Alice: Alice's Adventures in Wonderland*. Illustrated by Barry Moser. North Hatfield, MA: Pennyroyal Press, 1982.

Castle, Terry. *The Female Thermometer: 18th-Century Culture and the Invention of the Uncanny*. New York: Oxford University Press, 1995.

Christiansen, Hans-Christian. "Comics and Film: A Narrative Perspective." In *Comics & Culture: Analytical and Theoretical Approaches to Comics*, ed. Anne Magnussen and Hans-Christian Christiansen, 107–21. Copenhagen: Museum Tusculanum Press, 2000.

Chute, Hillary. *Disaster Drawn: Visual Witness, Comics, and Documentary Form*. Cambridge, MA: The Belknap Press, 2016.

Coulthart, John. Alan Moore Interview, 1988. www.johncoulthart.com/feuilleton/2006/02/20/alan-moore-interview-1988/. February 20, 2006.

del Toro, Guillermo. "Mike Mignola Is a Genius: An Unapologetically Subjective Introduction." In *Hellboy: Conqueror Worm*. Portland, OR: Dark Horse Comics, 2002.

Deleuze, Gilles. *Cinema 1: The Movement-Image*. Trans. Hugh Tomlinson and Barbara Habberjam. Minneapolis: University of Minnesota Press, 1989.

———. *Cinema 2: The Time-Image*. Trans. Hugh Tomlinson and Robert Galeta. Minneapolis: University of Minnesota Press, 1989.

Eco, Umberto. "The Myth of Superman." In *Arguing Comics: Literary Masters on a Popular Medium*, ed. Jeet Heer and Kent Worcester, 146–64. Jackson: University Press of Mississippi, 2004.

Eisenman, Stephen. "The Tensions of Enlightenment: Goya." In *Nineteenth Century Art: A Critical History*, ed. Stephen Eisenman, 78–97. London: Thames & Hudson, 1994.

Enns, Anthony. "The City as Archive in Jason Lutes's *Berlin*." In *Comics and the City: Urban Space in Print, Picture, and Sequence*, ed. Jörn Ahrens and Arno Meteling, 45–59. New York: Continuum Books, 2010.

Feiffer, Jules. *The Great Comic Book Heroes*. Seattle, WA: Fantagraphics Books, 2003. [Originally published in 1965.]

Fiore, R. "Days of Yesteryear." http://www.tcj.com/days-of-yesteryear/. February 27, 2013.

Fitzsimons, Kate. Does the Man Have a Point? http://comicsbeat.com/does-the-man-have-a-point/. September 4, 2010.

Friedberg, Anne. *Window Shopping: Cinema and the Postmodern*. Berkeley: University of California Press, 1993.

Gardner, Jared. "Archives, Collectors, and the New Media Work of Comics." *Modern Fiction Studies* 52, no. 4 (2006): 787–806.

Gianni, Gary. "Introduction." In *Hellboy: Strange Places*. Portland, OR: Dark Horse Comics, 2006.

Groensteen, Thierry. *Comics and Narration*. Trans. Ann Miller. Jackson: University Press of Mississippi, 2013.

———. *The System of Comics*. Trans. Bart Beaty and Nick Nguyen. Jackson: University Press of Mississippi, 2007.

Gunning, Tom. "The Art of Succession: Reading, Writing, and Watching Comics." *Critical Inquiry* 40, no. 3 (2014): 36–51.

————. "The Cinema of Attractions: Early Film, Its Spectator and the Avant-Garde." In *Early Cinema: Space, Frame, Narrative,* ed. Thomas Elsaesser, 56–62. London: British Film Institute, 1990.

————. "Narrative Discourse and the Narrator System." In *Film Theory and Criticism: Introductory Readings,* ed. Leo Braudy and Marshall Cohen, 470–81. New York: Oxford University Press, 1999.

Hatfield, Charles. *Alternative Comics: An Emerging Literature.* Jackson: University Press of Mississippi, 2005.

————. "Comic Art, Children's Literature, and the New Comic Studies." *The Lion and the Unicorn* 30, no. 3 (2006): 360–82.

————. *Hand of Fire: The Comics Art of Jack Kirby.* Jackson: University Press of Mississippi, 2012.

————. "The Vessel Shaped by Its Contents, or, Form in Superhero Comics." Talk given at symposium "Secret Identity Politics: The Place of Superhero Studies in Comics Studies," Stanford University, May, 2014.

Hatfield, Charles, and Craig Svonkin. "Why Comics Are and Are Not Picture Books: Introduction." *Children's Literature Association Quarterly* 37, no. 4 (2012): 429–35.

Hayot, Eric. *On Literary Worlds.* New York: Oxford University Press, 2012.

Herder, Johann Gottfried. *Sculpture: Some Observations on Shape and Form from Pygmalion's Creative Dream.* Trans. Jason Gaiger. Chicago: University of Chicago Press, 2002.

Horsman, Yasco. "Infancy of Art: Comics, Childhood and Picture Books." *Journal of Graphic Novels and Comics* 5, no. 3 (2014): 323–35.

Iser, Wolfgang. "The Reading Process: A Phenomenological Approach." *New Literary History* 3, no. 2 (1972): 279–99.

Jay, Martin. *Downcast Eyes: The Denigration of Vision in Twentieth-Century French Thought.* Berkeley: University of California Press, 1994.

Jennings, Dana. "Imax? Try a Cosmos between Covers." *The New York Times,* July 31, 2014.

Johnson, Crockett. *Harold and the Purple Crayon.* New York: Harper & Brothers, 1955.

Joseph, Michael. "Seeing the Visible Book: How Graphic Novels Resist Reading." *Children's Literature Association Quarterly* 37, no. 4 (2012): 454–67.

Kannenberg, Gene, Jr. "The Comics of Chris Ware." In *A Comics Studies Reader,* 306–24. Jackson: University of Mississippi, 2009.

Krauss, Rosalind. *Passages in Modern Sculpture.* Cambridge, MA: MIT Press, 1981.

———. "'The Rock': William Kentridge's Drawings for Projection." *OCTOBER* 92, Spring (2000): 3–35.

Kunzle, David. *The Early Comic Strip,* vol. 1. Berkeley: University of California Press, 1973.

———. *The History of the Comic Strip: The Nineteenth Century,* vol. 2. Berkeley: University of California Press, 1990.

Lovecraft, Howard Phillips. "Supernatural Horror in Literature." In *Dagon and Other Macabre Tales,* ed. S. T. Yoshi, 347–413. Sauk City, WI: Arkham House, 1965.

Manchess, Gregory. An Interview with Colorist Dave Stewart. www.tor.com/blogs/2010/08/an-interview-with-colorist-dave-stewart. August 25, 2010.

Manning, Shaun. Going to the Chapel: Mignola Returns to Drawing Hellboy. www.comicbookresources.com/?page=article&id=18580. October 27, 2008.

Maresca, Peter, ed. *Little Nemo in Slumberland: Splendid Sundays 1905–1910.* Palo Alto, CA: Sunday Press Books, 2005.

———, ed. *Little Nemo in Slumberland: Splendid Sundays 1906–1926.* Palo Alto, CA: Sunday Press Books, 2009.

McCloud, Scott. *Understanding Comics: The Invisible Art.* Northhampton, MA: Tundra, 1993.

Melville, Herman. *Moby-Dick; or, The Whale.* Illustrated by Barry Moser. Berkeley: University of California Press, 1981.

Mendelsund, Peter. *What We See When We Read: A Phenomenology with Illustrations.* New York: Vintage Books, 2014.

Mignola, Mike. "Afterword." In *Hellboy Library Edition, vol. 2: The Chained Coffin, The Right Hand of Doom, and Others.* Portland, OR: Dark Horse Comics, 2008.

————. *Hellboy: The First 20 Years*. Portland, OR: Dark Horse Comics, 2014.

————. "Introduction." In *Hellboy Library Edition, vol. 3: Conqueror Worm and Strange Places*. Portland, OR: Dark Horse Comics, 2009.

————. *Mike Mignola's Hellboy and Other Stories: Artist's Edition*. San Diego, CA: IDW, 2014.

————. "Story Notes." In *Hellboy Library Edition, vol. 2: The Chained Coffin, The Right Hand of Doom, and Others*. Portland, OR: Dark Horse Comics, 2008.

Miller, Frank. *The Dark Knight Returns*. New York: DC Comics, 1987.

Molotiu, Andrei. "Abstract Form: Sequential Dynamism and Iconostasis in Abstract Comics and in Steve Ditko's *Amazing Spider-Man*." In *Critical Approaches to Comics: Theories and Methods,* ed. Matthew J. Smith and Randy Duncan, 84–97. New York: Routledge, 2011.

Moore, Debi. Guest Blog: Dark Horse Editor-in-Chief Scott Allie Interviews Artist Dave Stewart. www.dreadcentral.com/news/60960/guest-blog-dark-horse-editor-chief-scott-allie-interviews-artist-dave-stewart#ixzz3C62r597p. October 20, 2012.

Moriarty, Jerry. *The Complete Jack Survives*. Oakland, CA: Buenaventura Press, 2009.

Mulvey, Laura. *Death 24× a Second: Stillness and the Moving Image*. London: Reaktion Books, 2006.

Nel, Philip. "Same Genus, Different Species?: Comics and Picture Books." *Children's Literature Association Quarterly* 37, no. 4 (2012): 445–53.

Nodelman, Perry. "Picture Book Guy Looks at Comics: Structural Differences in Two Kinds of Visual Narrative." *Children's Literature Association Quarterly* 37, no. 4 (2012): 436–44.

op de Beeck, Nathalie. "Found Objects: (Jem Cohen, Ben Katchor, Walter Benjamin)." *Modern Fiction Studies* 52, no. 4 (2006): 807–30.

————. "On Comics-Style Picture Books and Picture-Bookish Comics." *Children's Literature Association Quarterly* 37, no. 4 (2012): 468–76.

————. *Suspended Animation: Children's Picture Books and the Fairy Tale of Modernity*. Minneapolis: University of Minnesota Press, 2010.

Potts, Alex. *The Sculptural Imagination: Figurative, Modernist, Minimalist.* New Haven, CT: Yale University Press, 2000.

Poulet, Georges. "Phenomenology of Reading." *New Literary History* 1, no. 1 (1969): 53–68.

Rossaak, Elvind, ed. *Between Stillness and Motion: Film, Photography, Algorithms. Film Culture in Transition.* Amsterdam: Amsterdam Unversity Press, 2012.

Rust, Martha Dana. *Imaginary Worlds in Medieval Books: Exploring the Manuscript Matrix.* New York: Palgrave Macmillan, 2007.

———. "'It's a Magical World': The Page in Comics and Medieval Manuscripts." *English Language Notes* 46, no. 2 (2008): 23–38.

Salvatore, Brian, and David Harper. Mignolaversity: A Colorful Conversation with Dave Stewart. http://multiversitycomics.com/interviews/mignolaversity-a-colorful-conversation-with-dave-stewart/. March 5, 2013.

Saunders, Ben. "Superheroes after 1986." In *The Cambridge Companion to Comics,* ed. Bart Beaty. New York: Cambridge University Press. [Forthcoming.]

Schneider, Greice. "Jack Survives—Jerry Moriarty." http://blog.comicsgrid.com/2011/02/jack-survives-jerry-moriarty-2/. February 24, 2011.

Shelley, Mary Wollstonecraft. *Frankenstein; or, The Modern Prometheus.* Illustrated by Barry Moser. Berkeley: University of California Press, 1984.

Sikoryak, R. "Black Press Review Daily: Color Comics Fun." In *Hellboy: 20th Anniversary Sampler.* Portland, OR: Dark Horse Comics, 2014.

Smajić, Srdjan. *Ghost-Seers, Detectives, and Spiritualists: Theories of Vision in Victorian Literature and Science.* Cambridge, UK: Cambridge University Press, 2010.

Spiegelman, Art. *Co-Mix: A Retrospective of Comics, Graphics, and Scraps.* Montreal: Drawn & Quarterly, 2013.

Walker, Brian. "Disrespecting the Comics." In *Society Is Nix: Gleeful Anarchy at the Dawn of the American Comic Strip, 1895–1915,* ed. Peter Maresca, 12. Palo Alto, CA: Sunday Press Books, 2013.

Ware, Chris. *The Acme Novelty Library,* vol. 16. New York: ACME Novelty Library, 2005.

———. *Building Stories*. New York: Pantheon, 2012.

Weiss, Allen S. "Ten Theses on Monsters and Monstrosity." *TDR: The Drama Review* 48, no. 1 (2004): 124–5.

Whissel, Kristen. "The Digital Multitude." *Cinema Journal* 49, no. 4 (2010): 90–110.

Wiesner, David. *Art & Max*. New York: Clarion Books, 2010.

———. *Free Fall*. New York: HarperCollins, 1991.

———. *Mr. Wuffles*. New York: HarperCollins, 2013.

———. *The Three Pigs*. New York: Clarion Books, 2001.

Zbarackia, Matthew D., and Jennifer Geringer. "Blurred Vision: The Divergence and Intersection of Illustrations in Children's Books." *Journal of Graphic Novels and Comics* 5, no. 3 (2014): 284–96.

Index

abstraction, 164, 176, 193 234n28, 242n28; in *Hellboy*, 36, 104, 108, 160, 175, 180
Adachi, Mitsuru, 191
Adams, Neal, 11, 193
Aldiss, Brian, 26
Allie, Scott, 48, 49, 56, 71, 72–73
Alton, John, 36
Andersen, Hans Christian, 89
archive, 17, 21, 145, 224n32
Arcudi, John, 49, 54, 56, 224n1
art history, 10, 18–19, 20, 85, 91–93, 96, 108, 123–124, 125–126, 134, 154, 164, 175–179, 181–186, 193, 200–208, 232n42, 232n43, 234n18, 234n28, 241n37, 242n28, 243n5
Azzarello, Brian, 45

Bá, Gabriel, 49, 52
Baker, Nicholson, 135, 136–137, 235n31
Ballard, J.G., 26
Balzac, Honore de, 40
Barks, Carl, 31, 52

Barry, Lynda, 3, 18
Barthes, Roland, 92
Batchelor, David, 91–93, 96
Bazin, André, 224n5
Beasts of Burden (comic), 49
Beaty, Bart, 239n17
Beckman, Karen, 151
Benjamin, Walter, 1–4, 13, 17–18, 20–22, 74, 83, 84, 85, 88–90, 92–93, 97, 100, 130–131, 135–137, 189, 205, 209, 223n20, 223n22
Bernstein, Leonard, 27
Bloch, Robert, 235–236n39
Bogart, Humphrey, 69
book, the: bibliophilia, 13, 17, 133, 135; "bookishness," 2, 13, 22–23, 69, 124, 134, 188–189, 234n28; collecting, 2, 13, 17, 21, 46, 130, 135, 188, 223n22, 224n32; illustrated children's books, 2–3, 22, 88–90, 93, 133, 137, 230n18, 233n52; library, 1, 2, 17, 68, 135, 189; materiality, of, 1, 13, 85, 89, 125, 131, 133–137, 140–141, 148, 195, 234n28. *See also* reading

194, 195; temporality, 160, 168, 171, 172–173, 179, 180–181, 191–192, 194, 239n19; world-building, 22, 25, 27, 34–39, 40–41, 48–49, 54, 145, 181, 227n33
Hellboy (films), 14, 33, 41, 150, 157, 160, 162, 194
Hernandez Brothers, 47, 93, 231n29; Mario, 232n36; Gilbert, 241n39
Herriman, George, 11, 175, 230n9, 240n28
Hilgart, John, 101
Hitchcock, Alfred, 40
Hodgson, William Hope, 73
Hofmann, Werner, 242n48
horror genre. *See* comics, horror
Horsman, Jasco, 236–237n41
Howard, Robert E., 9, 58, 62, 71
Huizenga, Kevin, 68–69

iconostasis, 163, 193, 242n48
illuminated manuscripts, 10, 18–19, 20, 123–124, 125–126, 134, 232n42, 234n18; codicological conscious-ness (imagination), 23, 131, 133, 144, 197; manuscript matrix, 124, 125, 134; text as consciousness, 131–132
imagination, 19, 20, 29, 86–88, 90, 91, 100, 124–126, 127, 134–135, 148, 149, 167, 188, 195, 205, 208, 242n45; imaginative space, 13, 132, 134, 148, 197, 200, 205. *See also* illuminated manuscripts; codicological consciousness (imagination)
Infantino, Carmine, 149
Iser, Wolfgang, 28, 131–132, 133, 140

James, M. R., 73
Jason (John Arne Sæterøy), 172, 229n18

Jay, Martin, 231n20
Johns, Geoff, 227n28
Johnson, Crockett, 230n10
Joseph, Michael, 236–237n41

Kant, Immanuel, 19, 58
Katchor, Ben, 21
Ketcham, Hank, 225n10
Kindzierski, Lovern, 231n30
King, Frank, 97, 98, 175
Kirby, Jack, 7, 9, 11, 14, 65–68, 85, 142, 149, 163–164, 190, 193, 200
Krauss, Rosalind, 154, 176–179, 181–186, 241n37
Kristeva, Julia, 92, 96

Lee, Jae, 11
Lee, Stan, 65, 75, 226n23
Le Fanu, Sheridan, 69
Leroi-Gourhan, André, 100
literary theory, 24–29, 40–41, 43, 58, 100, 121, 131–132, 133, 140–141, 197, 200, 205–208, 224n4, 232n42, 224n4, 225n12, 228n4, 230n18
Lovecraft, H.P., 7, 17, 22, 57–58, 62–63, 65, 71, 73, 123, 127–128, 228n4; "Lovecraftian," 63, 69, 75, 144
Lutes, Jason, 21
Lydgate, John, 125, 240n26

Ma, Jean, 151
Maleev, Alex, 49
marginalia, disruptive power of, 18–19, 20–21, 208–209
Matisse, Henri, 92
McCay, Winsor, 11, 88, 89, 97, 143, 168, 175, 130n10, 237–238n6, 239n20, 240n28; *Little Nemo in Slumberland*, 85, 87–88
McCloud, Scott, 100, 127, 149, 190–192, 194, 242n44